Becoming a Visually Reflective Practitioner

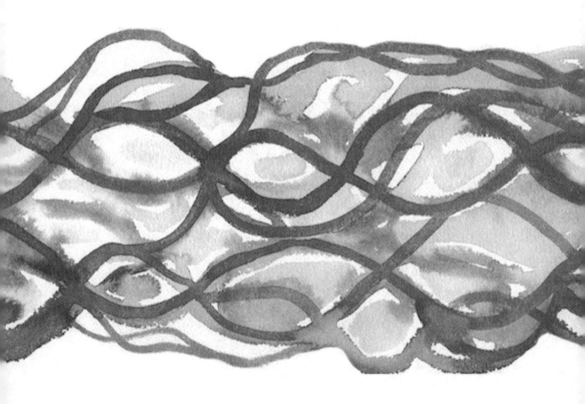

Becoming a Visually Reflective Practitioner

An Integrated Self-Study Model for Professional Practice

Sheri R. Klein and Kathy Marzilli Miraglia

Bristol, UK / Chicago, USA

First published in the UK in 2021 by
Intellect, The Mill, Parnall Road, Fishponds, Bristol, BS16 3JG, UK

First published in the USA in 2021 by
Intellect, The University of Chicago Press, 1427 E. 60th Street,
Chicago, IL 60637, USA

A catalogue record for this book is available from
the British Library.

Cover designer: Aleksandra Szumlas
Copy editor : Newgen
Cover image and frontispiece image: Sheri R. Klein
Production manager: Laura Christopher
Typesetting: Newgen

Print ISBN 978-1-78938-486-4
ePDF ISBN 978-1-78938-487-1
ePub ISBN 978-1-78938-488-8

Printed and bound by CPI.

To find out about all our publications, please visit
www.intellectbooks.com
There you can subscribe to our e-newsletter,
browse or download our current catalogue,
and buy any titles that are in print.

This is a peer-reviewed publication.

Contents

Figures

 # Introduction

How do you identify as a professional? What are the experiences occurring in various components of your professional practice? How do you experience change within professional practice? What new pathways are envisioned as a result of self-study? These are some key questions that lie at the heart of a reflective professional practice. Responses to these kinds of questions will undoubtedly vary from individual to individual, and over the course of a professional life. Cultivating responses to these questions will also take time and require a variety of paths due to the diverse nature of professional roles and identities of *visual arts practitioners*.

Visual arts practitioners may be defined as professionals who have education, training, and/or work experiences in the visual arts; assume a role or position affiliated with the visual arts, such as studio artist, educator, researcher, writer, entrepreneur, therapist, community activist, curator, administrator; and typically juggle multiple and overlapping professional identities associated with the visual arts. The reality of having multiple, fluid, and entangled professional identities is common amongst visual arts practitioners (Daichendt 2010, 2014; Thornton 2013) and often results in unresolved and conflicting attitudes toward professional practice (Kind et al. 2007; MacDonald 2017; Zwirn 2006). The often-blurred boundaries between personal and professional identities (Wenger 1998) require the reappraisal of professional practice (Hall 2010: 103), particularly as professional identities continue to shift and emerge.

The concept of *becoming* is applicable to understanding professional identities and professional practice as a continuous process of forming, changing, and evolving. Professional practice can be likened to a cartographic space that is "connectable [,] [...] modifiable [,] [...] has multiple entryways and exits"

(Deleuze and Guatarri 1987: 21) and is created through rhizomatic movements that defy "linear unity" (Deleuze and Guattari 1987: 6). Rather, professional practice may be likened to "a stream without a beginning or end" (Deleuze and Guattari 1987: 25). This stream (Figure I.1) is envisioned as a *braided stream*[1] that is highly dynamic, multichanneled, and "reformed continuously" (National Park Service n.d.)

The braided stream as a metaphorical construct for professional identity and professional practice embraces the natural ebb and flow of professional practice that is inclusive of an ongoing practice of reflection. Extending John Dewey's (1933: 33) claim that reflection is "an important human activity in which people recapture their experience, [and] think about it" in ways that lead to inquiry, (Dewey 1933: 7) supports *reflective practice* as: (1) "the capacity for self-evaluation and self-improvement through rigorous and systematic research and study of his or her [one's own] practice" (McKernan 1996: 46) and (2) a process in which reflection occurs within the context of one's practice (Schön 1983). The practice of reflection with the aim of professional growth has evolved into what is known as *self-study* that may be understood as a research methodology and a sustained practice of reflection that is guided by questions related to professional practice (Korthagen and Kessels 1999).

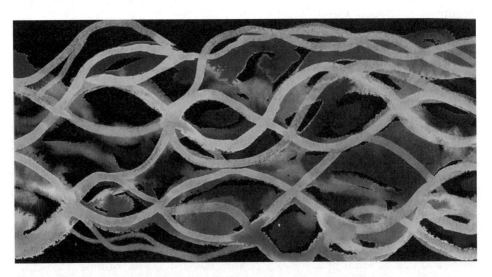

FIGURE I.1: Sheri R. Klein, *Braided Stream Visual Metaphor for Self-Study Model*, 2020. Ink on paper and digitally enhanced. Courtesy of artist.

Self-study

Self-study, also referred to as practitioner inquiry and self-inquiry, is characterized by "a means of a systematic methodology," but is not limited to a "single or most correct way to carry out the research" (Ezer 2009: 16). While self-study is often associated with the fields of education and teacher education (Ben-Yehoshua 2009; Brandenburg and McDonough 2019; Gallagher et al. 2011; Kitchen et al. 2020; Loughran et al. 2004; Lassonde et al. 2009; Ritter et al. 2018; Russell 2004), practitioners within and across many professional sectors and disciplines have embraced self-study to inform professional practice (Pinnegar and Hamilton 2009; Strom et al. 2018; Tidwell et al. 2009; Van Cleve 2008).

The self-study model in this text acknowledges that "the identity of the researcher is central to research work" (Ezer 2009: 12) and that "professional development is dynamic and not static" (Ben-Yehoshua 2009: ix). As professional practice is a relational, fluctuating, and a longitudinal process, self-study necessitates a balanced approach with a critical and appreciative eye toward professional practice (Cooperrider and Whitney 2005).

The theoretical considerations for the self-study model used in this text are highly networked and address the individual and collective nature of professional identity and practice, and the interstitial spaces of practice. In addition to drawing upon areas of *reflective practice* (Byers and Forinash 2004; Cooperrider and Whitney 2005; Duffy 2015; Klein 2008; Klein and Miraglia 2017; Palmer 2017; Schön 1983; Thorton 2005; Walker 2004) and *self-study methodology* (Brandenburg and McDonough 2019; Kitchen et al. 2020; Loughran et al. 2004; Pinnegar and Hamilton 2009; Russell 2004), we look to *arts-based research* (Barone and Eisner 2012; Cahnmann-Taylor and Siegesmund 2017; Chilton and Leavy 2014; Leavy 2017; Rolling 2013; Sinner et al. 2019; Sullivan 2009); *identity theory development* (Crenshaw 1991; Escobar 2008; Trede et al. 2012); *career and professional development* (Ben-Yehoshua 2009; Cooperrider and Whitney 2005; Steffy et al. 2000); and *adult transformation learning theory and research* (Dirkx 2012; Knowles et al. 2015; Merriam and Kim 2012; Mezirow 1991; Mezirow 2012). In addition, the exploration of *rhizomatic principles* (Deleuze and Guattari 1987) and *network theory* (de Landa 1997) illuminate understandings as to how individuals and communities of professional practice create identities, enact interests, and self-organize through networks (cyberspace, organizational, etc.) in ways that offer "movements of de-territorialization" that can allow for states of "becoming" (Escobar 2008: 296).

Self-study model components. The theoretically grounded self-study model is composed of four salient areas of practice: identity, work cultures, change and envisioning. These areas emerge through a search of transdisciplinary literature

as consistent components of the professional practices of visual arts practitioners. The questions for self-study were developed as general guiding questions that are applicable to a wide range of visual arts practitioners. They are grounded in theory and practice and in a phenomenological research design that supports inquiry about lived experience (van Manen 1990).

These guiding questions include:

- How do you identify as a professional?
- What is occurring in the various components of your professional practice?
- How do you experience change related to your professional practice?
- What new pathways are envisioned as a result of self-study?

Each chapter of this text explores an aspect of the self-study model and provides opportunities for the creation of written and visual artefacts as responses to end-of-chapter prompts with the aims of: (1) developing a sustainable visually reflective practice and (2) understanding and directing professional practice through the creation and interpretation of self-study artefacts.

Self-study as a visually reflective practice

The complexities of professional practice, which include shifts, conflicts, uncertainties, transitions, and ebbs and flows, require a robust toolbox of self-study methods that can enable reflection on professional practice. Most methods for engaging in reflection on professional practice still rely heavily on analytical, linear, logical, and rational thinking. Methods appropriate for visual arts practitioners should naturally embrace opportunities to "think contemplatively or imaginatively [...] [to] develop discernment, and see qualitative nuances" (Klein 2008: 111) about professional practice. The self-study model in this text supports a *visually reflective practice* that embraces arts-based research, interpretative and visualization methods (de Freitas 2012; Denzin and Lincoln 2017; Saldaña 2015; Savin-Baden and Howell-Major 2010) which are central to the practices of artists and that afford self-study practitioners ways to "grasp the dynamism of the rhizomatic process" of self-study (de Freitas 2012: 588). Artistic methods are further discussed in Chapter 2. Interpretive and mapping methods are discussed in Chapter 6.

Key to the self-study model is arts-based research that is "guided by aesthetic features" (Barone and Eisner 2012: ix) and where art making processes serve "as a primary source of inquiry" (Chilton and Leavy 2014: 404). Arts-based research is long associated with visual and performing arts, arts education, and art therapy

research (Badenhorst et al. 2019; Barone 2003; Bennett 2013; Bresler 2007; Biggs and Karlson 2011; Butler-Kisber 2008; Cahnmann-Taylor and Siegesmund 2017; Chen 2019; Deaver and McAuliffe 2009; Eisner 2002; Grauer and Sandell 2000; Griffiths 2011; Hiltunnen and Rantala 2015; Hofess and Hanawalt 2018; Jokela et al. 2019; Kay 2013; Kjørup 2011; Klein and Miraglia 2019; Knowles and Cole 2008; La Jevic and Springgay 2008; Leavy 2017; MacDonald 2017; McNiff 2013; Mulvihill and Swaminathan 2019; Nelson 2013; Rolling 2013; Scotti and Chilton 2014; Shenstead 2012; Sinner et al. 2019; Sullivan 2009; Thorton 2005).

However, arts-based research is gaining a wider application in other disciplines and professional sectors to examine issues related to education, disability, leadership, social science, the workplace, lifelong learning, and social change (Adams and Arya-Manesh 2019; Allen 2020; Capous-Desyllas and Morgaine 2017; Forest 2009; Gourlay 2010; Hiltunnen and Rantala 2015; Knight and Lasczik-Cutcher 2018; Kortjass 2019; Lenette 2019; Romanowska et al. 2013; Lenette 2019; Shank and Schirch 2008; Tracey and Allen 2013). As a "transdisciplinary approach," arts-based research "crosses borders of theory and methodology" (Wang et al. 2017: 11) and provides visual arts practitioners opportunities for "promoting reflection, building empathic connections, forging coalitions, challenging stereotypes and fostering social action" (Leavy 2009: 255). Furthermore, arts-based self-study strengthens linkages to multiple artistic disciplines (Weber and Mitchell 2004; Leavy 2017) and multiple ways of understanding that are "embodied, emotional, spiritual, aesthetic, relational and intuitive" (Chilton and Leavy 2014: 407).

Audiences

The primary audiences for this text include those who seek to engage in self-study, who identify as visual arts practitioners, and who may experience multiple professional identities. These practitioners may include public school art teachers, private school art teachers, artist-teachers, independent artists, visual art and design university faculty, visual arts and art education university students, visual arts administrators, social practice and/or community-based artists, and/or other visual arts professionals who work within galleries and/or art museums settings. Many anticipated users of this text are likely to be enrolled in graduate level courses and programs in the fields of studio art, art education, teacher education, art therapy, and/or educational administration.

Most users of this text will be visual arts practitioners who have a proclivity toward creating using arts-based methods and conducting research

using interpretive methods. Secondary audiences for this text include those professionals who may have a strong interest in self-study, reflective practice, and using arts-based methods but who may not identify as a visual arts practitioner, or have a limited background in the visual arts. It is anticipated that practitioners from other disciplines may find that creating and visualizing can be "physically, sensuously, and emotionally satisfying and pleasurable" (Dissanayake 1995: 26).

Finally, it is also anticipated that users of this text will likely

- have varying experiences in conducting self-study research
- juggle competing demands of a professional practice and appreciate constructivist approaches toward professional development that allow for self-pacing and discovery
- understand that the complexities of professional practice and the diversity of experiences require multiple paths and processes for self-inquiry
- have a vested interest in deepening their understanding of professional practice through self-study.

How this text is used may vary relative to individual audience needs. If working independently, or as part of a class or course, there are several ways to use the self-study model: (1) self-select an area or chapter and pursue only that area or (2) work sequentially through each area of the model and the text. The benefits of a sequential movement through the self-study model, and the completion all the chapters in this text, will allow for a more complete understanding of the self-study model and the self-study process. The flexibility of the model, however, is that it can serve multiple purposes for individuals and groups with diverse needs.

Aim and focus of this text

The aim for this text is to provide visual arts practitioners on all levels of practice with a self-study framework and model to investigate the multiple dimensions of professional practice using arts-based and interpretive research methods in support of a sustainable visually reflective practice with the aims of greater self-awareness and the creation of new professional pathways. In self-study, the "self" becomes the subject of study, and the personal and professional can and do overlap; personal issues impact professional practice, and professional issues impact personal lives. Distinctions between what constitutes

self-development and professional development are important to understand. Self-development focuses on the exploration of strategies to overcome personal obstacles and issues. Professional development focuses on the exploration of strategies to address professional questions, issues, and obstacles. The focus of this text, in terms of content and end-of-chapter questions, is on exploring issues and questions related to the professional domain, professional identity, and professional practice. In this sense, a central focus of this text is about care and attention toward one's professional practice in ways that foster professional growth.

Chapter overview and focus

Chapters are layered and presented in a sequence that allow for the exploration of the self-study model. The following is an overview of the chapters:[2]

Chapter 1: Framework and components of a self-study model for visual arts practitioners

This chapter provides a detailed overview of the conceptual framework and components of the self-study model for visual arts practitioner inquiry.

Chapter 2: Overview of arts-based media for self-study

This chapter explores various artistic methods, media, materials and other considerations for engaging in an arts-based self-study.

Chapter 3: Exploring the complexity of professional identity formation

This chapter explores the numerous intersecting factors that contribute to the formation of professional identity. Intersectionality and social identity theories drive the discussion concerning connections between personal, cultural, group, and professional identities. The chapter discusses dual, multiple, overlapping, hybrid, and conflicting identities relative to the professional identities of visual arts practitioners. It also examines the impact of conflict on identities resulting in identity dissonance. The roles of communities are emphasized in the creation and sustaining of professional identities.

Chapter 4: Factors shaping professional identity and practice in work cultures

This chapter provides a theoretical overview about the factors influencing professional identity and practice within work cultures. Central to this discussion are a variety of cultural and social factors shaping professional practice within work cultures, such as group identity, group tension and conflict, group cohesion, and mentoring.

Chapter 5: Exploring change within professional practice

This chapter explores the nature and qualities of change impacting professional identities and professional practice. It also discusses ways in which visual arts practitioners may consider navigating professional change with a goal of a sustainable professional practice.

Chapter 6: Issues and methods for self-study artefact interpretation

This chapter focuses on interpretive research methods for selecting and interpreting written and visual self-study artefacts. It outlines interpretive methods of mapping with a variety of options that support thematic, visual, and metaphorical interpretations. The chapter also explores considerations relevant to the interpretation of self-study artefacts.

Chapter 7: Envisioning professional practice

This chapter addresses how self-study interpretations can guide the process of envisioning new goals, pathways, and lines of flight within professional practice. It explores envisioning as a reflexive, collaborative, and visual process. The chapter also discusses the two phases of envisioning: decision making relative to goal setting and using arts-based mapping methods as central to the envisioning process.

Appendices. The included glossary (Appendix 1) serves as a resource of key terms introduced throughout this text. Guidelines are included to guide readers in the creation and reflection on written artefacts (Appendix 2) and visual artefacts (Appendix 3). In classroom settings, these guidelines may be used or adapted by instructors. Other appendices include guidelines for visual journaling (Appendix 4) and art materials (Appendix 5).

Responding to end-of-chapter prompts. The end-of-chapter prompts serve as invitations at the end of each chapter to explore artistic methods and materials, questions, and understandings of chapter content. The integrated processes of *inquiring, analyzing, creating, reviewing,* and *sharing* are embedded into the framework of all end-of-chapter prompts. While some end-of-chapter prompts are more specific and provide greater guidance, other end-of-chapter prompts are more general in nature. This is intended to allow readers to have a range of freedom and choices—understanding that readers will have varying skills, goals, motivations, and experiences. A range of arts-based methods is discussed in Chapter 2. A diverse range of visual artefacts created by visual arts practitioners are infused throughout this text to illustrate how arts-based methods and materials can be used for purposes of self-study and reflection on professional practice.

Finally, on a personal note...

Self-study, as a systemic inquiry, allows for the emergence of insights and questions about professional practice that is essential for remaining enthusiastic about and engaged in professional practice. We have both experienced the pulls and tugs of entangled professional identities—as visual artists, university educators, researchers, administrators, and leaders. Furthermore, we have experienced a diversity of organizational work cultures as well as the impact of change on our professional identities and within our professional practices. We envision this text as a highly adaptable text for a wide number of visual arts practitioners who may find themselves with a need to more fully understand the complexities of and challenges within professional practice. With this, we invite readers and practitioners at any level of professional practice to engage in self-study in ways that can unfold new meanings and offer promising new pathways.

NOTES

1. The term "braided stream" as a metaphor for the self-study model is credited to author Sheri R. Klein.
2. While this text is the result of a collaborative effort, *primary* authorship of chapter content is acknowledged:

 Sheri R. Klein: Chapter 3, Chapter 5, Chapter 6, the methods for goal setting outlined in Chapter 7, Appendix 4, and rhizomatic principles discussed throughout the text.

 Kathy Marzilli Miraglia: Chapter 4 and Chapter 7.

1

Framework and Components of a Self-Study Model for Visual Arts Practitioners

Introduction

The focus of this chapter is to expand on the framework and components of the self-study model that is inclusive of arts-based methods and a variety of thinking processes with the aims of multidirectional, imaginative, and flexible thinking about professional practice. The theoretical underpinnings of the self-study model are grounded in the numerous intersecting domains discussed in the Introduction and throughout this text—all of which support reflexivity, dialogue, connectivity, and creativity. While the components of the self-study model are individually discussed, in practice they are relational and evolve in rhizomatic and nonlinear ways (Deleuze and Guatarri 1987). Thus, a visual arts practitioner's self-study inquiry may be akin to a "nomad's venture—[of] movement, discovery, and sought after places offering potential for new perspectives" (Charney 2017: 42). In consideration of these potentials, rhizomatic principles are discussed relative to the self-study model. The four core components of the self-study model are outlined followed by a discussion of the various integrated methods applicable to the self-study process.

Rhizomatic principles applied to the self-study model

Deleuze and Guattari's (1987) metaphor of rhizomes is a lens to understand how professional practice as a whole can be dynamic, complex, unpredictable, multidirectional and resilient. Rhizomes are defined as plant growths characterized by lateral shoots and with offshoots that can grow in any direction in an "acentric non-hierarchical network of entangled and knotted loops folding and growing

through multiple sites of entry" (de Freitas 2012: 588). Rhizomatic thinking, as explained by Deleuze and Guattari (1987) describes the way that ideas can be interconnected and generative. In this sense, professional practice as rhizomatic is a continuously adapting and generative system of practice. Of critical importance to the self-study process and model are the rhizomatic principles of *multiplicity, rupture, lines of flight,* and *assemblage* (Deleuze and Guattari 1987). Multiplicity refers to the "random and multi-directional aspect of growth" (Charney 2017: 11) that can occur within the life of a professional practice. Rupture describes the breakage of pathways or connections within or between areas of professional practice that may occur at any time, and particularly, at transitional points. Rupture, however, does not mean loss. If, for example, "the rhizome [that is, professional practice] is ruptured at any point in two pieces, the two pieces would grow along the lines of rupture and regenerate themselves" (Senagala 1998: 3). *Lines of flight* describe new thoughts or professional paths "with the capacity to extend ideas in new directions" (Charney 2017: 11). Assemblage refers to a process of gathering, adding, and combining often-unrelated things, objects, or ideas. Relative to professional practice, assemblage can explain how a professional practice is "a constantly changing assemblage of forces and expectations" (Stagoll 2005: 27 in MacDonald 2014: 234) and where practice is formed, and re-formed, as a result of unexpected or random events.

Four core components of professional practice and the self-study model

The four areas of professional practice and self-study are discussed to elucidate each area of the self-study model recognizing that in practice they are relational, evolving, interconnected, and rhizomatically networked. As practitioners move back and forth between, and in-between, the spaces of professional practice, professional practice may be understood as "unfolding experiences" and a "process of becoming" (MacDonald 2014: 15–16).

Figure 1.1 is a collage of drawings representing the four areas of professional practice and the self-study model that is suggestive of the rhizomatic, expansive, and fluid nature of professional practice. Working with photocopies, and relying on intuition (Bosch 1996), several versions of the model were drawn and combined; areas of the drawings were randomly placed in a process of selection and regrouping to allow for new patterns and rhizomatic lines of flight.

Figure 1.2 is a digitally enhanced version of Figure 1.1 and was created by a digital tracing of the edges and contours of the collage. The notion of tracing has relevance for professional practice for it is through reflection that pathways of practice can be retraced to gain new configurations and insights.

11

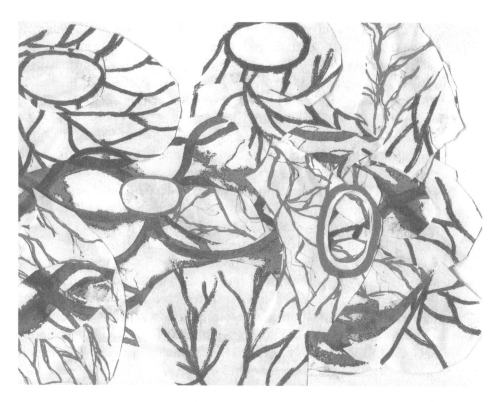

FIGURE 1.1: Sheri R. Klein, *Rhizomatic Collage of Self-Study Model*, 2020. Collage of ink drawings. Courtesy of artist.

Professional identity. Professional identity is central to professional practice and is shaped by many variables and intersectional factors (Crenshaw 1991; Klein and Diket 2018; Ropers-Huilman and Winters 2010) that are further discussed in Chapter 3. Many of the variables shaping professional identity may be understood to fluctuate and influence in varying degrees and at varying times. Some variables may be important at one stage of a professional practice, but not at another stage. Fluctuations to professional identities may also occur due to unforeseen events in one's personal and professional life that result in changes to a professional practice.

The complexity of professional identity formation requires an understanding of the kinds of identities associated with visual arts practitioners, such as hybrid, multiple, overlapping, and shifting professional identities. The exploration of professional identity also addresses identity change and dissonance; how, why, and when it occurs; and the roles of communities in shaping professional identities.

Work cultures. This component of the self-study model highlights the relationships between individuals and the collective (i.e., communities and organizations)

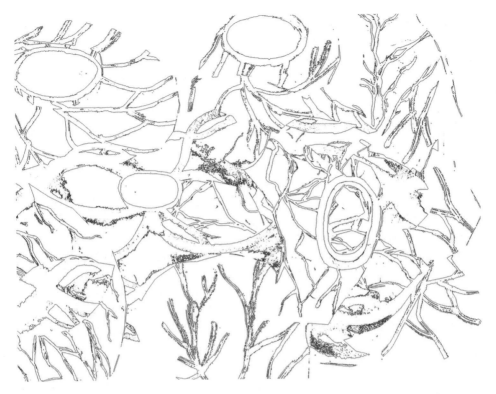

FIGURE 1.2: Sheri R. Klein, *Tracings*, 2020. Digitally enhanced collage. Courtesy of artist.

and places in which visual arts practitioners engage in professional practice. Intersectionality and social identity theory (Crenshaw 1991; Klein and Diket 2018; Ropers-Huilman and Winters 2010) inform understanding of the roles of work cultures and climates, group tension, group cohesion, and mentoring in influencing personal, group and cultural, as well as professional identities. These complex dimensions of work cultures are addressed in Chapter 4.

Change. Uncertainty and change are part of every professional practice and experienced as a result of both expected and unexpected events. Some potent areas for self-study are the spaces of professional practice where vulnerability and uncertainty exist. Understanding the qualities and components of change can be helpful in working through changes that impact professional practice. Strategies for navigating change are offered in Chapter 5 with the aim of developing a reflective, flexible, resilient, and hopeful stance toward professional practice in the face of change.

Envisioning professional practice. Envisioning new pathways for professional practice is part of an ongoing process of inquiry and reflection. Self-study can assist

visual arts practitioners in envisioning new practices through the interpretation of self-study artefacts that can yield new insights, questions, and lines of flight. Looking more closely at specific areas of practice that are exciting and invigorating as well as at those areas that may feel confusing, stagnant, or uncertain can lead to the cultivation of new insights, questions, paths, and goals. Strategies and methods for interpreting self-study artefacts are discussed in Chapter 6. Strategies for using findings from the interpretation process toward envisioning professional practice are discussed in Chapter 7.

Integrated methods for self-study

Arts-based methods, media, and approaches. Arts-based research, as the application of "artistic approaches to qualitative inquiry" (Wang et al. 2017: 7), embraces the role and identity of the "artist-researcher" who uses "artistically inspired methods or approaches" and/or where the "role of qualitative researcher and artist are fully blended" (Wang et al. 2017: 10). We recognize that users of this book may align with one or both of these positions.

Wang et al. (2017) outline three forms of arts-based research: research about art, art as research, and art in research. The self-study model in this text advances the notion of *art in research* in which the primary identity of the professional is an inquirer about his/her/their practice, where "art [making] serves as means to an end" and where a researcher uses "artistic forms supporting qualitative inquiry" (Wang et al. 2017: 14). Arts-based methods are infused into self-study but can be infused with other research methodologies, such as action research, A/r/trography, autoethnography, feminist, narrative, phenomenology, studio-based research and practice-based research, and/or sensory ethnography,[1] to explore individual, collective, and community-based research questions (Barone and Eisner 2012; Bresler 2007; Cahnmann-Taylor and Siegesmund 2018; Chilton and Leavy 2014; Knowles and Cole 2008; Leavy 2019).

Some practitioners using this text may be from the social sciences and familiar with visual research methods that incorporate methods of photography and photo elicitation (Harper 2002), film, diaries, maps, diagrams, illustrations, and collages in research (Banks 2015; Goopy and Kassan 2019; Mannay 2015; Mitchell 2011; Pink 2007; Pusetti 2018; Rose 2016; Van Leeuwen and Jewitt 2000). Arts-based research methods clearly utilize "forms of thinking and forms of representation that the arts provide" (Barone and Eisner 2012: xi) and that depends on "*arts techniques* rather than social science research methods" (Rose 2016: 333, emphasis added). Walking, as a sensory-based research method, is now used widely by researchers across disciplines to explore relationships of the self to place, location,

history, and environments (Heddon and Turner 2010; Pierce and Lawhon 2015; Pink et al. 2010; O'Rourke 2013; Springgay and Truman 2018). It may be combined with other arts-based research methods, such as photography, audio, and/ or video.

Arts-based research embraces a wide range of artistic media and materials that include but are not limited to the visual arts, the performative arts, integrated arts, and the digital arts. Arts-based methods can include the use of "already existing images [...] or images created by a researcher [practitioner]" (Rose 2016: 15). Drawing, painting, photography, printmaking, and collage are widely used arts-based methods to explore identity (Gauntlett and Holzwarth 2006; Jeffers 1996; Leavy 2009; Unrath and Nordlund 2009), particularly with visual arts educators in early/induction and mid-career phases (Badenhorst et al. 2019; Dalton 2019; McDermott 2002; Scotti and Chilton 2017; Sutters 2019) and as "starting points for reflection" (Beltman et al. 2015: 228).

Visual metaphors are often used to explore career transitions and professional change (Barner 2011). Wilson's (2019) fiber works are an excellent example of clothing construction as a metaphor and a method for self-study on professional identity practice. Drama and poetry are often used as research methods as a means to explore professional issues and identities (Cahnmann and Siegesmund 2018; Norris 2000). The creation of avatars within virtual world environments (Mon 2012; Schulte 2014; Wu 2013) further offers opportunities for professionals to explore professional identities within virtual environments.

Visual journal method. The visual journal is a highly adaptable format for the purposes of self-study using integrated arts-based media to explore the "emotional, personal and biographical" (Gourlay 2010: 87) dimensions of professional practice. Visual journals, as portable self-study artefacts, can be easily shared and discussed in context of learning communities to promote dialogue and reflexivity. Visual journals are recognized as a "powerful mode for the reflexive investigation of identities," and they can provide visual arts practitioners with "a means by which to express complex experiences" and help "reticent practitioners to express themselves in an alternative format" (Gourlay 2010: 83). The visual journal is widely used by visual arts practitioners to engage in reflective practice (Boud 2001; Grauer and Sandell 2000; Klein 2010; Klein 2018; La Jevic and Springgay 2008; Shields 2016; Todd-Adekanye 2017) for it is a "structured and deliberate research method" used to "extend professionalism, have more effective conversations with ourselves" (Gray and Malins 2004: 113), as well as to advance well-being and reduce stress (Mims 2015). Guidelines for beginning and using a visual journal in a self-study are outlined in Appendix 4.

Mapping methods. In *A Thousand Plateaus*, Deleuze and Guattari (1987: 12) write, "the map is open and connectable in all of its dimensions [...] It can be torn,

15

reversed [...] reworked by an individual, group [...] it can be drawn on a wall, conceived as a work of art, constructed as a political action or meditation [...] it has multiple entryways." Mapping is also a visual method for constructing interpretations of self-study artefacts (Futch and Fine 2014; Gray and Malins 2004; Klein 2014; West 2004) in rhizomatic ways that can guide envisioning professional practice. Various methods of mapping for the interpretation of self-study artefacts—such as word mapping, hermeneutical mapping, concept mapping, chart mapping, mind mapping, narrative mapping and collage mapping—are discussed in Chapter 6. Figure 1.3 is an example of a mind map about the self-study process that affords the use of drawing and integrated thinking processes.

Integrated thinking processes. The self-study model supports inquiry using integrated thinking processes that allow for divergent, qualitative, interpretive, and reflexive thinking. Saldaña outlines numerous ways to think qualitatively: thinking connectively, complexly, emotionally, empathically, intuitively, interpretively, and artistically, emphasizing that "there is no *one* way to think qualitatively" (Saldaña 2015: 3, emphasis added). In thinking qualitatively, visual arts practitioners can

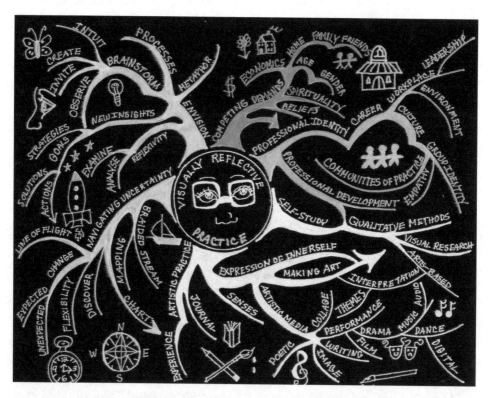

FIGURE 1.3: Kathy Marzilli Miraglia, *Mind Map of a Visually Reflective Self-Study Process*, 2020. Digitally enhanced drawing. Courtesy of artist.

move beyond dualistic thinking about practice (i.e., good/bad, right/wrong) in ways that can foster relational, expansive, and rhizomatic understandings (Klein 2019).

Using a range of qualitative thinking is highly advantageous for those engaged in self-study for in "qualitative thought […] significant relationships are intuitively grasped" (Costantino 2015: 193). The following *integrated thinking processes* can be useful to self-study in ways that allow for knowing through divergent and convergent thinking, knowing through the senses, and knowing through a critical and reflexive stance toward practice:

- *Brainstorming*: a process of generating as many ideas as possible without editing and before making a decision. The four tenets of brainstorming are: (1) rule out internal criticism; withhold contrary judgment of ideas until later; (2) free associate ideas; (3) pursue a quantity of ideas—the greater the number, the more the likelihood of useful ideas; and (4) seek out a combination of ideas and possible solutions (adapted from Osborn 1963). Brainstorming allows for the exploration of ideas in order to create and visualize something yet to be realized; it requires unconventional or divergent thinking (Rancor 2007). Brainstorming can be used during any phase of a professional practice to illuminate questions and concerns surrounding professional identities and practice.

- *Intuiting*: a process described as a "capacity for attaining direct knowledge or understanding [a phenomenon] without the apparent intrusion of rational thought or logical inference" (Sadler-Smith and Shefy 2004: 77). Gladwell (2007: 11) refers to intuition as the "adaptive unconscious," or the power of knowing within a few seconds and feeling through the senses. Intuiting is a process of sensing and perceiving data from sight, sound/silence, smell, and touch.

- *Observing*: a process of taking in information about a phenomenon, behaviors, and/or interactions while suspending judgment. It is a method of data collection that requires an alertness and determining what needs attention (Tishman 2018). In essence, observation is deeply seeing in ways that can foster empathy (Jeffers 2017) and listening with greater sensitivity.

- *Creating*: a process involving the visualization of a concept or an idea that relies upon intuition and observation as well as risk taking, playfulness, and experimentation. The creative impulse is universal (Dissanyake 1995), and we are all capable of creating. Professional practice is a site for creation, experimentation with novel solutions, and the integration of new findings (Runco 2007) that can likely "bring into being the results you desire" (Fritz 1989: 6). Creating is an important act "in the face of uncertainty" and through times of "living with doubt and contradiction" (Bayles and Orland 1993: 2). In this sense, creating is an act that requires persistence and being open to change and influences.

- *Reflexivity*: a process of critically examining worldviews, biases, beliefs, values, relationships, and issues related to the dimensions of professional practice.

17

Reflexivity focuses on the importance of being self-aware and taking responsibility for personal views and stances (Patton 2002). Reflexivity requires self-observation and analytical thinking (D'Cruz et al. 2007). Samaras (2011: 54) posits that practicing reflexivity is "more than mere reflection"; reflexivity is a process of understanding how one's perspectives are formed to determine if and how changes should occur. As a cyclical process, reflexivity affords the "refining [and] reframing of identities, beliefs, and actions," all of which impact professional practice (Loughran and Northfield 1998: 17).

Conclusion

This chapter has outlined the components of a self-study model composed of four areas: professional identities, work cultures, change, and envisioning practice. Arts-based research methods and integrated thinking processes support an integrated self-study model to explore a wide range of questions and issues related to professional practice (Table 1.1) The visual journal, as an integrated arts-based research method, is highlighted as a viable method for creating self-study artefacts and documenting and preserving the self-study process and outcomes. The various thinking processes discussed in this chapter are reinforced in the careful construction of end-of-chapter prompts used throughout this text.

Methods	Processes	Purposes
Arts-based methods	Digital arts Integrated arts Performative arts Visual arts	To explore professional identity and issues through artistic expression; to foster reflection and reflexive understandings about professional practice
Mapping methods	Chart mapping Collage mapping Concept mapping Hermeneutical mapping Mind mapping Narrative mapping Word mapping	To guide self-study artefact interpretation and envisioning professional practice in multidirectional and rhizomatic ways

Integrated thinking processes		
Integrated methods	Brainstorming Intuiting Observing Creating Reflexivity	To think qualitatively: artistically connectively complexly emotionally empathically intuitively interpretively

TABLE 1.1: Summary of methods and processes incorporated into the self-study model.

Prompts

The following end-of-chapter prompts invite you to explore chapter issues and topics. Select one or more prompts from 1A and 1B to complete.

1A Inquire and analyze: Written reflections

These prompts are designed for written responses. They may also facilitate discussions with other practitioners and communities of practice. Refer to "Guidelines for writing self-study reflections" (Appendix 2). The written responses can take the form of digital files, word-processed, printed hard copies, or handwritten responses that are directly included in a visual journal.

Note: Please review "Guidelines for Self-Study Visual Artefacts" (Appendix 3) regarding the visual journal. Begin your visual journal before you respond to the end-of-chapter prompts.

1. Which component(s) of the self-study model (professional identity, work cultures, change, and envisioning) are particularly challenging for you at this time, and why?
2. Which component(s) of the self-study model (professional identity, work cultures, change, and envisioning) are working really well for you at this time, and why?
3. Which of the integrated thinking processes are helpful for examining your professional practice? Which seem challenging and why?
4. What questions do you have concerning arts-based methods? What would you like to know more about?

5. How might a visual journal be a good tool for self-study? What questions do you have about visual journaling?

1B Create

These prompts are designed for responding visually. See Table 2.1 in Chapter 2 for ideas concerning artistic media and methods. Refer to "Guidelines for Self-Study Visual Artefacts" (Appendix 3).

1. In your visual journal, review the guidelines as well as some print and videos about visual journaling techniques. Explore two-dimensional techniques in your journal.
2. Consider the four areas of the self-study model: *Professional Identity*, *Work Cultures*, *Change*, and *Envisioning Practice*. What books are important to you as a professional regarding these areas of practice? Is there one book that has been the most important to you? Create a photo of these books and place in your journal with a brief summary as to why these are important to you.
3. Create a two-dimensional collage that is a *visual metaphor* about your professional practice. In selecting a visual metaphor, you might think about landscapes, weather conditions (sunrise, sunset, fog, rain, thunder, storms) and/ or architectural elements (doors, windows, etc.). Create a title or caption for the collage, and briefly note how and why this visual metaphor was selected.
4. Practice *integrated thinking* about one selected professional issue of concern, or a situation that is problematic to you at this time. Use the processes outlined in this chapter: *brainstorming, intuiting, creating, observing,* and *reflexivity* to examine the issue: (1) *brainstorm* ways this concern/issue might be addressed; (2) using *intuition* and feelings; perceive and sense the issue and make notes on your perceptions; (3) *create* an image (a map, drawing, or other visual) to express your understandings and insights relative to this issue; (4) *observe* yourself and others without judgment in situations related to this issue and make notes about this; and (5) *reflexively* examine this issue, your biases related to this issue, and what might be the perspectives of others in this situation. After you have engaged in these processes, review all your notes and image(s), and use both logic and intuition to arrive at a list of *new insights* about the issue. Place the image in your journal with a brief summary.
5. Create and print several digital photos of your studio or office space at home, in the organization you work, or at another site. Using the digital photos of your workspace, observe the kinds of objects and images in your current workspace. Observe the natural or urban space and architecture outside of your current workspace. Take a reflexive approach to analyzing your space. Write an accompanying

caption for your image that addresses the following: How does your workspace reflect you as a professional? What do you enjoy about your workspace? What might be changed in your workspace? Create a collage using the digital photos of your workspace and your statement and place in your journal.

1C Review

Review your written and visual artefacts created in Chapter 1. What initial impressions do you have? Are there any emerging issues and questions? Record your responses in your journal.

1D Share and reflect

Share selected artefacts and insights gained from Chapter 1 with collaborators or colleagues for the purposes of further dialogue and reflection. Summarize your insights and conversations and record in your journal.

Suggested methods and media for this chapter:

> Collage
> Drawing
> Mapping
> Digital photography
> Visual journal
> Writing

NOTE

1. The evolving nature and sheer number of examples of arts-based research prohibit any comprehensive in-text listing of researchers, methods, or resources. Some of the best places to begin might be journals such as, the *Art/Research International: Transdisciplinary Journal*, *International Journal of Art and Design*, *The International Journal of Education through Art*, *International Journal of Qualitative Methods*, *Journal of Aesthetic Education*, *Journal for Artistic Research*, *Qualitative Inquiry*, *Qualitative Research*, *Studies in Art Education*, and *Visual Ethnography*. Handbooks, such as *The Sage Handbook of Qualitative Research* (Denzin and Lincoln 2017) and *The International Handbook of Research in Arts Education* (Bresler 2007) are also resources to locate arts-based studies. Numerous recent textbooks focused on arts-based research also can provide an overview of current approaches, methods, and issues (Cahnmann-Taylor and Siegesmund 2018; Leavy 2019).

2

Overview of Arts-Based Media for Self-Study

Introduction

Responding to end-of-chapter prompts in this text necessitates having some familiarity with artistic terms, methods/techniques, and materials. Recognizing there will be a wide range of visual arts practitioners' experiences with artistic media and materials, this chapter provides a very basic and general overview. In addition to an overview about artistic methods and materials, we briefly address other considerations that are important to an arts-based self-study such as space and time.

Arts-based media

Arts-based research methods utilize artistic media and techniques with the aim of creating an artistic work in the context of a self-study. Arts-based research includes the *visual arts*, *performative arts*, the *integrated arts*, and the *digital arts*. Each of these forms is encouraged for self-study practice as they afford a variety of visual, tactile, kinesthetic, and interdisciplinary responses. Specific artistic media and processes associated with two- and three-dimensional art forms vary widely. Appendix 4 provides an overview of the processes for visual journaling and Appendix 5 provides basic recommendations for artistic materials. Readers with interests in specific artistic media areas are encouraged to explore resources (books on techniques, online videos, etc.) to address questions that arise in the context of self-study. The list of references at the end of the book can jumpstart this process.

As part of self-study, the exploration of media is encouraged as way to generate artefacts that may not happen otherwise, and to gain confidence and skills using artistic media. Exploration with the following kinds of media is encouraged:

Digital art media. Includes digitally produced photographs (Northrup 2012), graphics, imagery, and sound; content that is shared, streamed, or broadcast through digital platforms; content created or shared within virtual environments and in social media. In the context of a self-study, iPhones, iPads, cameras, and laptop imaging and editing tools can create digital artefacts, such as photographs (Figure 2.1) as well as other integrated works incorporating text and sound.

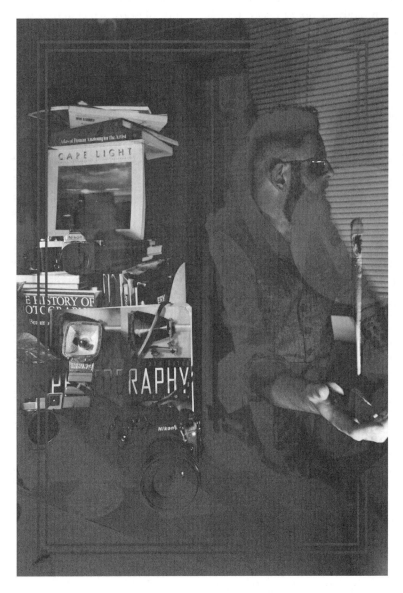

FIGURE 2.1: Chase Stevens, *Reflection*, 2019. Color print. Courtesy of artist.

Integrated arts media. The combination of a visual image with text and writing that can take the form of book arts, collage, visual essays, visual journals, and a variety of visual poetic forms.

- *Book arts* can combine drawing, printmaking, mixed media, papermaking, and writing using the book as format. Examples include altered books, handmade books, and journals. While special supplies are often needed for the creation of many handmade books, there are many kinds of book arts that may not require extensive tools and supplies (Heyenga 2012; Thomas 2011). Book art formats are perfect for exploring various papers, techniques of lettering (Marlborough 2016), mark making (Missigman 2018), and collage (Stout 2016).
- *Collage* is the layering or overlapping of fragments of papers, cloth, images, and other print materials that are adhered to a surface; papers are often combined with drawing and painting materials. As a highly intuitive and visual method, it is often used in qualitative and arts-based research (Butler-Kisber 2007; Butler-Kisber and Poldma 2010), as a "reflective process, as a form of elicitation, and as a way of conceptualizing ideas" (Butler-Kisber and Poldma 2010: 3). The collage method is particularly useful for advancing nonlinear ways of knowing and the construction of new meanings that are driven by emotions, feelings, and aesthetic concerns.
- *Visual essays* juxtapose writing and visuals with a sequence of images such as drawings or photographs that focus on a specific issue or topic. The central element of the visual essay is the visual (photos, prints, drawings, or illustrations) that can be created in the context of self-study. The essay serves as a response to the visuals and can range in length from a few paragraphs to several pages. The final visual essay is an integration of the visual and text in a format that can be insightful, reflexive, and that considers the thoughtful juxtaposition of writing and images.
- In a self-study, *visual journals* utilize arts-based methods and writing for purposes of "internal dialogue" (Leavy 2009: 9) to acknowledge questions, feelings, emotions; to record insights and impressions; and to explore ideas, build connections and refine thinking; they can be reliable sources of data for a self-study. There are a wide variety of print and video resources for exploring mixed media journaling to gather inspiration and ideas (Barron 2014; Berry 2011; Ward-Harrison 2011).[1]
- Figure 2.2 is a page from an art teacher's visual journal concerning the purposes of her reflective visual journal. In this page, she uses acrylic paint and ink washes with anthropomorphic imagery to create a surreal and dreamlike effect. She uses cloud-like shapes to contain her list of purposes for the journal: "question and investigate," "practice play," "record," "clarify thoughts, ideas and intent," "reflect," "grow," "self-exploration," and "self-awareness."

Poetic methods. Qualitative researchers use a variety of poetic methods in all phases of research that include data creation, analysis, and interpretation (Barney et al. 2012; Janesick 2015: Cahnmann-Taylor 2009: Pointdexter 2009). Poetic method "makes an art form out of ordinary language" (Brady 2009: xii). Reading different kinds of poetry journals in addition to seeking out poetry resources can be helpful when engaging in poetic methods (Oliver 1994; Padgett 2000).

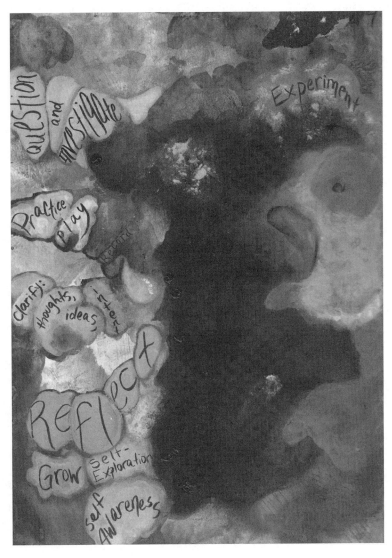

FIGURE 2.2: Annie Cox, *Untitled*, journal page, 2018. Mixed media collage. Courtesy of artist.

The language of research texts such as transcripts, researcher notes, and/or written journal entries, for example, can be used to create free verse, haiku, or other poetic forms. When using poetic method, it is important to "learn how to incorporate rhythm, form, metaphor and other poetic techniques" (Cahnmann-Taylor 2009: 29) that may include "line breaks," "enjambment," and "use of punctuation" (Cahnmann-Taylor 2009: 17).

Visual poetry is an experimental poetry format where words are arranged on a page to create shapes, symbols, and visual-text relationships. *Blackout poetry* is another visual poetic form that allows for new associations of words and in a highly visual format. Blackout poetry can be created using pages from old books, or newspapers, but any text can be used, such as journal entries and written responses to end-of-chapter prompts. Words are circled; other words are darkened and blacked out leaving the remaining text as the poem. Lines, patterns, and drawings often are added to the page to add visual interest.

Figure 2.3 is an example of blackout poetry using transcript text that has been transformed. Resonating text and words were circled, while other words are covered and obscured with visual imagery.

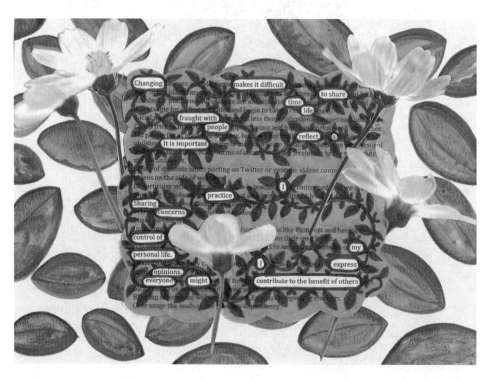

FIGURE 2.3: Karlisle Becker, *Untitled*, blackout poem, 2018. Mixed media. Courtesy of artist.

Performance-based media. Performance-based media can include choreography, dance, movement, dramatic presentations, music, singing, sound, or other multimedia-based presentations that combine more than one art form and media. Performance-based works might also include the method of walking as research (Springgay and Truman 2018; van der Vaart et al. 2018).

Pluralistic approaches to the creation of visual artefacts using arts-based media offers a wide range of possibilities for the exploration of materials and ideas in self-study. Table 2.1 provides a summary of arts-based media referenced in this chapter.

Considerations in creating self-study artefacts

The following considerations are offered for reflection relative to the creation and dissemination of self-study artefacts:

Aesthetics. Attending to aesthetics of visual artefacts is central to arts-based research. It requires attention to the sensory, the visual, and to the look and feel of visual artefacts.

Permanence/Impermanence. Some self-study artefacts might be ephemeral, that is, created with the intent not to be permanent. One example might be a mandala drawing on the beach. In the case of self-study, the creation of artefacts requires the creation of tangible evidence of self-study in works that can be recorded, documented, and preserved to allow for the process of interpretation and goal setting.

Context. Context refers to how, when, and where self-study artefacts will be exhibited, displayed, shared, and/or performed with others and to what kinds of audiences. Ethical considerations may also be relevant when disseminating self-study artefacts. Some ethical considerations are further discussed in Chapter 6.

Considerations: Space and time

A studio or workspace is an important consideration for an ongoing self-study. While some readers might have access to university or institutional art studio spaces, others might need to create a home-based studio space to create artefacts for self-study. Committing a designated space for reflection can allow for a continuity of focus and practice. Organized and stored materials allow for safety and accessibility. The designated space should be comfortable and conducive for creating with good light, good ventilation, and appropriate storage space. Creating a schedule that is reasonable, flexible, and yet consistent is important to beginning and sustaining a self-study.

Genre	Specific media
VISUAL ARTS MEDIA	Ceramics Drawing Fiber Graphic art Illustration Installation art Painting/printmaking Sculpture and three-dimensional modeling
INTEGRATED ART MEDIA	Assemblage Book arts Collage Graphic novels Illustrated books Visual essays Visual journaling Visual narratives Visual poetry
DIGITAL ARTS	Animation Computer graphics/digital avatars Data visualizations Digital photography Film/video
PERFORMATIVE ARTS	Dance Drama/theatre Improvisation Movement Music Role playing Songs

TABLE 2.1: Summary of artistic media for self-study.

Prompts

The following end-of-chapter prompts invite you to explore chapter issues and topics. Select one or more prompts from 2A and 2B to complete.

2A Inquire and analyze: Written reflections

These prompts are designed for written responses. They may also facilitate discussions with other practitioners and communities of practice. Refer to "Guidelines for writing self-study reflections" (Appendix 2). The written responses can take the form of digital files, word-processed and printed hard-copies, or handwritten responses that are directly included in a visual journal.

1. Which of the media discussed in this chapter would you like to explore further in the context of your self-study?
2. What are your experiences with digital media, integrated arts media, and performance-based media? How do you think these types of media could assist you in reflection on professional practice?
3. How can poetic methods assist in reflection on professional practice?
4. Reflect on the considerations for creating self-study artefacts that are listed in this chapter. What concerns or questions do you have about these considerations?
5. Regarding studio space, what is your current situation? What changes might need to occur to facilitate your self-study?

2B Create

These prompts are designed for responding visually. See Table 2.1 for ideas concerning artistic media and materials. Refer to "Guidelines for Self-Study Visual Artefacts" (Appendix 3).

1. Learn about an artistic technique or media using YouTube and/or using print resources (artist books, art technique books, etc.). Log your learning, insights, and questions in your journal. Experiment with the technique or medium in a few of your journal pages.
2. Select one of the art media forms from Table 2.1. Create a visual self-portrait that reflects you as a professional using a media of your choice.
3. Select one of the media forms from Table 2.1. Create a work that speaks to your significant professional accomplishments and milestones.
4. Create a visual or blackout poem using the text from a written end-of-chapter response from Chapter 1. Find the anchor words as you scan the text; these words might stand out to you or represent a significant idea in the text.

Scanning the rest of the text, line-by-line, use a pencil to lightly circle any words that connect to the anchor word in some way. Avoid circling the same word twice. Read your poem of circled words. Return to text and circle additional words if needed for the final poem. Take a black marker and "black out" the areas around the selected words. You also might create line drawings on the text in the background or add color washes to the page. The result will be a blackout poem with visuals (Depasquale 2016). How does your poem expand your understanding of poetry *and* your professional practice?

5. Freedom and experimentation are key to an artistic practice—and a professional practice. Engage in and document a performative work such as a poetry reading, song, dance, and/or movement that explores the concept of freedom and what freedom means to you as a professional.

2C Review

Review your written and visual artefacts created in Chapter 2. What initial impressions do you have? Are there any emerging issues and questions? Record your responses in your journal.

2D Share and reflect

Share selected artefacts and insights gained from Chapter 2 with collaborators or colleagues for the purposes of further dialogue and reflection. Summarize your insights and conversations and record in your journal.

Suggested methods and media for this chapter:

Blackout poetry
Collage
Drawing
Mixed media
Performative media
Sculpture
Visual journal

NOTE

1. Several visual journals may be needed to complete the exercises and prompts in this text. It is recommended that the journal is large enough to include space for writing, responding to prompts, and for mixed media exploration.

3

Exploring the Complexity
of Professional Identity Formation

Introduction

Identity lies at the heart of all professional practice. *Professional identity* may be understood as a sense of being a professional that is created in a socially mediated process (Gee 2001) within professional roles and communities of practice (Costello 2004). This mediated process is enacted through formal and informal interactions with other members of professional communities, through the "use of professional judgment and reasoning," and through processes of "critical self-evaluation" (Paterson et al. 2002: 7).

Two kinds of professional identities relevant to visual arts practitioners are *academic identity* and *artistic identity*. An *academic identity* may be defined as the roles associated with "teaching and [/or] research activities that are subject or discipline-based" (Deem 2006: 204) and where "faculty members [academics] learn the academic culture according to their discipline and specific department through a socialization process" (Mendoza 2007: 75). An artistic identity is created through a sustained inquiry and engagement with artistic media and creative processes and in connection to artistic communities of practice.

For some time, visual arts practitioners have acknowledged their multiple professional and often conflicting identities (Anderson 1981; Unrath et al. 2013; Wilson 2019) from multiple roles, such as "teacher, activist, and archivist" (Sullivan 2004: 810). While not an exhaustive list, it does suggest that professional self-identification is a "messy" process (Rolling 2015: 4) that is further complicated by external and internal factors impacting identity formation. Many

of these factors will be explored in this chapter to suggest that professional practice is a space that is "multilayered, [and has] multidimensional complexities, tensions and contradictions" (Kind et al. 2007: 841) that require reflection-on-practice over time.

In this chapter, we explore intersectionality theory to inform understanding of identity formation. Factors such as, gender, race/ethnicity, social class, disability, and place are discussed relative to identity formation. Various forms of professional identities are discussed: overlapping, hybrid, and shifting identities and identity dissonance.[1] Finally, the role of communities of practice in shaping professional identities is explored to reinforce identity formation as dynamic and relational and subject to the influences of person, place, context, and culture.

Intersectionality and identity formation

While there are different perspectives about the nature of identity formation relative to professional practices (Booysen 2018; Burke and Stets 2009; Vignoles et al. 2011; Sluss and Ashforth 2007; Trede et al. 2012), intersectionality theory supports the ways in which various complex factors such as, gender, race, culture, power, and privilege intersect to inform identity—which includes professional identity (Crenshaw 1991; Gonzales-Smith et al. 2011; Chávez and Guido-DiBrito 1999; Symington 2004). Other multiple factors are identified relative to the formation of professional identities (Barney et al. 1995; Booysen 2018; Carroll et al. 2015; Dill 2009; Klein and Diket 2018; Tisdell 2003). Intersectionality theory considers how "components and interpretations of identity are interconnected to each other" (Ropers-Huilman and Winters 2010: 38) in ways that are not mutually exclusive but rather are overlapping, entangled, and subject to change over time (Beltman et al. 2015). Interesectionality theory also illuminates how "two or more dimensions of identity (such as gender, ethnicity or religion) may result in multiple and intertwined layers of discrimination or disadvantage" (Tariq and Syed 2017 in Klein and Diket 2018: 122).

In the drawing *Overlaps* (Figure 3.1), repeated figure eight looped shapes overlap and interweave in ways that speak to the complicated entanglements and overlaps of professional identities. Understanding the formation of professional identities through an intersectional lens supports how professional identity can be shaped by the individual and the collective (Vignoles et al. 2011) as well as the intersections of personal, social, and cultural identities.

32

FIGURE 3.1: Sheri R. Klein, *Overlaps*, 2018. Ink on paper. Courtesy of artist.

Personal identity, social identity, and cultural identities

Personal identity. *Personal identity* is shaped by personality, character traits, goals, and values (Owens et al. 2010) as well as other "aspects of self-definition" (Booysen 2018: 4). A personal identity "integrates the person and [his/her/their] social-role[s] based identities" and merges with a "collective identity, or [a] social identity, that refers to aspects of social group or category identification to which individuals belong" (Booysen 2018: 5).[2]

 Social identity. Professional identity is created in the context of roles and sites of practice and may understood to be relational (Rodgers and Scott 2008), or "socially bestowed, socially sustained and socially transformed" (Berger 1963: 116) within organizational systems and communities of practice. A role is "a typified response to a typified expectation" (Berger 1963: 112) and provides a "pattern according to which the individual is to act in the particular situation." Professional roles are interpreted through an understanding of social expectations in a social context; choices are made whether to adapt and adhere to expected social norms. Social

identity is, therefore, "not something one has," but is "developed through trans-actions with the environment" (Beijaard et al. 2004: 107) and social encounters.

Social identity theory, therefore, positions identity formation as cocreated between individuals, environments, and social institutions (Kelchtermans and Vandenberghe 1994; Ropers-Huilman and Winters 2010: 38). It is further explained as

> a result of relations within professional, or work groups, and is determined through agreement among group members that you share a similar "self" (i.e. values, beliefs, norms, speech) with members of that group. Group acceptance contributes to increases in self-worth, and self-esteem, and ultimately to the trust and sanction of a group.
>
> (Klein and Diket 2018: 122)

Social identity is also shaped by group ethics, standards, and a consensus among its members regarding what constitutes professional knowledge, norms, and expectations. A discussion of social identity acknowledges components of status and power as social identity is interpreted relative to the "prestige of a group" (Ashforth and Mael 1989: 20) and one's position within a group. Power is manifested within groups and institutions with "social power defined in terms of control" (Ezer 2009: 23); influence within a group is manifested relative to intergroup relations and status within those groups.

Along these lines, the "power of dominant groups [within a professional discipline, or within an institution] are institutionalized in [its] laws, rules, norms, [and] habits of those groups" (Ezer 2009: 23). All professional disciplines and organizations are inherently systems of power relations and, hence, important sites of social identity formation.

Social identities with a group, or institution, may undoubtedly privilege some members, and not others; one's social identity and status depends on whether or not one's professional identities are aligned with the values within that group, or institution. Thus, professional identities, to some extent, are shaped and affirmed by constructs of power within professional organizations/institutions through social relations as well as through the institutional policies and structures. Since individuals are likely to be members of multiple professional circles of practice (institutional, professional associations, and other groups), multicommunity membership is likely to play a strong role in professional identity formation (DeWeerdt et al. 2007).

Intersectionality theory illuminates the understanding of social identity as it focuses on the "meaning and consequences of multiple categories of group membership" and "categories of identity, difference [individual/institutional/social and

[cultural] disadvantage[s]" (Booysen 2018: 13). Group identity theory informs why and how individuals are motivated to form associations and attachments to and within social groups for the purposes of belonging, self-esteem, social motivation, and social influence. Group identity ultimately provides individuals with a "distinctive and meaningful identity" (Spears 2011: 204). Group identity can also provide the support needed to address "identity as a focus for collective action with important implications for social equality" (Costello 2006: 33). Political affiliations as one particular form of group identity are value driven and are groups where acute differences can exist among and between members.

Cultural identity. Cultural influences shape self-perception and the perception of others. The cultural influences on professional identity include family, friends, community, schools, religious institutions, the digital culture, the global culture, and work cultures. Relationality as enacted "through peer group structure[s]" (Mac an Ghaill 1994 in Connell and Messerschmidt 2005: 839) is critical to understanding the influence of cultural identity on professional identities.

Broadly speaking, cultural identity refers to

> identification with, or sense of belonging to, a particular group based on various cultural categories, including nationality, ethnicity, race, gender, and religion. Cultural identity is constructed and maintained through the process of sharing collective knowledge such as traditions, heritage, language, aesthetics, norms and customs.
>
> (Hsueh-Hua Chen 2014: 1)

While there are many cultural factors that can influence professional identities, the cultural factors of, gender, race, social class (Hill-Collins 1990; Veenstra 2011), and disability remain central to professional identity formation. While discussed separately, it is important to bear in mind that these factors overlap and are interwoven into identity formation with some factors being more or less dominant at different times. The intersections of these factors are further complicated by the diversity and variances of personal identity, individual experiences, age, the particulars of social and group identities, and connections to place.

Gender. Relationships between gender, identity, and professional roles have been explored widely in interdisciplinary scholarship (feminist, linguistic, organizational, and management) and across various professional sectors. Gender is acknowledged as a critical factor shaping professional, social, and group identities with gender encompassing a spectrum: binary (male, female); nonbinary; transgender; untendered; and "congruence" with a gender (Gender Spectrum n.d.). Therefore, it is not possible to make universalizing claims about the construction of gender identity and all the ways it may intersect with professional identities.

Pluralism and inclusivity might best define genders including "masculinities and the complexities of gender construction for men" (Connell and Messerschmidt 2005: 832). Furthermore, pluralism and inclusivity might also characterize how third-wave feminist scholars (Dicker and Piepmeier 2003; Garrison 2004) recognize gender identity as being shaped by external factors such as "technology, global capitalism, multiple models of sexuality, changing national demographics" (Dicker and Piepmeier 2003: 14) and broader concerns of social justice (Heywood 2006; Symington 2004).

The intersectionality of gender and race can result in what is known as double oppression (Hill-Collins 2004), particularly in areas of academic employment and leadership (Klein and Diket 2018). Furthermore, discriminating attitudes against age (as in ageism) can influence perceptions and status of social, group, and professional identities, and is further complicated with the intersections of gender, race, ethnicity, and disability (Cuddy and Fiske 2002). The intersection of feminist and identity scholarship suggests that it is wise to "stretch our thinking about gender and feminism" and to understand gender as a not "a single [stand alone] category of identity" (Samuels and Ross-Sheriff 2008: 5).

Race/ethnicity. Definitions of race continue to be debated with race understood to be socially constructed categories and "products of human perception and classification" (Cornell and Hartmann 2007: 24). Ethnicity is broadly defined as social groups that have common cultural and/or religious practices, language, and "memories of migration or colonization" (Weber 1968: 389). Complications with ethnic identification persist due to identification with some groups and not others, or an identification with more than one ethnic group. Furthermore, identification with ethnic groups can also change over time. Finally, professional identities are profoundly shaped by the intersectionality of race and ethnicity (Wilson 2019) along with other factors such as social class and gender (Knight 2007; Tanaka et al. 2014) as well as the contributing factors of personal identity, work cultures, mentoring, and professional communities.

Social class. Social class can be broadly understood as social and economic categories that communicate wages/salary, consumer potential, occupational categories, and social status. Historically, in the United States, for example, the terms "blue collar" or "working class" refer to an economic category that describes individuals who engage in nonprofessional work sectors, while middle class has been associated with the employment based on holding university degree credentials. These categorizations today cannot be universally applied as employment and incomes fluctuate over time and categories can change due to a globalized economy, or a worldwide pandemic. However, the perception of social class does impact self-perception, personal identity, group identity, and assimilation within professional cultures (Barney and Laws 1995; Dykins-Callahan 2008).

Class issues and conflicts (particularly for first-generation and minority faculty and students) continue to impact professional identity formation.

Disability. Current research in art education affirms a wide spectrum of what may constitute disability (Derby 2012; Gerber and Guay 2006; Kallio-Tavin 2020, 2015; Wexler 2009) and the understanding of disability as an area of study (Derby 2012). Scholarship in disability studies continues to embrace arts-based research (Allen 2019; Eisenhauer 2010) and issues of identity (Riddell and Watson 2014) while also challenging "the reliability of categories and the definitions of disability" recognizing that there are "entangled forms of oppression" (Keifer-Boyd et al. 2018: 267).

Recent scholarship in disability studies considers an "individual's experiences of impairment" (Swain and French 2000 in Sulewski et al. 2012: n.pag.); a wide number of "social-political and cultural factors that propagate issues of discrimination and subjugation for people with disabilities" (Allen 2019: 72); the intersections of aging, ethnicity, class, and gender with disability (Riddell and Watson 2014); the acknowledgment of the spectrum of disabilities and that "disabilities come in many degrees of visibility" (Gill 1997: 45). Subsequently, professional identity is impacted by individual and collective experiences and the degree to which individuals are able to resolve self-esteem issues, internal conflicts, "environmental impediments," and "feelings of invalidity" (Gill 1997: 46), and make positive connections to communities of professional practice (Gill 1997).

Other factors shaping professional identity

Place. In the current age of globalization, it is important to recognize cultural factors shaping identities, such as civic identity, national identity (Schwartz et al. 2011), immigration status (Akhtar 1999), and *bicultural identity* (Huynh et al. 2011)—all of which have connections to place as a critical factor in shaping identity (Morley 2001). Bicultural identification "refers to a new culture that emerges from a dynamic interaction, rather than merely a summation, of existing cultures" (Huyhn et al. 2011: 838). More specifically, bicultural identity can be defined as

> [p]eople who have internalized at least two cultures [...] bicultural individuals may be immigrants, refugees, sojourners, indigenous people, ethnic minorities, or mixed-ethnic individuals [...] not necessarily cultural minorities or those in non-dominant ethno-cultural groups [...] individuals from the dominant group (e.g., non-Hispanic White Americans) who have lived abroad or in ethnic enclaves, and those in inter-ethnic relationships, may also be bicultural.
>
> (Huynh et al. 2011: 827)

Many scholars recognize the complicated and negotiated identities of professionals who are transnational; who live, work, and study in different locations from their place of origin (Yoon 2017); who work in global work environments (Shokef and Erez 2006); or those who may have an expatriate identity. In addition, professionals who experience migration due to extreme situations, war, and other emergencies are likely to experience dissonance and hyphenated selves (Sirin and Fine 2007).

One art educator utilizes his transnational identities as a basis for his research. He writes,

> immigration, location, and professional organization are crucial elements for my professional identity as an art educator [...] I soon realized that my immigration to the United States from South Korea since 1998 offers unique and hybridizing perspectives to see art education with Asian philosophies and worldviews. My research interests such as ethnic visual culture, Asian art and culture, global visual culture, and intercultural research are the outcomes of my identity shaping and hybridization between art education experiences in both Korea and the United States.
>
> (Shin 2019: n.pag.)

Place is a critical factor in the construction of personal and professional identities with "place identifications" and "expressed identifications with a place" (Twigger Ross and Uzzell (1996: 205). Place identification can be understood as a dynamically constructed (Lefebvre 1991 in McCabe and Stokoe 2004) phenomenon that changes with the fluctuations of geographical location(s). For many individuals of Indigenous national heritage, identity is associated with specific places that are connected to language and community relations (Pewewardy 2003) as well as ceremony and deep generational connections to land.[3]

Border crossings. The intersection of place with personal and cultural identities impacts the extent to which one is able to assimilate. For example, race and social class are acknowledged factors in the creation of marginalization of individuals within professional communities of practices beginning in postsecondary professional school settings (Costello 2006). The presence of "race/classed behaviors" (Costello 2006: 20), such as voice, accents, food tastes, clothing/appearance and worldviews, not "conform[ing] to privileged [middle] class ideals and mannerisms" (hooks 1994: 182) may be viewed as "hegemonically threatening characteristics" (Dykins-Callahan 2008: 364) in certain social/work/groups/organizational workplaces. Furthermore, the adoption of social norms by professionals who are working in international contexts is a challenging prospect as one navigates the differences of norms and practices relative to dual social, cultural, and professional expectations.

Thus, the work culture may also be understood as the convergence of "entangled social realities" (Knight 2007: 25), in a field," where "*field identities*" are shaped by "*adjustments* of voice, dress, language, and posture" (Cousin 2010: 17, emphasis added). Critical to the discussion of field identities is border crossing and border theory (Anzaldúa 2012) that illuminate the movements of professionals who cross geographical, social, and cultural borders and who live and work in cultures that vary differently from their life experience. *Transitioning identities* can be understood as "coexisting with one another, [as] a person can have a gendered, [classed], religious, racial, ethnic, political, and professional identity all at the same time" (Quintana 2007: 165). At the same time, identities may fluctuate and shift as a result of border crossings.

Table 3.1 summarizes the factors shaping the intersections of personal, social, and cultural identities discussed in this chapter that inform professional identity formation. In practice, there is movement and flux in and between identities that allow for movement, migration, border crossings, and assimilation; it is a space of liminality, of shifting identities, loss and gain, re-formation of identities, and spaces where new identities may be formed.

Overlapping and hybrid professional identities

An overlapping or *hybrid identity* includes a combination of two or more identities representing distinct disciplines or areas of practice. An overlapping identity suggests two or more identities that hold more or less of equal value and are simultaneously enacted. A hybrid identity, often marked with a hyphen to note

Personal identity	Cultural identity	Social identity
Beliefs Experiences Goals Traits Values	Age, Bicultural, Disability, Gender, Place, Race, Religion, Sexuality, Social class, Transnational	Group identity Group affiliations
-----Border crossings---shifting identities-----		

TABLE 3.1: Factors shaping the intersections of personal, social, and cultural identities.

the separations between professional identities and roles, allude to two or more distinct identities with a value or importance placed on the first identity, and noted by the sequencing. Several kinds of overlapping or hybrid professional identities that are associated with the professional lives of visual arts practitioners will be discussed: the artist-teacher, the doctoral student-practitioner, the hybrid academic, the hybrid artist, mid-career academics, and the retired visual arts professional.

The artist-teacher. The term art teacher describes those who teach visual art in a private and/or public school setting and "emphasize[s] the professional role of the teacher" (Thornton 2013: 27). Art educator is a term used interchangeably with art teacher; however, art educator can refer to those who teach in art museum, community setting, and/or in a postsecondary institution, such as a community college, private art school, or a four-year university. Uniquely, the artist-teacher identity implies several things: (1) an "artist who also teaches" (Thornton 2013: 28); (2) there is "professional expectation for the teacher to also be a practicing artist" (Thornton 2013: 28); and (3) the term describes "teachers who mainly earn their living through teaching although they value their art making practices as an aspect of personal identity as an art teacher" (Thornton 2013: 28).

Some common factors in the creation of an artist-teacher identity are: (1) commitment to both art and teaching practices; (2) having support from other artists and the art establishment; (3) having a planned and structured artistic practice; and (4) having support from a teaching/education culture/establishment (Thornton 2013: 85). The construction and development of the artist-teacher identity is a "complex and idiosyncratic process" that ultimately requires "personal and professional identities as a teacher and an artist" (Hall 2010: 109) and having "technical knowledge and practice and [a] creative philosophy" (Hatfield et al. 2006: 43).

The identity of the artist-teacher is laden with complex and often contradictory narratives, values, roles, and expectations (Carter 2014; Daichendt 2010; Graham and Zwirn 2010, Knowles 2015; Hall 2010; Hammer 1984; Rabkin et al. 2011; Thornton 2005; Unrath et al. 2013) that can result in tensions and negotiations. Such tensions are addressed by an artist-educator who explains,

> as both a teacher and as an art maker, I use the aesthetic to problematize my practices. Both teaching and art making are precarious spaces. Within them, I trust the possibilities that occur as the result of the irresolution that exists between structure and improvisation.
>
> In the work *Haunting* (Figure 3.2), three simple elements, fields, rhythms, and forms support each other, exchange identities and generously open up spaces that the next encounter draws upon. Thus, continuing the project of art making. The space between my art making and my teaching is a precarious space that vibrates

FIGURE 3.2: John Howell White, *Haunting*, 2019. Oil on canvas. Courtesy of artist.

with anticipation and possibility, and yes, creates newly formed, albeit contingent, structures that delight in and resist the next improvisational encounter.

(White 2019: n.pag.)

For White, teaching and art-making provide spaces for both structure and improvisation, in spaces that allow for rhythms, new forms, and relationships to emerge. Like White, there are numerous visual arts practitioners who "fall between the two fields—the arts and education" (Rabkin et al. 2011: 45). Furthermore, having dual professional identities may be "problematic" for many visual arts practitioners as they confront different questions about how and where they apply their creativity (Knowles 2015: 18).

Teaching and artistic practices while entwined are also distinctive (MacDonald 2017), thus requiring those preparing to teach art at the elementary and/or secondary levels to grapple with the challenges of meeting expectations for teaching and "negotiating the uncertainty and transience of beginning teacher identity" (MacDonald 2017: 165). Art educator Pfeiler-Wunder's study confirms feelings of conflict amongst preservice art teachers as they examined stereotypes about art teaching using collage and paper dolls to explore the "potential friction of expected teaching roles" (Pfeiler-Wunder 2017: 5). Other research suggests that student teachers (outside of art education) also struggle to "make sense of varying and sometimes competing perspectives, expectations and roles" (Beijaard et al. 2004: 115). These struggles do not appear to ease up in the first year of teaching, and new teachers experience a continued and persistent need a to find a "sense of identity within their school" (Cohen-Evron 2002 in Kuster et al. 2002: 52).

Some of the identity management strategies pre-service art teachers have used include: "(a) accepting one role and excluding the other; (b) integrating two identities into one; or (c) separating, holding and balancing more than one professional identity by managing time and space" (Hatfield et al. 2006: 46). While maintaining an artistic identity may be beneficial and important to art educators (Lim 2006), sustaining the identity of artist-teacher relies upon factors outlined by Thornton (2013) and the validation of both the artist and the teacher. It may also result in a short-term goal of choosing "one or the other" (Hatfield et al. 2006: 46).

Doctoral student-practitioner. Tierney and Rhoads describe the socialization process within higher education as follows:

> Anticipatory socialisation [that] occurs during graduate school, where individuals learn attitudes, actions, and values about the faculty group in their discipline and the profession at large. [...] The organisational stage occurs as faculty members embark upon their academic careers [...] and face extraordinary challenges to gain membership into the profession.
>
> (Tierney and Rhoads 1993: 21)

There is strong evidence of the role of the university experience in forming identities for the doctoral student (Cornelissen and van Wyk 2007) and that "doctoral

education is as much about identity formation as it is about knowledge production" (Green 2007: 53) and adapting to postsecondary institutional values (West and Chur-Hansen 2004). It is quite common for doctoral students to also assume professional roles as teachers or artists while engaging in formal studies. Compton and Tran believe that doctoral students "exist in a space that is simultaneously researcher, student, and teacher"; they often migrate between institutional borders, and between roles as "student" and "professional" (2017: 2). Findings from a longitudinal study (Jazvec-Martek 2009) also suggest that doctoral students' identities vacillate between such multiple roles as student and professional. For the newly hired doctorate, socialization will continue to shape new faculty identity (Clarke et al. 2013) relative to their new roles, institutions, and locations.

Hybrid academic identities. It is not uncommon for those in postsecondary environments to assume multiple, overlapping, and hybrid professional identities due to the nature of academic appointments (often in dual departments and colleges), the broad interests and backgrounds of professionals, and the changing nature of higher education contexts (Milbrandt and Klein 2008).

Many academics assume multiple and differing appointments during a career and have one foot in the "academic domain, and [one foot in] an administrative or management domain" (Clarke et al. 2013: 16). As visual arts practitioners continue to explore their identities, in the context of research and self-study, practitioners acknowledge that "tripartite identities" are a reminder "to draw from multiple domains" (Kay 2013: 5) that enrich and comprise professional practice.

The reality of multiple and hybrid responsibilities and roles for visual art academics are likely to remain an issue relative to increased organizational changes and an increase of entrepreneurial models within higher education that result in "new job descriptions" and "new perceptions of professional identity within higher education" (Clarke et al. 2013: 18).

In her poem, university art educator Heather McLeod focuses on the multiple and overlapping spaces of her professional identities: artist, educator, researcher, and writer and within the context of the neoliberal university climate. In "Frayed Threads Wildly Escaping," she explores possibilities of collective response,

> *Loosely woven*
> *strand over strand,*
> *I'm vintage fabric.*
> *Artist, educator, researcher, writer,*
> *(frayed threads wildly escaping with the wind).*
> *Cut follows cut,*
> *the neo-liberal university*

mangles scholar teacher magic.
But stitch your torn poetic cloth to mine.
Patch and mend,
hem ragged edges,
trim.
Side by side
we'll embroider
a crazy quilt,
strong and spiritous,
our world
to boldly
re-enchant.

(McLeod 2019: n.pag., original emphasis)

Hybrid artist identities. Studies demonstrate that there are many twists and turns in the professional cycle of an artist (Forks in the Road 2010) as they often take on two (or more) roles throughout a career cycle, and which might include any number of combinations. The reality of the fluid nature of career evolution (Akkerman and Meijer 2011) is such that artists may "play more than one role in an organization or with/in their professional life" (Berk 2015: 4). Furthermore, an artist may identify with more than one media, for example, painter-printmaker, throughout a professional career cycle. Thus, artists can also have hybrid artistic identities that emerge and evolve at different career junctures and as a result of varying personal, social, cultural, and artistic influences. Being open to change, new interests, influences, and artistic media support artistic development as a journey and a process throughout one's life.

In the case of identifying as having hybrid and/or overlapping professional identities, individuals may choose to identify with one or another more closely. Social identity complexity theory explains "the degree to which individuals view their multiple identities as similar in terms of prototypic characteristics and/or overlapping in terms of in-group members" (Roccas and Brewer 2002 in Caza and Creary 2016: 16). For example, a "simple professional identity structure" (Caza and Creary 2016: 16) would describe a hybrid-professional who identifies with a single professional identity; this structure would tend to compartmentalize identities. A more complex identity and "holistic" structure (Caza and Creary 2016: 22) would acknowledge multiple and varied and simultaneous professional identities. Factors as to how professionals prioritize, compartmentalize, and embrace all identities are based on whether these roles and identities are "externally driven or self-initiated" (Caza and Creary 2016: 24).

Virtual and online identities. Virtual environments, such as Second Life (SL), are utilized by individuals across various professional sectors for the purposes of teaching, learning, and research (Jarmon et al. 2009; Stokrocki 2010). Within the virtual environment, and the creation of an avatar-self, new and online identities are formed and enacted (Au 2008; Stokrocki 2014) in ways that may, or may not, be consistent with offline identities (Bonasio 2018) and can often impact off-line personality (McLeod et al. 2014). Studies support that the appearance of an avatar is found to greatly influence a user's comfort level, social interactions, and identity within SL (Jarmon et al. 2009).

In addition to taking on new identities within virtual environments, participation in social media, such as Instagram, Facebook, Twitter, blogs, discussion boards, and forums, result in the formation of online identities that focus on "self-presentation" (Papacharissi 2002) with "pictures, avatars, icons, nicknames, fonts, music, and video to represent themselves" (Marwick 2013: 358). However, different platforms allow for different forms of self-presentation. While "identity expression is influenced by the perception of audience" (Marwick 2013: 358), the objectives of a user's ability to obfuscate identity through having "multiple accounts, posting coded messages, and retreating to smaller sites for private conversations" can result in the creation of singular and multiple online identities and spaces in which "to construct, perform, and mobilize identity [and to] make it possible to try out different lifestyles and subjectivities" (Marwick 2013: 362). As users can also create new forms of self-representation by deleting and uploading images, posts, and accounts, an online identity or identities may be understood as not fixed and continually in-process.

Shifting identities

Mid-career. Mid-career is defined as, "beyond novice status and [when a faculty] becomes a full-fledged member of his or her profession and institution [...] and continues until disengagement begins in anticipation of retirement or a major career transition" (Clarke et al. 2013: 14). Mid-career academics are now living through a period of unprecedented change in higher education: "greater student diversity, new educational applications of technology, for-profit education competitors [...] [and] 'changed work demands and performance expectations'" (Clarke et al. 2013: 15). Subsequently, the identities of mid-career academics are often transformed through increase of "multiple responsibilities" and "new job descriptions" (Clarke et al. 2013: 18). Changes to professional roles in mid-career that are not aligned with one's personal values may result in personal and professional discontent, disconnect to professional practice and professional communities, and a lack

of professional productivity—all of which can impact professional identity. That said, mid-career may also be a vibrant time of regeneration; deepened connections to practice; the development of new goals, projects, and collaborations; the pursuit of formal and informal learning relative to professional roles and interests—and new identity development (Hall 1986).

Retirement/Post-retirement. There is no doubt as to the "interplay between the personal and professional" (Peel 2005: 496) as it plays out in retirement and post-retirement where professional identity undergoes "constant construction, destruction, and repair" (Zemblyas 2003: 108) in a "dynamic, interactive and lifelong process" (Cornelissen and van Wyk 2007: 840). A change to identity as a result of retirement is likely to follow a change in roles and responsibilities (Ibarra 1999) in a "dynamic and continuous negotiation and renegotiation of roles and [professional] memberships" (Trede et al. 2012: 374).

In a retirement, the movement toward taking on "new roles [will] require new skills, behaviors, attitudes, and patterns of interactions" (Ibarra 1999: 765); and some new roles may not have or require professional affiliations. The phase of retirement is a critical time for considering whether to maintain connections to professional communities and practice and/or to explore and develop a new personal or professional identity.

Retirement can be challenging for visual arts practitioners who have maintained long, steady, and deep connections to professional practice. The experience of the "loss of an anchoring identity" (Reitzes et al. 1996: 651) can result in a threatened identity (Breakwell 1986). Continuity theory (Atchley 1976) helps to explain how individuals may continue to hold on to occupational or professional identities as they transition into retirement. A gradual phasing out of full-time work (Atchley 1976) may ease an identity crisis (Miller 1965) and the shock of release from professional roles, obligations, identities, and communities of practice and movement toward new affiliations and identities. Again, intersecting personal, cultural, and social factors play important roles in the renegotiation of personal, social, and professional identities in retirement.

Identity change, dissonance, and adaptions

As discussed, professional identity formation is "not a fixed attribute of a person, but a relational phenomenon best characterized as an ongoing process [...] in a given context" (Gee 2001 in Beijaard et al. 2004: 108) that is "reshaped over the life of an individual" (Beltman et al. 2015: 226). Professional identities may be described as evolving, as professionals transition into or out of new roles and need "to make sense of varying and sometimes competing perspectives, expectations,

and roles that they have to confront and adapt to" (Samuel and Stephens 2000 in Beijaard et al. 2004: 115).

The linkages between identity and job satisfaction are strong (Canrinus et al. 2012). Identity dissonance occurs when professional roles are not congruent with values, personal, and cultural identities (Costello 2006: 26) and can result in an identity crisis, and a reevaluation of goals. In transitioning times, such as post-graduation, job seeking, mid-career, retirement, or during organizational mergers and reorganizations (Clark et al. 2010), identity dissonance is likely to occur. Identity dissonance results in a threatened identity (Breakwell 1986) and may be particularly felt in the negotiation of overlapping and hybrid professional identities in transitioning from one professional role to another, or from a professional life to retirement and post-retirement. Identity dissonance may also occur as women experience conflict with the expectations of motherhood and academic roles (Miller and Demers 2019). The unsettling experience of identity dissonance can be mitigated in a number of ways that include reflection, peer support, mentoring, renewed connections to communities of practice, reliance on family and friends, and receiving other kinds of support that may be needed to address psychological, financial, and other issues resulting from change.

The role of communities in shaping professional identities

The issue of belonging is critical to being and becoming a professional (Williams et al. 2012). Two kinds of community identities are relevant to professional identity formation. A *communal identity* is shaped by/in social groups where "beliefs and values are formed" (Sullivan 2004: 817). In addition, a *collective identity* refers to an identity of "having shared goals, resources, and aspirations for the profession" (Daniels 2002: 213). The first identity signifies an identity enhanced by a group membership and the latter signifies the importance of an identity linked to shared vision(s) for practice.

Findings from a study of artist-teachers in a UK-based master's level program suggests that "artist-teachers construct and renegotiate artist and teacher identities in communities or networks of practice" (Hall 2010: 108). The role of community in identity formation cannot be underestimated (Lave and Wenger 1991) in forming and negotiating professional and social identities (Knowles 2015), particularly in times of identity transitions and identity dissonance. Professional associations offer various ways for visual arts practitioners to engage in communities of practice that can strengthen professional identity. Mentoring as a support system within communities of practice can assist new and transitioning practitioners to assimilate into professional roles (Hoffess and Hanawalt 2019) and see

"professional development as a relational activity" (Kind et al. 2007: 841). Communal and relational engagement affords practitioners at all levels opportunities to form alliances that can mitigate against professional isolation.

Social media as a communal space can "serve as identity-construction mechanisms" (Ibarra et al. 2005 in Clarke et al. 2013: 12). Engagements in social media such as websites, blogs, online discussion forms, and other platforms support the construction and expression of professional identities and connections to professional communities for learning and sharing knowledge. Research supports that

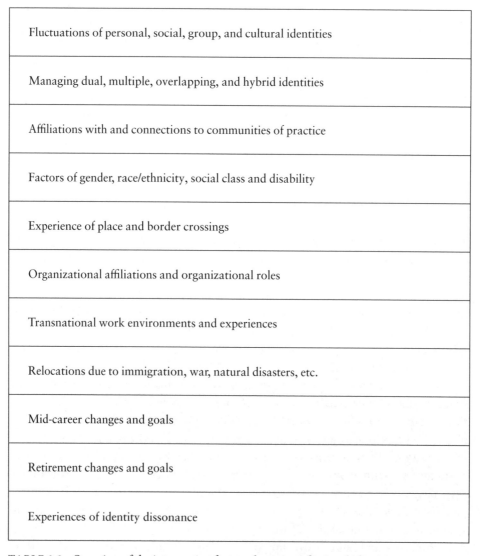

Fluctuations of personal, social, group, and cultural identities

Managing dual, multiple, overlapping, and hybrid identities

Affiliations with and connections to communities of practice

Factors of gender, race/ethnicity, social class and disability

Experience of place and border crossings

Organizational affiliations and organizational roles

Transnational work environments and experiences

Relocations due to immigration, war, natural disasters, etc.

Mid-career changes and goals

Retirement changes and goals

Experiences of identity dissonance

TABLE 3.2: Overview of the intersecting factors shaping professional identities.

"memberships in [professional] groups matter" (Ropers-Huilman and Winters 2010: 40). Alliances, collaborations, and dialogues across communities of practice are becoming imperative for advancing professional practices and advancing personal and social change. Table 3.2 is a summary of the factors discussed in Chapter 3 that impact professional identities and identity dissonance.

Concluding thoughts

Contemporary research considers the many intersecting factors of personal, social, cultural, and professional identities; the impact of globalization on professional and group identities (Schwartz et al. 2011); and the overlapping, hybrid, fluid, and shifting nature of identity formation—all of which requires a reflexive stance toward the "construction of new understandings" (Kind et al. 2007: 857) about professional identity.

Professional identity formation was contextualized in several theoretical frameworks: social identity theory, intersectional theory, personal identity theory, bicultural theory, field identity theory, and continuity theory. Professional identities were also discussed as negotiated "within [work] cultural contexts, institutions and people" (Rodgers and Scott 2008: 751). Having multiple and/or conflicting identities does not necessarily mean choosing or negating one identity over another—or being limited by a label. Rather, it is an opportunity to be reflexive and to examine the tensions surrounding the representation of self and culture (Subedi 2006) and to understand professional identity development as a "journey of becoming a 'critical learner'" (Peel 2005: 495) and a reflective practitioner.

Exploring the "interstitial" (Berk 2015: 40) as "spaces between categories of identity" as "places to confront, chronicle, reflect, and understand the conflicts, tensions, alignments, and ambiguities of one's multiple professional identities [...] where hyphens, slashes, and bridges between identities create new dialogues of the meaning of teacher [or other kinds of] identity" (Irwin 2004 as cited in Berk 2015: 40) can result in greater self-awareness. Having a clearer understanding about professional identity is an expected outcome of self-study that can be beneficial particularly for those who may be transitioning into new professional roles (Bennett 2013).

Lisa Kay's mixed media and visual metaphor (Figure 3.3) combines fabric, old clothing, tissue paper, rice paper, cellophane, raffia, beads, necklaces, and found objects in a sculptural installation that captures the spirit and complexities of multiple, hybrid, and overlapping professional identities. With a hopeful attitude about the cycles within a professional life, Kay writes,

This piece was inspired by the phrase "phoenix rising from the ashes," which is derived from an ancient myth. This metaphor applied to my professional life is the

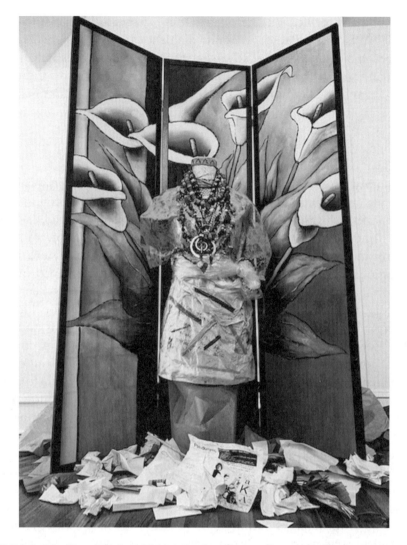

FIGURE 3.3: Lisa Kay, *Rise /rīz/*, 2019. Mixed media installation. Courtesy of artist.

on-going process of becoming—merging stronger, smarter, and more powerful. It symbolizes the cycle of regeneration and transformation, growth and triumph.

(Kay 2019: n.pag.)

Prompts

The following end-of-chapter prompts invite you to explore chapter issues and topics. Select one or more prompts from 3A and 3B to complete.

3A Inquire and analyze: Written reflections

These prompts are designed for written responses. They may also facilitate discussions with other practitioners and communities of practice. Refer to "Guidelines for writing self-study written reflections" (Appendix 2). The written responses can take the form of digital files, word-processed and printed hard-copies, or handwritten responses that are directly included in a visual journal.

1. How do you define your professional identity/identities? If you identify with multiple professional identities, what challenges do you experience?
 a. How have these changed over time and why?
 b. Metaphors are tools to enhance professional identity development (Alsup 2006). What visual metaphor would best describe your professional identities at this time?
2. What personal, social, and cultural factors shape your professional identity at this current time: age, gender, social class, sexuality, race, ethnicity, bicultural identities, national origin, geographical location, exceptionality, political, educational affiliations, civic identity, national identity, and transnational identity, or other? Which three factors are the most dominant and why?
3. How and when have you experienced identity dissonance or changes that impacted your professional identity, and with what outcomes and consequences?
4. How have the places you have lived influenced your professional identities and with what outcomes?
5. How do professional communities, including social media, inform and impact your professional identity/identities at this time?

3B Create

These prompts are designed for responding visually. See Chapter 2, Table 2.1 for ideas. Refer to "Guidelines for Self-Study Visual Artefacts" (Appendix 3).

1. Using a visual method of the "pie chart" (Compton and Tran 2017), divide a circle into sections that represent the emphases you place on each of your professional identities; the larger the area, the greater emphasis. Label these sections with your identities. Reflect on time spent in each area of emphasis, and what changes might be needed.
2. Looking to narrative as a form of inquiry (Connelly and Clandinin 1999), what kind of narrative or story might you write and illustrate about your professional identities?

3. How does clothing reflect your artistic and/or professional identity/identities? Create a three-dimensional self-portrait, or a garment (if you have sewing skills) that speaks to your professional identities.

4. Educator Nel Noddings in *Happiness and Education* (2004: 32) reminds us, "how important place is in our lives."

 a. Reflect on the places where you live and work or have lived and worked in the past. Think about landmarks, people, sounds, and so on.

 b. Use your iPhone, iPad, or camera to create photographs or use existing photographs of places you where you live/lived and work/worked. Select about six photos. Create a visual essay of about 300–500 words with photos. In your essay, reflect on how place has influenced you as a professional.

5. The "spaces between categories of identity" are "places to confront, chronicle, reflect, and understand the conflicts, tensions, alignments, and ambiguities of one's multiple professional identities [...] where hyphens, slashes, and bridges between identities create new dialogues of the meaning of teacher [or other kinds of] identity" (Irwin 2004 as cited in Berk 2015: 40). Explore the in-between spaces of your professional identities using methods of poetry—free verse or haiku. Address what it feels like to be a hyphenated professional: ex-artist-teacher. Illustrate your poem in a media of your choice.

Specific prompts such as "if only," "because [...]," or "I remember" can also invite the creation of rhythm to build poetic form (Cahnmann-Taylor 2009: 20). *Identity poetry* as a method uses the prompt of "I am [...] to explore personal, social and cultural histories and identities" (Janesick 2015: 121). (Note: The haiku poem typically consists of three lines, first line: five syllables, second line: seven syllables, third line: five syllables.)

3C Review

Review your written and visual artefacts created in Chapter 3. What initial impressions do you have? Are there any emerging issues and questions? Record your responses in your journal.

3D Share and reflect

Share selected artefacts and insights gained from Chapter 3 with collaborators or colleagues for the purposes of further dialogue and reflection. Summarize your insights and conversations and record in your journal.

Suggested methods and media for this chapter:

Fiber works
Installations
Mixed media
Narratives
Photography
Poetry
Sculpture
Visual essays
Visual journal

NOTES

1. We acknowledge that other factors can impact professional identity: age, ancestral histories and narratives, disabilities, generational divides, religion/spirituality, and sexuality. These are further discussed in Chapter 4.

2. Additional pronouns are acknowledged to to recognize non-binary identified professionals, however, there are too many variations to list.

3. It is acknowledged that Indigenous people are not a homogenous group and are diverse and "distinguishable according to language, behavior, dress, geography, foods, technologies and creation stories" (Yellow Bird 1999: 3).

4

Factors Shaping Professional
Identity and Professional Practice
in Work Cultures

Introduction

The workplace is a complex organizational structure that functions as a space for participants to enact roles and responsibilities and to work to achieve individual and collective goals and missions. It is a dynamic "interplay between individual, relational, collective, and group identity" (Booysen 2018: 1). Professional workplaces for visual arts practitioners may include private and public schools, universities, hospitals, art museums and galleries, nonprofit organizations, professional associations, and/or other types of agencies and institutions; spaces for work may be virtual. While work identities are created in the context of the work domain (Miscenko and Day 2015), the nature of workplaces and professional identities are "constantly changing, co-constructed, negotiated, and re-negotiated" and vigorously "shaped and reshaped by both internal and external forces" (Booysen 2018: 4).

Some of these forces include organizational values, beliefs, histories, missions, and aims; other forces include individual and group cultural factors. In this chapter, numerous components and factors that shape professional identity and practice respective to work culture are explored: cultural factors of gender, race, and ethnicity; social class; disabilities; religion/spirituality; and generational divides. Group identity is discussed relative to workplace culture and climate. Factors influencing both group tensions and conflict and group cohesion are discussed relative to professional and group identity. Finally, mentoring is discussed as a critical intervention toward the aims of assimilation and accommodation in workplaces that can strengthen both professional and group identity.

Social and cultural factors shaping professional identity in a work culture

As discussed in Chapter 3, the intersectional factors of gender, race/ethnicity, and social class tend to be the dominant cultural factors in shaping professional identity formation. The discussion of each of these relative to the workplace is extended while addressing several other important cultural factors shaping professional identity in the workplace: sexuality, disability, religion/spirituality, and generational divides. Figure 4.1 represents a visual and intersectional perspective of a visual arts practitioner's work/professional identity and a relational "self" (Atewologun 2018; Collins 2015; Crenshaw 2010).

Gender. While it is not possible to make generalizations about how gender is identified or experienced in the workplace, persisting issues do affect those who identify as women. Women in the United States represent 47 percent of the workforce (Burns et al. 2012) and globally women represent 40 percent of the labor force in more than 80 countries (Fetterolf 2017). As a result, women's issues in

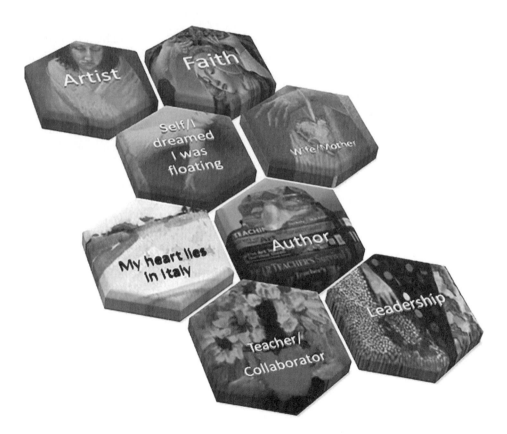

FIGURE 4.1: Kathy Marzilli Miraglia, *Untitled*, 2017. Digital collage. Courtesy of artist.

the workplace continue to remain a dominant focus in scholarship across disciplines (Bernstein et al. 2001; Desai 2003; Dillabough 1999; Mennino et al. 2005; Winslow 2010).

One of key issues impacting women in the workplace is the "spillover" (Mennino et al. 2005: 107) of multiple roles and responsibilities of women and its impact on personal and professional identities of women (di Leonardo 1985). Mennino et al (2005: 107) describe "spillover" as a state in which one tries to balance and juggle the multiple roles and responsibilities associated with work and family. It is estimated that 66 percent of working women engage in some form of domestic caretaking and overlapping roles of caretaker such as motherhood, elderly care, hands-on health providers, surrogate decision-makers and advocates, as well as providing the majority of care to spouses, parents, parents-in-law, friends, and neighbors (Family Care Giver Alliance 2003).

Other persisting issues related to women and workplaces include gender divides notably in persisting pay disparities. The intersections of social class, race, and gender in the workplace in general is evident in many organizational work cultures where high percentages of women, particularly women of color, keenly continue to experience pay gap disparities. According to Hegewisch and Hartman (2019), women in the United States workplace representing all race and ethnic groups earn less than men of that same ethnic group. Gender divides also appear with regards to leadership where the "problem of advancement" is not due to "an absence of candidates" (Monroe and Chiu 2010: 306). An example of this is within public education teacher unions in the United States where males continue to dominate in collective bargaining negotiations in spite of the high numbers of female union membership (Artz 2012).

Sexuality. LGBTQ issues remain a central issue in the workplace (Kerns et al. 2014; Kehrer 2016; Pauliny 2006; Ressler and Chase 2009; Terriquez 2015). While the cultures of institutions vary, it is clear that LGBTQ self-identification in the workplace can "alter the shape of academic [professional] life" (Pauliny 2006: 58). Most workplace policies now focus on diversity and inclusivity that considers gender and sexuality; however, "existing statistics, university equity reports and other online documents present a different discourse" about inclusion (Ndandala 2016: 75). A large study undertaken in the United States (Kosciw et al. 2007) confirms a correlation between attitudes in conservative rural locations with higher instances of LGBTQ individuals feeling unsafe and unsupported. While heteronormativity continues to be challenged relative to work contexts (Kearns et al. 2014), harassment and discrimination persists in many workplaces as antiharassment policies, procedures, and training varies greatly across institutions. All of these factors can prohibit the formation of a secure status within professional workplaces, and thus impact both personal and professional identities.

Race and ethnicity. White (Caucasian dominated) workplaces persist in North American universities (Samuel and Wane 2005) and in nonprofit organizational sectors (Burns et al. 2012); 36 percent of the United States workplace is non-Caucasian (Burns et al. 2012: 2). While trends toward globalization and inclusivity drive the influx of multicultural and cross-cultural work teams (Snell et al. 1998), hiring practices suggest that minorities continue to "face serious discrimination in academic labor markets" (Misra et al. 1999: 215). In spite of advances toward more equitable, transparent, and diverse communities of practice, racism and sexism remain as "two systems of oppression" (Ng 1994: 41) that impact professionals in the workplace, particularly, professionals of color.

The experiences of African-American higher education professionals highlight the internal and external conflicts impacting professional identities and status in the workplace (Knight 2010), and the complexity of "[a] racialized/gendered identity within academic structures" (Wilson 2018: 217) where professionals can be both "limited and empowered" by gender and race (hooks 1999: 124). The processes of assimilation-accommodation are critical to understanding identity formation in work cultures, particularly for professionals who may experience racialized/gendered identities. Assimilation "concerns the absorption of new elements into the identity structure, while accommodation refers to the adjustment of the existing structure in order to find a place for new elements" (Brygola 2011: 64). As professionals who are culturally different from the norms of a dominant work culture "assimilate themselves into the mainstream American [or another] culture" (Shin 2011: 72), they strive to adopt the cultural and linguistic patterns of the majority culture. In doing so, there may be threats to one's identity, and some measure of identity loss. Furthermore, while professionals may desire to assimilate, the realities of racial discrimination and other oppressive structural forces in work cultures can impede full assimilation and result in professionals who experience marginalization, devaluation, feelings of difference, and a lack of a sense of belonging to work or professional communities (Miraglia forthcoming, 2021).

Social class. A class is a group of people who hold common values, equal in rank to each other, who hold similar positions, and are differentiated from others outside of that class. Class may be understood as "various stratification variables [that] tend to converge [and] form a pattern [...] [that] creates social classes" (Gilbert 1998: 15). Social class is a stratified system of patterns defined by income, wealth, occupation, level of education, prestige, associations, power, and/or mobility (Fuller 2004; Gilbert 1998). Social classes are stratifications associated with terms such as working class, middle class, and upper class. The construct of privilege intersects with race and certain social classes (Lui et al.

2007) with privilege understood as an entitlement, benefit, or advantage not granted by merit but rather by social position (Lui et al. 2007; Raths 1954).

The attainment of education, particularly higher education, is often viewed as a pathway toward social and upward mobility. However, working-class professionals often face issues in the academic workplace such as "significant Othering" (Dykins-Callahan 2008: 355) related to social class issues. In some work cultures, "Othering" may escalate to extreme measures, which can severely impede and prohibit assimilation and accommodation in organizations.

Disabilities. According to the American Disabilities Act (ADA) of 1990, disability refers to "a person who has a physical or mental impairment that substantially limits one or more major life activity." The ADA is a United States civil rights law ensuring that any persons with a disability should have open access to the general public (ADA 1990). Professionals in the workplace who experience and identify as having disabilities often experience discrimination and stigmatization (Derby 2013). Discrimination can manifest in segregation, unequal promotion opportunities, and ignored requests for accommodations. Depending on the culture of the workplace, those identifying with disabilities may not be heard (Brueggemann et al. 2012) in a culture that views "disability as inferior" (Derby 2013: 378). Robert and Harlan's (2006) research suggests that disability discrimination is disproportionately directed against women and minorities in the workplace.

Religion/spirituality. There are organizations and work cultures whose religious foundations are an integral part of the culture and mission of the institution. Most institutional and work cultures associated with visual arts practitioners tend to be secular with a nonreligious mission. While religion and spirituality may be a very important part of a personal identity (Dancy 2010; King 2007; Nelson 2010), these identities may not be explicitly integrated within a professional identity or practice.

Generational divides. Current workplaces are composed of professionals representing a variety of generations including members from the Greatest Generation, Baby Boomers, Generation X, and the Millennials. Each generational group is unique as they share "life experiences [that] tend to distinguish one generation from another" (Smola and Sutton 2002: 364). The current workplace is multi- and cross-generational and composed of workers from every generation—with exception of the Greatest Generation.

The Greatest Generation refers to the generation of the Great Depression in the United States and World War II (Brokaw 2001). Baby Boomers are persons born during a rise or boom in the United States population following World War II, sometime between 1946 and 1964. Baby Boomers are now reaching retirement

age with 10,000 baby boomers turning 65 every single day (Berman 2018). *Generation X*, born between 1965 and 1979, are often described as "technically competent, and very comfortable with diversity, change, multi-tasking, and competition" (Smola and Sutton 2002: 365). *Millennials*, born between 1980 and 1994, "embrace the benefits of technology such as the Internet, cell phones, and online social networks that emerged during their youth" (Kleinhans et al. 2015: 91). An art educator who is part of Generation X explores some of the challenges and expectations that she anticipates in the workplace (Figure 4.2). She writes,

> I am aware that I am expected to have broad knowledge in art, design, visual culture, and education, and to be facile and adaptable in an era where art and art education practices are becoming increasingly social and interdisciplinary. My drawing explores some of the challenges experienced in response to the pressure to meet these expectations. I explore the tension between security and flexibility as it concerns job security in an era when full-time faculty positions are being reduced. The art educator (me) navigates a network of pathways, sometimes following established paths, and at other times creating new paths as she struggles to locate her philosophical and actual position and the direction she should take (visually represented by feet in different stances and movements) relative to the expectations and choices she confronts.
>
> (Johnson 2019: n.pag.)

As new generations continue to find their way in the workplace, one of the key issues is ageism. Nelson (2002) believes that ageism is one of the most socially condoned prejudices occurring on a national and international scale. McCann and Giles (2002: 164) interpret ageism in the workplace as a "unique-ism" given its ability to trigger feelings of premature endings or impending retirement. Reports of ageism in the workplace are a growing concern (McCann and Giles 2002; Roscigno et al. 2007). Workers over the age of 50 often experience disrespectful behavior (Baltes and Finkelstein 2011) as well as discrimination and stereotyping. Generalizations that older workers are in physical and cognitive decline, suffer from memory loss, have communication difficulties, possess an inability to cope with change, have performance and productivity issues, and have high absenteeism from work are erroneous (McCann and Giles 2002). While "age has been, and continues to be, an important cultural dimension of status in our society" (Roscigno et al. 2007: 313), the professional over 50 plays a critical role (Ng and Feldman 2009) in the workplace offering talent and a culmination of lifelong professional experiences.

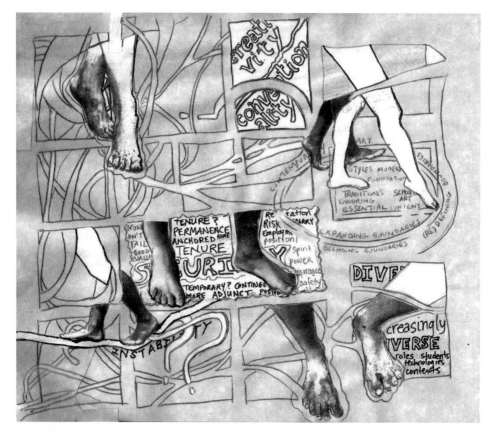

FIGURE 4.2: Nicole Johnson, *All Things, All Ways, All Places*, 2019. Mixed media on parchment paper. Courtesy of artist.

Group identity, work culture, and climate

Group identity shapes and is shaped by work climate and culture. *Workplace climate* may be defined as the tone or feel of a workplace relative to its capacity to be experienced as welcoming, safe, and inclusive (Johnson et al. 1996; McLaughlin 1992). Organizational or *workplace culture* is "difficult to define and even harder to assess, [as it] reflects deeply embedded beliefs and practices so ingrained they are taken for granted" (Gonder 1994: 4). Workplace culture involves an organization's values, beliefs, ideologies, and principles as well as the perceptions of workplace participants (Gonder 1994; Johnson et al. 1996; Van Houtte 2004). The reproduction of a work culture also lies in the narratives and stories told and shared by organizational participants that are communicated to new members; these stories

hold the key to values, beliefs, and ideologies deemed important and which impact the work climate.

The shared and felt perceptions and understandings of organizational policies, histories, stories, practices, and procedures (both formal and informal) (Reichers and Schneider 1990) influence professional practices, efficacy, work satisfaction, and how professional goals are realized. Perceptions of work culture and climate may vary due to differences in personal, social, and cultural identities and life experiences.

Group conflict and tension in the work culture. One of the key concerns of and aims for visual arts practitioners is fitting in to an organizational and work culture. Due to the diverse nature of workplaces, the varying nature of individuals and groups, and the variety of cultural factors impacting professional identity, professionals are likely to experience or witness some kind of group conflict or tension in the work culture.

One example is the artist-teacher collaboration, where artists, classroom teachers, and/or art teachers work collaboratively in teaching art within public or private elementary or secondary school settings. Often these collaborations can be problematic. The relationship is described as having "layered complexities, tensions, and contradictions that are part of artist and teacher experiences" (Kind et al. 2007: 841). Such tensions can be the result of different approaches to teaching art and different perceptions about the roles of the artist and teacher.

Visual arts practitioners, in both public and private school settings, also struggle with numerous competing internal and external institutional demands such as budget cuts, organizational realignments, high rates of student related issues, accountability, infusion and adoption of standards (McLaughlin 1992; Noddings 2012; Ravich 2010), mandated testing, and challenging teaching and learning environments (Cohen-Evron 2002; Bell and Miraglia 2003)—all of which have an impact on how work groups interact and solve problems. Group conflicts in the work culture may also arise around these issues as a result due to differing philosophical viewpoints, and a lack of alignment with institutional goals.

Workplaces, as sites of human interactions and behaviors, can develop unhealthy patterns of behavior, actions, and histories resulting in an unhealthy work culture that is prone to organizational stresses (Lewis 2004; Hoel and Salin 2003). Conflicts that develop to extreme negative and unproductive levels within a work culture most often occur in homogenous work cultures where "heterogeneous members of specific groups might experience the workplace differently depending on their [differences concerning] ethnicity, sexual orientation, and/or class and other social locations" (Atewologun 2018: 1). Such work cultures also tend to be rigid and not accepting of difference.

Consequently, what emerges from such cultures are *in-groups* and *out-groups*. In-groups are based upon "naturally occurring tendencies [that] may lead us to prefer people who are like us, and in some cases even to unfairly reject people" (Jhangiani and Tarry 2014: 494). In contrast, out-groups consist of individuals who are labeled and marginalized by an in-group. There is great variance regarding tolerance for group conflicts, what one perceives as a conflict, and how individuals and groups navigate conflict. One's role and status within a work group/workplace also effects in- and out-group status and group conflict resolutions. Table 4.1 summarizes the causes of conflicts that can contribute to fissures between professionals and work cultures.

Group cohesion and work culture. Diversity implies "the fact of differences" whereas pluralism implies "we *commit to* engage with the other person" (Simmer-Brown 1999: 100, emphasis added). *Group cohesion* is fostered through the creation of workspaces and cultures that embrace a pluralistic attitude, and a commitment to resolving differences and fostering positive interpersonal relationships based on trust and respect. Healthy work cultures offer spaces for diverse and shifting identities as well as for personal, cultural, and ideological differences. Key to group cohesion is leadership, and leadership styles that support inclusivity and group consensus building.

Varying personal, professional, and cultural identities
Rigidity of workplace culture
Homogenous work groups
External professional demands
Organizational changes
Marginalization; in- and out-groups
Varying alignments with a group mission and/or aims

TABLE 4.1: Causes of workplace conflict.

Group cohesion research suggests that the more group members meet, the frequency for productive exchanges amongst members increase, which in turn can result in the generation of positive emotions amongst members and stronger group cohesion (Lawler et al. 2000). For example, groups that may meet more regularly may be more inclined to work through differences that they experience. Group cohesion relative to identity formation and work cultures needs further consideration as it "contributes to increases in self-worth and self-esteem and ultimately to the trust and sanction of a group" (Klein and Diket 2018: 122).

Workplaces and cultures can be thus described as ecosystems (Miscovich 2018)—where diverse people, ideas, and place interact in habitats and climates that are always subject to change as participants come and go. Work cultures have been traditionally associated with brick-and-mortar institutional sites and spaces divided by offices and departments—all of which have engendered territorial thinking. Now, the emerging "digital workplace ecosystem" (Miscovich 2018) facilitates collaborative modes of working and flexible open workspaces. New modes of organizing space, time, and work cultures facilitated by technology offer new models for group identity formation, group cohesion, and mentoring. Table 4.2 summarizes the factors contributing to group cohesion in the workplace.

Leadership that fosters cohesive group identity
Mutual trust and respect
Honoring of differences
Commitment to inclusivity and pluralism
Mentoring opportunities
Creating time for relationship building

TABLE 4.2: Factors contributing to group cohesion in the workplace.

Mentoring and the work culture

Important to assimilation and accommodation relative to workplaces and cultures are induction or mentoring programs, which offer potential for professional development, validation, satisfaction, feelings of belonging, and group cohesion. *Mentoring* is a set of interactions with an experienced professional intended to advise and educate a novice and/or a peer professional, with the aims to facilitate personal and professional growth, and to provide support to those individuals (Hellsten et al. 2009; Ingersoll and Strong 2011; Unrath et al. 2013). Mentoring can vary in length of time within a professional cycle; that is, a professional might have several mentors over the course of a professional cycle.

The positive benefits of mentoring are numerous. Mentoring can necessitate a strong personal relationship based on trust between the mentor and the mentee (Kalin et al. 2009) that can facilitate a successful assimilation into professional work cultures. It is also known to mitigate the effects of professional isolation that is encountered by many public school classroom teachers (Smith and Ingersoll 2004). Professionals who work outside of institutional structures, such as practicing and independent artists, may also require mentoring that is specific to their discipline (Becher and Orland-Barak 2018). Research has shown that results of effective mentoring in university academic environments have a variety of positive outcomes such as "enhanced teaching effectiveness, increased job satisfaction, faculty vitality, scholarly productivity, and faculty retention" (Cunningham 1999: 443).

Effective mentoring relationships are diverse in types and kinds. Yet, all seem to be rooted in a commitment to authenticity, trust, and caring. A university art educator reflects upon the value of mentoring and spaces for mentoring within her academic workplace. She writes,

> Formal structures of mentoring are few in academia. A place of respite and refuge at my institution is the Women's Center—a culture of fellowship, support, and self-care thrives there [...] Retreats that address the navigation of reappointment, tenure, and promotion, for example, are important. Veritable advice given by women who peel away the politics and give meaningful mentorship is gold. Networks are broadened, and new faculty learn with whom they can establish supportive mentoring relationships.
>
> (Hoeptner-Poling 2019: n.pag.)

Conclusion

This chapter has addressed cultural factors that shape professional identity, group identity, and professional practice in the work culture: disabilities, gender, generational divides, race and ethnicity, religion and spirituality, sexuality and social class. The work culture is extremely important to professional satisfaction and "is the strongest influence on an individual's ability to successfully balance job and home responsibilities" (Mennino et al. 2005: 113). The climate and culture of a workplace are established through the interplay of participants, their values, workplace histories, stories, unspoken and written policies, and leadership. Group identity can result in feelings of belonging, cohesion, and mentorship, as well as marginalization with in- and out-groups. Professional identity construction is often complicated when work culture values and group identity do not align with personal and professional identities. Mentoring relationships are critical to personal and professional identity formation as well as group identity and work culture success. Reflection upon work cultures and how cultural factors impact professional and group identities can reveal areas of alignment, where change is needed, and areas for envisioning new ways of relating.

Prompts

The following end-of-chapter prompts invite you to explore chapter issues and topics. Select one or more prompts from 4A and 4B to complete.

4A Inquire and analyze: Written reflections

These prompts are designed for written responses. They may also facilitate discussions with other practitioners and communities of practice. Refer to "Guidelines for writing self-study reflections" (Appendix 2). The written responses can take the form of digital files, word-processed and printed hard-copies, or handwritten responses that are directly included in a visual journal.

1. What cultural factors shape your professional identity in your work culture (past or current)? Which factors are the most critical at this time?
2. What factors contribute to *group conflict* in a work culture? How have you experienced group conflict in a work culture and with what outcomes?
3. What factors shape *group cohesion* and a positive professional work community? What are your experiences in such communities?

4. Have you observed any instances of generational divides in the workplace? If so, what kinds and with what impact?
5. What are your experiences with mentoring or being mentored? In what ways has the mentoring process helped you in your professional practice?

4B Create

These prompts are designed for responding visually. See Chapter 2, Table 2.1, for ideas. Refer to "Guidelines for Self-Study Visual Artefacts" (Appendix 3).

1. Explore how cultural factors influence your professional identity in the workplace in an artistic medium of your choice.
2. Using drama education methods (Norris 2000) address issues related to work culture. Create a script for a fifteen-minute vignette that focuses on group tension in a work culture (past or present). Use fictitious names and characters. Either solo or with multiple participants, perform this vignette. You can document the performance through photography or video.
3. Explore the issue of generational divides in the work culture. What do you perceive as generational issues? Create a visual narrative or visual essay about this issue.
4. Use your iPhone or iPad to take photos of your workplace and create a mixed media collage with photos with added components (drawing, text, etc.). Include text that describes how the physicality of your workplace shapes your professional identity.
5. Using a narrative visual format (i.e., comic book or graphic novel), create one to two page black and white wordless narrative (just images) about a mentoring experience in the workplace (either you being mentored or you mentoring another).

4C Review

Review your written and visual artefacts created in Chapter 4. What initial impressions do you have? Are there any emerging issues and questions? Record your responses in your journal.

4D Share and reflect

Share selected artefacts and insights gained from Chapter 4 with collaborators or colleagues for the purposes of further dialogue and reflection. Summarize your insights and conversations and record in your journal.

Suggested engagements for visual reflection:

Collage
Narrative
Performative
Photography
Video
Visual journal
Visual narrative

5

Exploring Change within Professional Practice

As discussed in previous chapters, professional identity can be impacted by a variety of fluctuating personal, social, and cultural factors and influences. It can also be shaped by the experience of change as one moves through the evolution of a career cycle (Measor 1985). The experience of change often brings some form of loss within a professional cycle that can impact and threaten a professional identity (Breakwell 1986)—where coherence and continuity of identity are interrupted.

A threat to identity results from a situation that may be related to

> [e]xistential issues [...] changes of environment, [changes to] the bodily sphere (physical abilities, or appearance) [...] A threat to identity may also occur in the context of close relationships with other people who are perceived as significant [...] [or when] [...] the individual loses self-efficacy and as a result changes in self-perception may occur.
>
> (Brygola 2011: 76)

In *Composing a Further Life*, Mary Catherine Bateson writes about "acts and chapters" in one's life, "landmarks and turning points along the way" [...] [and] "critical moments" (Bateson 2001: 97–98). Some of the critical moments are those that occur in a professional cycle when threats to identity surface; they are significant markers that beckon change. Subsequently, these times require a toolbox for understanding and navigating change within professional practice.

Change, professional practice, and identity

Change may be understood as a phenomenon occurring "out there" as well as a deeply felt inner shift of thinking, feeling, and knowing about self and one's

practice. Internal changes might be understood as a "change of heart" or a "change of mind," about an event or issue that results in external changes. These shifts may be initially subtle, and go unnoticed; but after time, the shifts may be hard to ignore. Some change requires an immediate response to redirect attention and focus.

Two main types of change that impact a professional practice are *expected* change and *unexpected* change. Expected change takes into consideration events that are more or less typical to a normal professional trajectory, such as completing an education, induction into a profession and a first job, advancements and recognition, participation in communities of practice, and building stable professional relationships. Expected life changes include a spectrum of experiences that are associated with a normal maturation process, that is mid-life (Picard 2000), moving from stage-to-stage, from student to professional, or from mid-career to retirement. That said, *situational adjustments* (Becker 1964) are likely to occur within every phase of a professional life. These situational adjustments may not be drastic or life altering; however, they may require some adaptations that can impact professional identity and practice. For example, situational adjustments may be needed to respond to increasing professional demands, particularly in student- or client-centered professions that can often result in stress, burnout (Santoro 2018), demoralization, and emotional exhaustion (Skaalvik and Skaalvik 2010; Day and Kington 2008; Zembylas 2003). As a result, enthusiasm toward professional practice may waver. Changes to feelings about professional practice are critical to monitor as stress and depression are linked to feelings of isolation (Novotney 2019) and can negatively impact outlook and decision-making abilities.

Unexpected changes may occur through job loss, reassignments, and changes to work cultures through reorganization—all of which can impact professional roles (Hall 1986) and identities. A generation ago it was expected that those employed would work until an age of 65, however, recent trends suggest that adults will experience multiple career changes. People are generally living longer, and 35 percent of the population born in 2002 will likely live to the age of 100 (Preparing for an Aging World 2001). Twenty-four percent of workers under age 34 have already worked in four industries compared to 59 percent of workers over 65 who spent time in just three industries for their entire career (Disik 2017). Visual arts practitioners with dual or multiple professional identities can experience change due to external and fluctuating economies and support (Creativity Connects 2016), while others may experience change as a result of relocation and engaging in transnational study and work opportunities (Yoon 2017). Subsequently, the contemporary professional practices of visual arts practitioners are likely to include numerous fluctuations, adjustments, and changes.

Unexpected life changes may also include personal factors such as, divorce, separation, death of family member, and/or the emergence of a serious illness. On a more positive note, unexpected life changes might include new job opportunities, promotions, unexpected increases of income, and the addition of new family members, and colleagues.

Change to professional practice and identity can elicit many emotions and feelings, such as confusion, doubt, and uncertainty. Change requires a recalibration of identity with time to reflect and to manage and minimize negative feelings and emotions that can impede well-being and productivity. Understanding the qualities and components of change can help in strategizing how to navigate through change.

Qualities and components of change

Varying speed of change. Change occurs at varying speeds; some change can arrive abruptly, while other change can persist over time. Regardless of the speed of change, people process change at different rates and speeds and with varying levels of patience, coping skills, and with varying kinds of resources and support.

Emergence of difficult emotions. Regardless of the speed of change, change is difficult. Change means disruption and often loss to what is familiar and expected. Fear, anger, and sadness are some feelings that can accompany change. The issue of "isolation and marginalization" (Zembylas 2003: 125) is one facing many professionals in times of change. Difficult emotions require recognition and the processing of emotions and feelings that surface through times of change in ways that feel appropriate and authentic.

Shifting identities. Changes to a professional life and professional roles can bring identity changes and shifts. The greater the change, there is likelihood of a greater identity shift. Shifting professional identities result in identity loss that requires adjustment to allow for new identities, goals, and confidence to emerge.

An art educator reflects on the shifting identities within her professional life as a process,

> I have been transitioning since I started college in 1966, with personal and professional changes intertwined. During the past year, I experienced the great transition from full-time, full professor to emeritus. The opportunity to take phased retirement, teaching one semester per year during my last two years, eased this transition. I found myself looking forward, but also backward. What have I achieved during my career? What legacies am I leaving for others? Who do I want to become as I advance in age? Reflecting on these questions led to conversations with long-time

friends and colleagues. My doctor suggested journaling and meditation. My son gave me a book by Pema Chödrön; a friend gifted me a week at a spa. For the first few months I just wanted to sit with my legs up and read murder mysteries. Once I got accustomed to having more control of my time, I started discussing new writing projects with friends and making commitments to continuing research. I began to balance the genuine pleasures of research and writing with time for exercise, friends, and fiction [...] I am still deciding who I will become as I move forward.

(Stankiewicz 2019: n.pag.)

Self-efficacy. Change can result in a fluctuation (decrease or increase) of feelings of self-worth and self-efficacy. However, people who respond most favorably to life transitions are those who "believed in themselves and their own abilities (self-efficacy) and [were] people who received support from others to expand their awareness and actions" (Lord and Hutchinson 1993: 11). Having a positive outlook in the midst of change and uncertainty appears to be critical in navigating both personal and professional change.

Strategies for navigating change

In times of change, self-awareness is critical for functioning, adapting, and navigating change. As emotions are critical to decision making (Damasio 1994; Le Doux 1996), it is important in times of change that priorities focus on well-being and emotional balance. Well-being is understood to be dependent upon the following factors: (1) external conditions (income, housing, etc.); (2) how one self-reports about one's satisfaction/dissatisfaction; (3) individual mood and outlook (pessimism/optimism), and (4) how one feels and their capacities to regulate emotions (Kahneman et al. 1999). Visual arts practitioners who may be navigating change and dealing with uncertainty, feelings of isolation, and alienation need strategies to see clearly and to stay positive during unsettling times. The following are several general considerations:

Pausing. Chödrön writes that "in every moment, we make a choice, which way do we go?" (Chödrön 2002: 174). However, when we are in the midst of change, we sometimes do not know which way to go, for we may feel stuck, and being stuck means we may feel unable to make a decision, or know what to do. In times of change, ambiguity and uncertainty can override our ability to see clearly, and make decisions. This is a time to *pause*—and to embrace a "moment-to-moment, non-judgmental awareness cultivated by paying attention" (Kabat-Zinn 2005: 108).

Taking time to pause in day-to-day living can occur through walking, gardening, listening to calming music, and simple breathing meditations that allow for a

slowing down, experiencing the senses, and gaining a greater sense of equanimity that is central to navigating change and uncertainty. Pausing allows for a focus and a standing in place to listen. Art educator Maxine Greene describes this kind of pausing as "an uncoupling from your practical interests, your impinging concerns [...] to make out contours, shapes, angles, even to hear sound as sound (Greene 2001: 53)." An art educator describes her process of embracing pausing (Figure 5.1). She writes,

> I was inspired by recent significant changes in my life and what kept me moving forward when things seemed to be unsettled. As someone who craves balance, I found it helpful to make a conscious effort to stay grounded while still moving forward. The images display moments where I was consciously taking time to pause and notice the things that remain consistent and comfortable while navigating change. The process of documenting new steps forward through the act of walking, with mindful pausing to reflect, really helped me focus on crafting a positive forward momentum and to embrace the new possibilities ahead.
>
> (Oliver 2019: n.pag.)

Positive self-talk. Times of change require we look at the way we talk—especially to ourselves. In times of change, it is easy to get into a cycle of negative self-talk that is nonproductive. Change requires that we carefully choose the words we say to ourselves. Sometimes we may just need to cut the inner negative chatter, and quiet the mind. Stating things in the affirmative and using present tense can help reinforce positive self-discourse.

Embracing fear. We can draw upon the same leaps of faith that artists use when they create an artwork—that is, not knowing how or if it is going to turn out. In spite of the uncertainty, and not knowing, taking a risk is often needed during times of change. We can approach change with the same fearlessness of an artist in front of a blank canvas and take small steps to move in new directions. Some fears may require more befriending through the art-making process.

An art educator explains her process of addressing fear by moving toward art and spiritual concerns. She writes,

> upon a pilgrimage to Sicily while on sabbatical, I was able to reflect, draw upon aspects of my Italian heritage, and contemplate the role faith plays in my artwork, and professional and personal life. I explored sacred places in search of female heroes, goddesses, saints, martyrs, and icons. I lingered at churches, street shrines, archaeological sites, and museums while considering the acts of devotion required for creating works of art that I encountered there. In my journal drawing, my goal was to examine my connections to these art works. In doing so, I acknowledge

FIGURE 5.1: Kristi Oliver, *Grounded: Mindful Pauses in Times of Change*, 2019. Photomontage. Courtesy of artist.

uncertainties and current patterns that no longer work. I feel a change and clarity happening. I vow to take a leap of faith into the unknown, endeavouring to move forward in search of fulfillment and joy. I aspire to embody the qualities represented in the figure at the top left of my journal page—she is the visualization of reconciliation with my creative self.

(Miraglia 2019: n.pag.)

FIGURE 5.2: Kathy Marzilli Miraglia, *Untitled*, 2019. Pencil and felt pen. Courtesy of artist.

Letting go. Rituals help us to let go and leave the past behind, but sometimes there are no formal rituals to help us mark an ending to a professional change or career transition. In these cases, we need to create customized rituals (artistic, religious, or secular based) that afford the letting go of feelings and attachments to former identities, and/or former professional roles. This is necessary to open up spaces for moving forward and living in the present. These rituals could embrace writing, creating images, storytelling, letter writing, singing, dancing, movement, or other acts that allow for expression of gratitude, and seeing adversity and change as teachers.

Finding and receiving support. Professionals need multiple levels of support particularly in times of change. In professional work contexts, various kinds of support might be needed: (1) *personal support* in the way of a mentor; (2) *learning support,* such as a "critical friend"; (3) *research support* such as, instruction and training, and (4) *contextual support*, from team members and/or a supervisor (McLaughlin 2003: 74). Emotional support may also be needed during change. In times of change, professional communities [or retreats] can be "repositories and contexts in which interpersonal, community and culture relationships can occur" (Altman and Low 1992: 7) and provide needed support and mentorship for those experiencing change. Professional support, in the realm of counseling, may also become necessary. Understanding what kind of support is in place, what support may be needed, and the ability to reach out for needed support are critical in times of change.

Giving and receiving wisdom. In *Composing a Further Life*, Bateson (2001) speaks about the stage of Adulthood II (beginning around age 50 and that may last into one's 80s or 90s, or beyond) as a stage for wisdom and active engagement. Change offers opportunities to share wisdom, insights, and lessons learned from experience. Change also is an opportunity to be receiving wisdom from others as we navigate toward new areas of professional practice. Countless books offer wisdom, inspiration and humor in the form of stories, poems, and quotes that can also inform and energize the process of change.

Sensing/appreciating beauty. Getting in touch with the sensory and visual world is important in times of change. Artistic and aesthetic images and objects offer opportunities for appreciating beauty. Architectural spaces and gardens offer spaces for peace and reflection. Paying attention to the everyday sensory and aesthetics experiences can begin with walks in nature, preparing meals, and crafting images, objects, and spaces that support feelings of belonging, warmth, safety, and hope.

One art educator writes,

when stressful changes arise, I employ diverse coping methods. I regularly call upon the aesthetics of everyday life, and the Scandinavian concept of *koselig* (cozy) to notice beauty and comforts in the things that surround me. My home is my sanctuary. Sitting in a comfortable location, I sip hot tea from a favorite porcelain cup, pet my dogs that provide unconditional love, and practice deep breathing exercises. These sensations soothe me. Tactile expressions provide outlets for me to process my inner-thoughts and concerns. I jot down notes, make comparative lists, write constructive plans, and create art journals. They are effective resources for me to reflect on what I am experiencing.

(Sickler-Voigt 2019: n.pag.)

Perspective taking. As the poet Rumi said, "Where there is ruin, there is hope for a treasure" (Tamrat 2014: n.pag.). It is really how one looks at things—do you see the ruin, or a treasure waiting to be discovered? Along these lines, art educator researcher Jessica Hoffman Davis writes in *Framing Education as Art* (2005: 14) that we are in a culture of 'right and wrong answers [...] [where the] mind is prioritized over heart." Focusing on the gratitude and what is going right are particularly important in times of change.

Celebrations. Celebrations are signifying markers in the form of a special event that helps us to acknowledge a special or transitional moment in time. They are a call to pause, to honor, and to acknowledge the big and small milestones reached within self-study and professional practice.

Creating. Change is also a perfect time to envision what might lie ahead; it is a potent time for writing, visual art making and expressing the complexity of feelings and emotions that accompany change. There are multiple advantages of having a record of personal and professional changes through the creation of artistic works and visual journals. The process of creating helps us to visualize what is happening and to document personal growth. Creating might also take place in the context of travels to places that are inspiring and invigorating for personal and professional renewal.

In this mixed media layered poem/painting, an artist explores the beauty, rhythms, and history of Carmona, Spain (Figure 5.3) as a place of "rose colored light scorched by the summer sun" and as a place for renewal and connection to her artistic identity" (Gianneschi 2019: n.pag.).

Conclusion

Our attitudes toward change impact how we respond to change. Do we see the glass as half-empty or half-full? The lens through which we view change is determined by many intersectional social, personal, and cultural factors; whether

FIGURE 5.3: Patricia RAIN Gianneschi, *Journey to Carmona*, 2019. Mixed media. Courtesy of artist.

change was expected or unexpected; the kind of support systems that are in place; and individual capacities to reflect, adapt, and be resourceful.

A sustainable professional practice is a practice that adjusts to change, is flexible, and gracefully absorbs the ebbs and flows within a professional practice. A sustainable practice is enhanced by workplace commitments to well-being through offerings that might include meditation, mindfulness, and yoga—all of which can invite greater awareness (Barbezat and Bush 2014).

A sustainable professional practice also embraces the qualities of nonpermanence and imperfection—two qualities associated with the Japanese aesthetic known as *wabi sabi* (Koren 2008). A sustainable professional practice is also characterized by positive emotions, meaningful work and relationships, and a sense of purpose (Seligman 2011). Paying attention to the sensory and visual and engaging in the creation of artistic works can also facilitate a sense of joy (Costantino 2010) that is critical to moving through change and envisioning new professional practices.

Prompts

The following end-of-chapter prompts invite you to explore chapter issues and topics. Select one or more prompts from 5A and 5B to complete.

5A Inquire and analyze: Written reflections

These prompts are designed for written responses. They may also facilitate discussions with other practitioners and communities of practice. Refer to "Guidelines for writing self-study reflections" (Appendix 2). The written responses can take the form of digital files, word-processed and printed hard-copies, or handwritten responses that are directly included in a visual journal.

1. How and when has change impacted your professional identities and practice and with what outcomes?
 a. Job changes (situational or lateral changes, advancement, etc.)?
 b. Mid-career?
 c. Retirement/post-retirement?
 d. Personal changes impacting work life?
2. Review the qualities and components of change. Which components are relevant now in your professional practice?
3. When have you experienced identity dissonance—when professional roles are not congruent with values, as well as with personal and cultural identities (Costello 2006: 26)—and what changes resulted?
4. In what ways can professional communities of practice assist you in times of change?
5. What strategies listed in the chapter would you use for navigating change and to enhance well-being and work-life balance?

5B Create

These prompts are designed for responding visually. See Chapter 2, Table 2.1, for ideas concerning artistic media and materials. Refer to "Guidelines for Self-Study Visual Artefacts" (Appendix 3).

1. In a media of your choice, create a humorous individual artwork about change within your professional practice.
2. Philosopher Gaston Bachelard writes, "There's many a story in the miniature of a single word" (Bachelard 1994: 179). What single word would you choose to begin your story about a significant professional change? Explore this word visually in a media of your choice.
3. Take time to pause in an inspiring interior/architectural or natural/exterior space of your choosing and one that fosters contemplation, beauty, and serenity. Capture the essence of this space using an artistic medium of your choice and reflect on how it brings you into greater balance.
4. In the spirit of being "moving researchers" (Cancienne and Snowber 2009: 198), how might you explore change through the act of walking? Document a walking engagement using photography or video.
5. Metaphors can serve as an important interpretive vehicle to helping individuals construct and make sense of their own career narratives in times of transitions (Barner 2011). What career transition have you experienced and what visual metaphor might best convey this experience? Create a visual metaphor in a media of your choice.

5C Review

Review your written and visual artefacts created in Chapter 5. What initial impressions do you have? Are there any emerging issues and questions? Record your responses in your journal.

5D Share and reflect

Share selected artefacts and insights gained from Chapter 5 with collaborators or colleagues for the purposes of further dialogue and reflection. Summarize your insights and conversations and record in your journal.

Suggested methods and media for this chapter:

Creative writing
Film and video
Integrated art forms
Movement
Performative works
Photography
Visual journal
Visual metaphor
Visual poem

6

Issues and Methods for Self-Study Artefact Interpretation

Interpretation is a process within self-study that involves closely looking at self-study artefacts using various methods and processes to discern what is revealed and evoked. Through feeling, sensing, analyzing, and synthesizing, the aims of interpretation are to reveal insights and new questions, and to make "decisions about meaning and significance" (Rose 2016: 102). The transdisciplinary nature of self-study artefacts requires an understanding of key issues relevant to interpretation. In addition, as there are many methods for interpretation, it is necessary to understand the purposes and methods that are applicable to the interpretation of self-study artefacts.

Key issues relevant to the interpretation of self-study artefacts

Several issues are critical to the interpretation of self-study artefacts using qualitative and arts-based methods: ethics, image ethics, informed consent, authenticity, trustworthiness, transparency, and rigor (Miles and Huberman 1994; Saldaña 2015). *Ethics* is a term that associated with research and professional practice and is defined as "a set of personal principles for intrapersonal interaction and interpersonal conduct rooted in obligatory codes and the individual's values attitudes and belief systems" (Saldaña 2015: 80). Taking an ethical stance in self-study practice places an importance on "thinking ethically" (Saldaña 2015: 82).

Thinking ethically is important for those engaged in self-study for several reasons. The act of research requires the acknowledgment of the others' ideas. Writing-style manuals can provide guidance for citing published works and images. Images acquired from social media sites require attention to image ethics and the proper citation of sources. Informed consent, or permission to publicly share images, names, or personal information (Janesick 2015; Mannay 2015; Prosser 2000) is needed, particularly, in matters of publication and dissemination of self-study work.

Authenticity can be achieved through attention to truthfulness in the creation and interpretation of self-study artefacts. *Trustworthiness* can be attended to through care toward sensitive content and a careful detailing of research methods—all of which strengthen research integrity (Brandenburg and McDonough 2019). A consistent journaling process can contribute to trustworthiness. Hermeneutical methods that rely on critical conversations also foster *transparency* and reflexivity (Moules 2002).

The issue of *transferability* is not particularly relevant as the aim of self-study is not generalizability. Finally, *rigor* may be defined as the "constant attention to the pertinence of interpretation to the particular world of practice under consideration" (McCaffrey et al. 2012: 221). Rigor is achieved through "immersion in the text [written and visual artefacts], repeatedly cycling between the parts and whole to make sense of the phenomenon" and achieving a "depth" (Patterson and Higgs 2005: 353) of understanding. All of these issues are relevant to the interpretive phases of self-study.

Overview of interpretive methods and phases for self-study artefacts

The interpretive processes of self-study require an understanding of relevant research methods: arts-based and mapping methods. A variety of arts-based methods are outlined for interpreting visual artefacts that consider the varied and complex qualities of artistic and text-based works (Butler-Kisber 2010; Janesick 2015; Klein and Diket 1999; Leavy 2009; Rose 2016; Saldaña 2015). Mapping methods, as a specific kind of research method, supports visualization as a process for generating connections and thematic understandings about self-study artefacts. Hermeneutical and phenomenological research methods (Patterson and Higgs 2005; van Manen 1990/1997) support interpretation and mapping methods as a dialogic and relational process (Tidwell et al. 2010) to explore the "phenomenon" of professional practice (van Manen 1990: 31 in Creswell et al. 2007: 253). Subsequently, the methods included in this chapter offer pluralistic options for self-study artefact interpretation that consider the varying experiences of self-study visual arts practitioners.

Phases of interpretation. Several phases of interpretation will be discussed: (1) pre-interpretation, (2) selection and organization of artefacts, and (3) methods and levels for interpretation. Before proceeding with the interpretation of artefacts, and deciding upon a level for interpretation, please review the contents of this chapter in its entirety to gain a familiarity with the listed processes, methods, and options for interpreting artefacts.[1]

Pre-interpretation phase. In the pre-interpretation phase, return to the guiding questions for self-study that are aligned with the areas of professional practice (identity, work culture, change, and envisioning practice):

- How do you identify as a professional?
- What are the experiences occurring in the various components of your professional practice?
- How do you experience change related to your professional practice?
- What new pathways are envisioned as a result of self-study?

While responses to these questions have likely emerged along the way, new insights and responses will emerge during the interpretation phase that can assist in the goal-setting process outlined in Chapter 7.

Selection and organization of artefacts. For this phase, use the journal (or a bound notebook) to record your interpretations. Also, have drawing paper, multi-colored index cards, a variety of pencils, black and colored thin markers, scissors, and nontoxic paper adhesive ready for engaging in mapping processes that will be discussed later in this chapter.

With the central questions to the self-study at the forefront, it is time to turn to the artefacts. How many and what kinds of artefacts have been completed? Artefacts are likely to be in the visual journal; they may also take the form of digital files, visual art images and objects, and/or moving images (film and video). One of the issues in the pre-interpretation phase is determining how many and what kind of artefacts should be interpreted.

It is important to recognize that the self-study process outlined in this text will likely generate an abundance of both visual and written artefacts. As interpretation takes time and labor, it is possible to be overwhelmed by the sheer volume of artefacts. Since generalizability is not particularly an aim of self-study, it may not be critical to analyze the entire set of artefacts.

A suggested method is proposed in which: (1) the journal remains central to self-study artefact interpretation and (2) a limited and manageable sample of self-study artefacts become the focus of interpretation.

The suggested number of artefacts are a *minimum of ten diverse artefacts*, or two artefacts from Chapters 1–5. A selection of one written and one visual artefact from each chapter is recommended. This number of artefacts can afford self-study practitioners to have a focused experience with interpretive methods using self-study artefacts.

Processes

1. Begin by gathering all the visual and written artefacts created in the self-study. Assemble them on a table or floor and into groups that are organized according to the chapters, with a total of five groups of artefacts that represent each chapter.

2. Use the guidelines in Table 6.1[2] to determine if a self-study artefact should be included for interpretation. These criteria are synthesized from a variety of sources that address arts-based and aesthetic interpretive criteria (Bresler 2006; Janesick 2015; Klein and Diket 1999; Leavy 2009). The categories of resonance, connections, and uniqueness speak to the qualities and complexity of diverse visual, text-based, artistic, and aesthetic works created in the context of an arts-based self-study.

3. Criteria in Table 6.1 can be used to determine whether an artefact elicits a strong or weak response. Artefacts yielding a strong response can be set aside for interpretation. While you may have more than ten artefacts that may yield strong responses, limit interpretation to ten artefacts that provide you with the *strongest* response.

4. After the selection of artefacts, set them aside for further interpretation.

Artefact criteria	Guiding questions	Response
RESONANCE	Is the artefact compelling and engaging (visually, conceptually, etc.)? Does the artefact: • evoke strong feelings or emotions? • resonate new insights about an area of professional practice?	Strong Neutral Weak
CONNECTIONS	Does the artefact: • embody clear connections to the chapter issues? • make connections to issues related to professional practice? • raise questions related to professional practice?	Strong Neutral Weak
UNIQUENESS	Does the artefact reflect: • a personal and unique viewpoint? • a unique artistic expression through exploration of materials?	Strong Neutral Weak

TABLE 6.1: Guidelines for the selection of self-study artefacts.

Keep going, or take a break? Important to the selection of artefacts process, and to interpretation at all phases, is using intuition and perception. Intuition is the "insight or knowledge gained through direct experience and perception that comes through 'gut feelings, or flashes of insight that enables us to engage proactively in problem solving' " (Klein 2008: 113). As such, intuition is critical to the self-study interpretative process, particularly, as hunches can lead to key insights. Rollo May in *Courage to Create* (1975) described insights as arriving at the moment between a problem and relaxation. The interpretation process can at times feel stuck and problematic. In these moments, instead of forging ahead, take some time off from the interpretation process, take a break and then return to interpretation. Be sure to note your hunches and insights along the way in the journal.

Overview of interpretation methods and levels of interpretation

Following the selection of written and visual artefacts, gather all the artefacts. It is recommended that visual and written artefacts be interpreted separately (Keats 2009) followed by a cross-artefact interpretation to explore relationships between the written and visual artefacts. Several methods for the interpretation of visual and written artefacts are outlined to offer different approaches for artefact interpretation. The process of interpretation concludes with a synthesis process of cross-artefact interpretation, the identification of key resonating insights, questions, metaphors, and issues that emerged from the interpretations and reflexive exercises.

Two levels of interpretation are offered. Select a level that is appropriate to the needs and aims for the self-study:

Level I interpretation (Basic): Includes three methods for interpretation of visual and written artefacts. This level may be best for practitioners who are new to interpretive methods, and/or who have time constraints; processes are outlined for this level.

Level II interpretation (Advanced): Includes a variety of methods for the interpretation of visual and written artefacts. This level may be best for practitioners who have more experience with interpretive methods and/or who may have more time to engage in the interpretive process; processes are outlined for this level.

Table 6.2 provides an overview of Level I and Level II artefact interpretation methods.[3] While some methods are shared between Levels I and II, Level II can provide a more in-depth interpretation. Both levels include processes of triangulation and reflexivity to enhance rigor and are discussed later in the chapter.

85

Level	Visual artefact interpretation method	Written artefact interpretation methods	Cross-artefact interpretation methods	Synthesizing interpretations	Other shared processes
Level I	Use Tables 6.1 and 6.3	Word mapping	Chart mapping and concept mapping	Expanded chart mapping	Triangulation Reflexivity exercise (Table 6.4)
Level II	Use Tables 6.1 and 6.3	Hermeneutical mapping	Chart mapping and mind mapping Narrative mapping or collage mapping	Expanded chart mapping	Triangulation Reflexivity exercise (Table 6.4)

TABLE 6.2: Overview of Level I and Level II artefact interpretation methods.

Guiding criteria for visual artefact interpretation (for Levels I and II)

The process for visual artefact interpretation acknowledges that: (1) "aesthetics is central to the production of arts-based texts as well as our evaluation of them" (Leavy 2009: 16); (2) arts-based research can evoke "stories, images, sounds, scenes, [and the] sensory" (Leavy 2009: 251); and (3) the interpretive process is one that can and should embrace researchers' feelings about their data (Klein 2020).

Important questions that can guide the interpretation of visual artefacts are:

"How does the work make one feel? What does the work evoke or provoke? What does the work reveal?" (Leavy 2009: 17). Numerous categories are included in Table 6.3 for visual artefact interpretation that considers the compositional, organizational, cartographic, sonic, rhizomatic, spatial, surface, associative, emotive, and intertextual qualities of diverse arts-based artefacts.[4]

Processes

1. Take each selected visual artefact separately and apply the criteria from both columns in Table 6.3. Respond to the artefact in an intuitive way. Create a separate journal page for responses to each artefact.[5]
2. What *qualities* does each artefact embody? What *specific attributes* does the artefact embody? Record impressions in the journal. Note: All the qualities listed in Table 6.3 may not apply to all visual artefacts.

Categories of artefact qualities	Specific artefact attributes
COMPOSITIONAL	Color Line Pattern Shape Texture Number of images Placement of images Stylistic: Representational; Abstract
ORGANIZATIONAL	Asymmetry Symmetry Networked Clustered Rhizomatic
CARTOGRAPHIC QUALITIES	Edges Boundaries Focal points Paths Strata
SONIC QUALITIES (audio, music, video, or performance)	Jarring Harmonic Improvisational Loud/soft mood Pauses Repetitions Rhythms Sonic textures and overlays

(continued)

RHIZOMATIC QUALITIES	Meandering Flowing Drifting Multidirectional Multi-viewpoints Interruptions/ruptures
SPATIAL QUALITIES (three-dimensional or moving images found in film, video or performance)	Dynamics and angles Light Linear Mood Movements Overlaps Point of view Patterns and rhythms Shadows and light
SURFACE QUALITIES	Eroded Fractured Weathered Smooth
ASSOCIATIVE QUALITIES	Art Literary Metaphorical Philosophical
EMOTIVE QUALITIES	Emotions Feelings
INTER-TEXTUAL RELATIONSHIPS	What are the relationships and/ or contradictions: Between words and images? Between sound and images? Between words and sound?

TABLE 6.3: Self-study visual artefact interpretive criteria.

3. Review the notes of your list of initial impressions. Which *Compositional, Organizational, Cartographic, Sonic, Rhizomatic, Spatial, Surface, Associative, Emotive Qualities,* and *Intertextual Relationships* apply to more than one artefact? Record impressions in your journal.

4. Which artefacts share numerous similar qualities? Record impressions in your journal.

5. Which artefacts are distinctly unique in their qualities? Record impressions in your journal.

6. Based on noted impressions, what qualities appear to be resonating in and across the visual artefacts? Record impressions in your journal.

7. Based on all the impressions from the visual artefact interpretation, what issues, feelings, themes, insights, questions, and metaphors arise? Record insights in your journal.

Continued interpretation: Mapping methods (Levels I and II)

Overview of mapping methods. Upon the completion of selecting and interpreting the visual artefacts, the next phase explores the interpretation of written artefacts and cross-artefact (written and visual) interpretation. A process known as *mapping* is recommended with the aim to illuminate patterns and relationships within and across artefacts. The richness and diversity of artefacts requires methods for interpretation that can afford new impressions, linkages, pathways, and montages of understanding.

Mapping as a visual research method is applied within social science research (Futch and Fine 2014; Kane and Trochim 2006); qualitative and arts-based research (Butler-Kisber and Poldma 2010; Copeland and Agosto 2012; Lapum et al. 2015; Powell 2010; Rodriguez and Kerrigan 2016; Van der Vaart et al. 2018; Wheeldon and Faubert 2009); and in data visualization (McCandless 2014; Tufte 1990/1997). As a process of "spatial inscription" (West 2004: 6), mapping allows for a synthesis of understanding and an uncovering of layers of meaning (Butler-Kisber and Poldma 2010). Mapping can visualize, "uncover and understand trends and patterns" and "may include hand drawn charts and diagrams [...] computer generated diagrams, timelines, illustrations, charts, *Word Clouds,* and infographics" (Klein 2014: 27).

Mapping methods also use processes of sorting and coding that are typical to qualitative and arts-based research interpretation (Creswell et al. 2007; Saldaña 2015). However, mapping also affords rhizomatic connections and hermeneutical conversations. Several methods for mapping are discussed that can allow self-study practitioners choices and approaches for artefact interpretation

(Butler-Kisber and Poldma 2010; Buzan 2018; Gray and Malins 2004; Paterson and Higgs 2005; Powell 2010; West 2004). The value of using several mapping methods and at different times during the interpretation process aims to develop interpretive skills and yield critical insights.

Selecting a level for written and cross-artefact interpretations

Select a level for written and cross-artefact interpretation and follow the methods and processes outlined for that level.

Level I: Mapping method for written artefacts

Word mapping. Word mapping describes a process of mapping connections using text-based data; it relies on coding, categorizing, and recategorizing in a process of visualizing relationships between words generated from self-study written artefacts.

Processes

1. Gather the selected five written artefacts; print out or photocopy these artefacts to retain the originals.
2. Begin by finding *key* words that feel important or evoke a connection in each of the written artefacts.
3. Circle these words, or make a list of all the words. Aim for a minimum of four to six words from each written artefact.
4. Using multicolored index cards, select a different color for each chapter. Beginning with words from Chapter 1 written artefacts, write each word on a separate index card.
5. Select different color cards for the words from written artefacts in the remaining chapters. Again, write each word on a separate card for each chapter. Upon completing this process, gather all the cards.
6. First, take all the cards with same color from the same chapter and arrange them in groupings for new meanings. Groupings can be approached in several ways: (a) randomly select cards and group; (b) take one card as a prompt and intuitively add other cards to the group; or (c) find cards with similar topics and group. Experiment with several kinds of groupings. Note these groupings and your insights in the journal.

7. Next, gather all the cards and shuffle a few times. Use the mixed color deck of cards to generate new groupings and new meanings. Again, create at least three or four new groupings using this deck of cards. Record the words for each grouping in your journal.

8. Explore research as poetry (Pointdexter 2009) with the words. Create a grouping that takes a poetic form, such as, free verse poetry. (For more about free verse poetry, refer to Oliver (1994), or other poetry references.) Record the free verse poem in the journal.

9. Reflect on all these groupings. What issues, feelings, themes, insights, questions metaphors, and other emerging categories are revealed by these groupings? Record your responses in your journal.

Level I: Cross-artefact interpretation methods

Two methods of mapping are suggested for cross-artefact (visual and written) interpretations: *chart mapping and concept mapping.* The following is an overview of processes aligned with each mapping method:

Chart mapping. Chart mapping is a method of visualization for organizing and categorizing ideas, themes, and interpretations. Columns and rows and can be drawn by hand or created digitally; color and size of fonts and color-coded rows and columns can contribute to the creation of a compelling visualization. Seek out ways to create charts that employ hand-drawn components to illustrate relationships, linkages, and patterns and that can result in beautiful displays of knowledge (McCandless 2014).

Processes

1. Create a chart with a series of columns for: "issues," "feelings," "themes," "insights," "questions," "metaphors," and "other relevant emerging categories."

2. Create two rows for the topics: "visual artefacts" and "written artefacts."

3. Using notes from the word groupings and the visual artefact interpretation processes, insert content (words and phrases for each topic) that emerged.

4. Circle key words and phrases in the chart.

5. What new insights emerged using the chart method?

6. Record impressions in your journal.

Concept mapping. Concept mapping is a research method and strategy (Daley 2004; Novak and Gowin 1984) to elicit nonlinear interconnections in research

in ways that are highly visual (Bagnoli 2009; Butler-Kisber and Poldma 2010). Concept maps are used as in phases of brainstorming as they allow for diagrammatic sketching, and for "documenting the relational aspects of initial data interpretations" (Butler-Kisber and Poldma 2010: para. 18). They rely on analytical and drawing processes using words and concepts in a visual format that results in both an organization and restructuring of research themes. Concept maps are often roughly sketched in pencil or pen and can be later refined using digital graphic tools. Subsequently, there may be several versions of concept maps about a specific research phenomenon.

Essentially, concept maps are visualizations comprised of "ideas with text being reduced to a series of small words or phrases that are encircled, and then prioritized and linked through a series of symbols and drawn shapes" (Butler-Kisber and Poldma 2010: n.pag.). The variations of concept maps include flow charts, storyboards and matrices all of which can "employ color, tone, line, plane, shape, scale, [and] symbol (Gray and Malins 2004: 107). Linkages between areas utilize graphic elements, such as other geometric shapes, arrows, lines, and text. This mapping method is effective for identifying categories and visualizing relationships within and between categories.

Processes

1. Use the content of the chart map to create a concept map.
2. In the concept map, use geometric shapes, words, directional lines, or arrows, symbols, and color.
3. Create a rough sketch using pencil to first create large shapes and categories. Then add smaller shapes and categories; use linear elements and symbols to make visual and conceptual connections and relationships.
4. Leaving the first map intact, create a new and refined version of the concept map. Add more color and details to this map.
5. What differences exist between the first and second versions?
6. What new insights emerged from the concept mapping process?
7. Record impressions in your journal.

Level I: Synthesizing interpretations

This phase focuses on: (1) identifying key findings: insights, questions, themes, issues, and metaphors from all phases of mapping; and (2) condensing and summarizing these connections.

Processes

1. Gather impressions and responses from the concept mapping process.
2. Review the chart with key findings from the word mapping and visual artefact interpretation processes.
3. Add any insights to the chart revealed from the concept mapping process.
4. Compare and contrast to see where insights, questions, themes, issues, and metaphors *repeat and overlap* and where there are *distinctive* areas of *difference.*
5. Circle words and phrases that repeat and resonate.
6. Create a list of these resonating words and phrases.
7. Generate a *final list* and select one resonating theme, question, issue, and metaphor that embraces the *essence* of the self-artefact interpretation process. Record final list in your journal.

Level II: Mapping methods for written artefacts

This level incorporates other methods of mapping to advance insights and to gain further experiences with interpretive mapping methods. In addition to the visual artefact mapping strategy (Table 6.2), the following mapping methods are suggested for Level II interpretations:

Hermeneutical mapping for written artefacts. Hermeneutical mapping is a visual research method focuses on the interpretation of text(s) through visualization, writing, and dialogue about the text(s) (Moules 2002; Polkinghorne 1989). Hermeneutical methods are guided by the assumption that knowledge is constructed through dialogue and "hermeneutic conversation" (Patterson and Higgs 2005: 343). Hermeneutic conversations can be dialogues with colleagues (a critical friend, a co-researcher, an instructor, and/or an individual who is familiar with the self-study process). The value of hermeneutic conversations is that they strengthen inter-subjective knowing and advance new insights and inter-textual connections. Hermeneutic understanding is explained as involving a

> careful and detailed reading and rereading of all the text, allowing for the bringing forth of general impressions, something that catches the regard of the reader and lingers, perturbing and distinctive resonances, familiarities, differences, newness, and echoes. Each re-reading of the text is an attempt to listen for echoes of something that might expand possibilities of understanding.
>
> (Moules 2002: n.pag.)

Processes

1. Use the selected five written artefacts. Make copies of these artefacts and retain the originals.
2. Take a copy of each written artefact and attach each to the center of a page. Use paper sized at approx. 11 x 17 inches or larger as you will need adequate margin space.
3. For each written artefact, use the margins surrounding the text to record what kinds of associations this artefact generates. Look for connections to art, philosophy, readings in literature, poetry, theory, and so on. Record notes, quotes, insights, references, impressions, and thoughts that are generated from a careful reading of artefacts. Leave spaces in the margins for additional impressions to be added.
4. Share the map with a "critical friend" (coresearcher, researcher peer, instructor, etc.) who can respond with their interpretations in the margins around the artefact. Additions might include questions, comments, resources, or other information to extend understanding and facilitate dialogue.
5. Briefly discuss the map with a colleague (in person or through video chat plat-form, email, etc.) relative to the insights and questions raised by this process.
6. Record these impressions in your journal.

Level II: Cross-artefact mapping methods

This level explores a variety of mapping methods for advancing interpretations through *chart mapping*, *mind mapping*, *narrative mapping*, or *collage mapping*. Use both chart mapping and mind mapping. Select either the narrative or the col-lage method. Each of these methods is briefly discussed followed by a list of pro-cesses. The methods of chart mapping and mind mapping are offered to support visualization as a key interpretive research method and to advance metaphorical, symbolic, and qualitative thinking about self-study artefacts.

Chart mapping

Processes

1. Return to the findings from your visual artefact interpretations (pp. 86–89) and the hermeneutical mapping process.

2. Create a chart with a series of columns for: "issues," "feelings," "themes," "insights," "questions," "metaphors," and "other relevant emerging categories."
3. Create two rows for the topics: "visual artefacts" and "written artefacts."
4. Using notes from the interpretations, insert content (words and phrases for each topic) that emerged.
5. Circle key words and phrases in the chart.
6. What new insights emerged using the chart method?
7. Record impressions in your journal.

Mind mapping

Free form maps, known as *mind maps*, allow for making nonhierarchical connections (Buzan 2018). Similar to concept maps, mind maps contain components of words, symbols, directional arrows, and integration of color. Yet, mind maps are characterized by linearity with the use of lines to suggest a visual branching out of ideas (resembling rhizomes) in a nonhierarchical diagram of connecting lines to depict associations between various topics (Buzan 2018: 61). This kind of map may assist in helping to see new interconnections between themes and categories.

Processes

1. Select a large sheet of paper (16 x 20 inches or 18 x 24 inches). Place in a horizontal direction.
2. Use the content of the chart to create a mind map.
3. Working from the center of the page, draw a central branch and attach other sub-branches to represent subthemes.
4. Align branches with key words, phrases, or images that represent themes, insights, issues, and questions emerging from the interpretation of both sets of artefacts.
5. Continue to add branches, words, images, color, and symbols to define and extend areas and to create visual interest.
6. What new insights emerged using the mind map method?
7. Record impressions in your journal.

Emotive mapping methods: Narrative and collage mapping

In this next phase, select either the *narrative mapping or* the *collage mapping* method.

Narrative mapping. Researchers often use drawings that combine figurative and landscape elements, metaphorical imagery, color, and visual texture to explore the emotional tones of the research phenomenon and the research process (Lapum et al. 2015; Jongeward 2009). Narratives, as a method of interpretation, can be used to "map" the emotional experience of a researcher's self-study process. In creating these narrative maps, consider using landscape components such as figures, architecture, symbols, landmarks, and different points of views (birds eye, close up, etc.) as well as "color, line shape and rhythmic relationships of parts" (Jongeward 2009: 242).

Processes

1. Using drawing materials, explore emotive responses about the self-study process. What feelings and emotions have been evoked by the self-study process?
2. Review the drawing for content, themes, imagery, text, and other components.
3. What new insights emerged through the narrative map method?
4. Record impressions in your journal.
5. Review the chart and add any content to the existing chart.

Collage mapping. Collage is a popular method and process used in arts-based art education and art therapy research (Butler-Kisber 2008; Butler-Kisber and Poldma 2010; Gerstenblatt 2013; Kay 2013; Margolin 2014; Powell 2010; Scotti and Chilton 2017) as well as self-study research (Hamilton and Pinnegar 2010). It can be used in any phase of the inquiry process that includes data analysis (Margolin 2014) and in a process that can "uncover, juxtapose, and transform multiple meanings and perspectives" (Scotti and Chilton 2017: 360) through nonlinear and relational visual representation. Collage mapping is an inquiry method "for formulating ideas and articulating relationships" to "help understand [research] phenomena in their formative stages, [and to] work through emergent concepts" (Butler-Kisber and Poldma 2010: 1).

Collage maps allow for multi- and mixed-media nonlinear narratives created through the juxtapositions of drawing, diagrams, photographs, computer generated illustrations, and self-study text (Powell 2010). Butler-Kisber and Poldma (2010: n.pag.) explain the collage mapping process for research,

When using collage reflectively, the researcher focuses on a question, dilemma, or the like, and then selects pictures that metaphorically reflect aspects of this thinking. Then operating intuitively, she [he/they] creates a collage producing a visual composition with the selected fragments. This collage process breaks away from the linearity of written thoughts by working first from feelings about something to the ideas they evoke, instead of the reverse. The resulting visual juxtapositions frequently reveal new connections.

Processes

1. Use a heavy weight (watercolor or printmaking) paper that is able to absorb mixed media and water-based materials. Recommended paper size should be no smaller than 11 x 17 inches to around 24 x 36 inches that allows for working on table, floor, or wall.
2. Collect a variety of collage materials that include: images and text from magazines, catalogs, maps, newspapers, greeting cards, fabric, drawing materials, adhesive, and scissors.
3. Review insights garnered from mapping processes used thus far. What have the interpretive processes revealed and evoked? Explore *one* issue, question, insight, or metaphor as a focus in the collage. Pay attention to feelings as in the creation of the collage.
4. The collage can be later titled and examined for imagery, themes, and emotive components.
5. What new insights emerged through the collage method?
6. Record impressions in your journal.
7. Review the chart and add any new content to the existing chart.

Level II: Synthesizing interpretations

At this point in the interpretation phase, there should be evidences of the following interpretative methods:

- visual artefact analysis
- hermeneutical mapping
- chart mapping
- mind mapping
- narrative mapping or collage mapping.

This phase focuses on: (1) identifying key findings: insights, questions, themes, issues, and metaphors from all phases of mapping; and (2) condensing and summarizing these connections.

Processes

1. Gather all existing maps with the chart that includes a summary of the key findings and insights from the visual and written artefact interpretations.
2. Review any journal impressions or notes.
3. Compare and contrast to see where insights, questions, themes, issues, and metaphors *repeat and overlap* and where there are *distinctive* areas of *difference.*
4. Circle words and phrases that repeat and resonate.
5. Create a list of resonating words and phrases that appear to emerge.
6. Generate a final list of one resonating theme, question, issue, and metaphor that embraces the *essence* of the self-artefact interpretation. Record in your journal.

Level I and II: Reflexive exercises

Triangulation. Upon the completion of interpretations, engaging in *triangulation* provides a space for critical conversation, insights, and reflexivity through relational learning (Ingold 2011). Triangulation is a process that can assist in identifying areas that may have overlooked or to discuss interpretations that may be puzzling, contradictory, or surprising. Triangulation requires dialogue with a collaborator or peer, or another researcher or "critical friend" who is familiar with your self-study and qualitative research methods to enable dialogue about the interpretations. Triangulation in the form of peer debriefing also enhances credibility within the self-study.

Processes

1. Share the results of interpretation (the chart and the list of resonating key themes, etc.) with a critical friend who can dialogue with you about the interpretations.
2. What new insights occurred as a result of this dialogic process?
3. Make any new adjustments to the chart if needed with new insights.

Post interpretation exercise. This phase focuses on reflexivity and the articulation of the relevance and meaning of the self-study process. The prompts in this exercise allow for a synthesis of understanding and a clarification of key insights gained from the self-study process.

Processes

1. Using Table 6.4,[6] review and respond to the prompts in your journal to facilitate a reflexive stance that will be useful in goal setting in Chapter 7.
2. Record impressions in your journal.

Conclusion

This chapter focused on interpretive methods for self-study artefact selection and interpretation using qualitative, arts-based phenomenology and hermeneutical research methods. Two levels of interpretation were outlined that included various methods of mapping to offer individuals and collective groups options for interpretation. Other issues relevant to self-study artefact interpretations were discussed: ethics, image ethics, authenticity, trustworthiness, transparency, rigor, triangulation, and reflexivity.

As a result of this self-study, and relative to my professional practice:
I realize that…
I feel energized to…
I need more time to…
I want to learn more about…
I was surprised that…
My assumptions have changed about…
My professional identities are…

TABLE 6.4: Post-interpretation reflexive prompts.

The following evidences generated from the interpretation process will be used in Chapter 7 toward the aims of imagining new lines of flight and generating new goals for professional practice:

- List of resonating theme, issue, question, and metaphor.
- Chart with consolidated themes, insights, questions, and metaphors.
- Responses from Table 6.4 post-interpretive reflexive exercise.

Prompts

The following end-of-chapter prompts invite you to explore chapter issues and topics. To engage in a process of reflection on the self-study process, select one or more prompts from 6A and 6B to complete. Responses may be useful in further inquiry.

6A Inquire and analyze: Written reflections

These prompts are designed for written responses. They may also facilitate discussions with other practitioners and communities of practice. Refer to "Guidelines for writing self-study reflections" (Appendix 2). The written responses can take the form of digital files, word-processed, hard copies or handwritten responses that are directly included in the visual journal.

1. How did you experience the interpretation processes and with what results?
2. In what ways did the mapping processes inform interpretation?
3. How did ethics inform interpretation?
4. How did triangulation and reflexivity inform interpretation?
5. What are the three most important things learned from interpreting your self-study artefacts?

6B Create

These prompts are designed for responding visually.[7] See Figure 2.1 for ideas concerning artistic media and materials. Refer to "Guidelines for Self-Study Visual Artefacts" (Appendix 3).

1. Review your final list of the resonating issue, theme, question, and metaphor. Using "new lines of flight" as a metaphor for practice (Deleuze and Guattari 1987), visualize what you anticipate are some "new lines of flight" within your professional practice.
2. Create a self-portrait that embodies how you felt as a researcher engaging in the self-study process.
3. Create a free verse poem about the self-study process using impressions and notes from the journal.
4. Create an object that represents key lesson(s) learned from the self-study process.
5. Create a visual to represent the essence of your findings from the self-study artefact interpretation process.

6C Review

Review your written and visual artefacts created in Chapter 6. What impressions do you have? Record your responses in your journal.

6D Share and reflect

Share selected artefacts and insights gained from Chapter 6 with collaborators or colleagues for the purposes of further dialogue and reflection. Summarize your insights and conversations and record in your journal.

Suggested methods and media for this chapter:

Collage
Drawing
Mapping
Mixed media
Poetry
Sculpture
Visual journal
Writing

NOTES

1. For instructors using this as a text, or readers engaging in self-study, it is recommended that you review all the processes listed in Chapter 6, decide on either Level I or Level II, and then create a list, chart, and/or visual to help organize the required steps to guide you in the process of interpretation.
2. Criteria in Table 6.1 developed by Sheri R. Klein.
3. Criteria in Table 6.2 developed by Sheri R. Klein.
4. Criteria in Table 6.3 developed by Sheri R. Klein.
5. In addition to having a separate journal page for responses to each artefact, the processes of interpretation outlined in Chapters 6 and 7 will require you to note impressions along the way. As a result, an additional journal may be needed for the interpretation phase.
6. Criteria in Table 6.4 developed by Sheri R. Klein.
7. While the written and visual artefacts created from Chapter 6 prompts are not part of the interpretation process, they can be archived for later reflection and interpretation.

7

Envisioning Professional Practice

Envision is a term derived from the Latin *en-*, meaning *"cause to be."* To envision professional practice is to look toward new possibilities and to consider how those possibilities might be realized. In this sense, envisioning is a hopeful process for imagining new lines of flight for professional growth. Chapter 6 focused on the selection and interpretation of self-study artefacts using arts-based methods in an "imaginative, artful, [and] flexible" process (Gray and Malins 2004: 156). This chapter will focus on the application of key findings from interpretation toward the articulation of new goals, pathways, and lines of flight. Two important phases of the envisioning process are discussed: (1) decision making relative to goal setting and (2) using arts-based mapping methods in the envisioning process.

Phases of envisioning

Decision making. Decision making is often described as a cognitive and problem-solving process involving the awareness of a problem, a processing phrase where alternatives are generated using brainstorming, the narrowing of options toward resolution, generating a plan for taking action, and implementing a solution and a plan for evaluating the outcomes (Bransford and Stein 1984). While decision making is unique to each individual (Huitt 1992), it is likely to be influenced by the intersections of lived experience, emotions (Damasio 1994), personal, social, and professional identities, and work cultures. Processes of reflection, visualization, and dialogue with others within professional communities can foster reflexivity needed for critical decision making concerning work culture, change, and other professional issues.

How decisions are made subsequently will vary from individual to individual; there is no one right way to make a decision. Indecision, or the inability to make a decision, can also occur due to several reasons: lack of experience and information needed to make a decision, fear of change, or using only logic to solve professional dilemmas. Perkins (2009: 14) suggests that intuitive decision making can be more effective, particularly, for those who have well-developed experiences in a domain for "knowledge, experience, and understanding of a situation are tremendously important in the balancing act of good decision making." Consistent with literature on the psychology of decision making (Galotti 2002), Perkins also suggests that decision making can be ineffective when

> people often act impulsively and impressionistically, with a limited view of the matter at hand, not looking beyond what the obvious options offer; not sufficiently consulting past experiences, general knowledge, informed friends and colleagues, and other sources; or not weaving evidence together in a coherent way.
>
> (Perkins 2009: 4)

As such, decision making can require "analytic, sometimes more intuitive [relying on hunches and feelings] sometimes making checklists, [and] sometimes telling stories and counter-stories to oneself" (Perkins 2009: 2).

Decision making is a critical component of professional practice and a necessary step toward breaking cycles of practice that are no longer effective and embarking "on a process that will foster continuous growth and development" (Sagor 2000: 7). This process, however, is also laden with risks. For envisioning requires stepping out of comfort zones, trying new approaches, forging new paths, as well as demonstrating skills and dispositions that support change.

Skills and dispositions important to decision making and envisioning. The following dispositional qualities are identified as important to decision making and envisioning professional practice: (1) *curiosity:* seeking out the unknown and intriguing; (2) *imagination:* seeing what is not currently present but could be; (3) *risk taking:* taking chances, creating something new, demonstrating a willingness to learn from mistakes, and demonstrating independent thinking (Burton et al. 2000); (4) *resilience:* an inner strength in the face of adversity; believing in yourself in the face of uncertainty, and staying the course in spite of challenges (Greitens 2015); (5) *positivity:* remaining optimistic; (6) *patience:* the ability to wait gracefully; (7) *gentleness:* a kindness toward self; (8) *mindfulness,* a quiet attention to self and others; and (9) *introspection:* looking inward in a process of nonjudgmental self-examination that allows for new insights, knowledge, and wisdom to emerge.

In addition to the listed dispositions, the following processes and skills are also important to decision making and envisioning professional practice:

- analysis of key issues and patterns
- brainstorming of options
- communication (written, visual, and verbal)
- perception using intuition
- connections to communities of practice
- reflexivity through having a critical eye toward practice.

Goal-setting process. While goal setting is a personal and highly individualized process, visual arts practitioners are typically affiliated with institutions that require an alignment of professional interests with institutional goals. The creation of professional goals can serve several purposes. On a practical level, the goal-setting process provides structure and focus for constructing a professional plan and taking action (Dundon 2002). Second, the goal-setting process allows for a return of feedback (Locke and Latham 2006) and guidance that can accelerate professional growth. As visual arts practitioners are situated within communities of practice, colleagues (Loughran and Northfield 1998) and mentors (Miraglia 2017) can serve as invaluable support systems for practitioners engaged in decision making and envisioning.

Some key questions to consider when setting goals include the following: What are my professional interests at this time? What goals and aims of my institutional affiliations do I need to consider? What key individuals need to be a part of my goal-setting process? What are my insights from the self-study process?

Using key self-study insights to guide goal setting.[1] Using key self-study insights to guide professional goal setting is a multiple phase process that includes: (1) reviewing key insights synthesized through interpretation; (2) articulating and mapping potential lines of flight; (3) articulating goals for professional practice; and (4) articulating ways to map progress.

Reviewing key insights. What key insights were gained from the self-study interpretation?

Processes

1. Review the resonating insight, question, theme, and metaphor synthesized from Chapter 6 interpretations.
2. Regarding the resonating insight, question, and theme, what connections do these have to the areas of your professional practice, such as identity, work culture, and change?

3. Based on the findings from interpretation, what appears to be the resonating area(s) of professional practice that warrant attention at this time: identities, work culture, change—or other?

Articulating and mapping potential lines of flight

Articulating potential "lines of flight" (Deleuze and Guattari 1987) considers new areas for pursuit or existing areas of practice that may require further attention. The processes of mapping afford the generation of potential lines of flight and pathways for taking future action(s).

Processes

1. Review resonating insight, question, and theme, etc. from Chapter 6 interpretations and your response to the reflexive exercise from Chapter 6, Table 6.4. These realizations can now influence potential lines of flight in professional practice. Based on responses to these prompts, what are some areas for focus, refocus, or new areas of pursuit? How do these relate to your responses to areas of identity, work culture, or change?
2. Create a short list of three to five potential areas for lines of flight within professional practice. Review the list to determine if these areas are
 • problematic
 • hopeful and intriguing
 • requiring further knowledge and self-study
 • requiring further observation
 • requiring immediate action and change.
3. Using the mind mapping method (discussed in Chapter 6), create a mind map and visualize these selected areas/potential lines of flight. Add color, arrows, and other visual symbols to enhance the map. Refrain from self-editing, or thinking of limitations as you construct this map.
4. Review the map. Determine which three potential lines of flight or areas might be prioritized for taking action.
5. What are the final top three identified areas, lines of flight or pathways for continued inquiry into and growth of your professional practice?

Articulating goals and a process for mapping progress

Processes

1. For each selected three areas/lines of flight for professional practice, create words or phrases that summarize or symbolize each potential path. Brainstorm needed resources for each path and potential projects that you might engage in for each path/line of flight. Create a chart (hand-drawn or digitally produced) to organize this information.
2. Using the chart, review each of the three potential paths and designate which will be a short-term and long-term goal.
3. For each path, create one to three specific goals. Add these goals to the chart for each pathway.
4. Share the chart and goals with a professional colleague, supervisor, and/or mentor, for input.
5. Revise goals if needed.
6. Make a final list of pathways with specific goals. Prioritize which goals will be implemented and when, and with what kind of timetable.
7. Add this information to the chart.

Mapping progress. Mapping can be used as a method to take a closer look at what directions and movements have occurred and to discern what redirections in professional practice might be needed. Some guiding questions for mapping progress of professional goals include: Where am I in relation to my goal(s)? What is emerging as a result of these goals and lines of flight? What unexpected insights, events, and issues have emerged? What has been achieved, revealed, and learned? What redirection may be needed? How are work and life in balance? Figure 7.1 is a collage by an art educator that addresses the importance of balancing personal and professional goals.

Arts-based mapping methods, such as collage and other methods described in Chapter 6, can be useful for reflection on the progress of professional goals. The visual journal can also be a method for mapping professional progress. In this sense, the pursuit of goals in the context of professional practice can be observed and assessed through the lens of practitioner-as-researcher-inquirer and with a view of professional practice as a site for continued and ongoing self-study research.

Celebrating progress. As the self-study model embraces appreciative inquiry (Cooperrider and Whitney 2005) and acknowledging what is going right in one's professional practice, it is important to take time to pause to acknowledge milestones, achievement of goals, and new areas of growth. It is also a time to remain

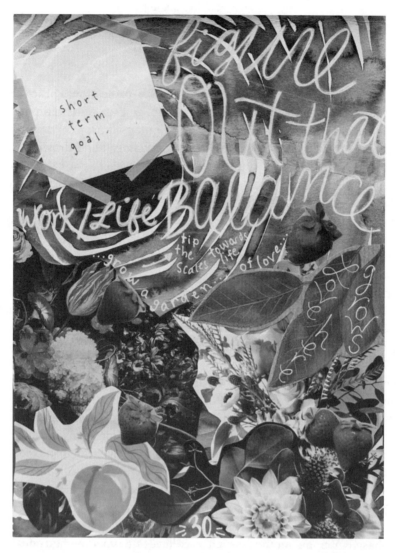

FIGURE 7.1: Keri Schlageter, *Untitled*, journal page, 2019. Mixed media. Courtesy of artist.

open to what kinds of unexpected issues, ideas, and events have occurred and that might be re-formed into new lines of flight within professional practice.

Conclusion

This chapter has explored the phases of envisioning professional practice with the aim of creating new lines of flight for professional practice guided by self-study inquiry. The process of envisioning professional practice is driven by key insights from self-study artefact interpretation using a variety of processes that focus on mapping as integral to this process.

Envisioning professional practice requires decision making that carefully considers individual interests, communities of practice, and professional and institutional affiliations. Goal setting as a process for envisioning relies on visual arts practitioners' abilities, skills, and dispositions, as well as analytical and intuitive processes. The creation of new professional goals and the mapping of professional progress can be enhanced through using arts-based methods that afford multidirectional, visual, and imaginative thinking about professional practice.

Prompts

The following end-of-chapter prompts invite you to explore chapter issues and topics. Select one or more prompts from 7A and 7B to complete all of which focus on reflections on the self-study process. Responses may be useful for future inquiry.

7A Inquire and analyze: Written reflections

These prompts are designed for written responses. They may also facilitate discussions with other practitioners and communities of practice. Refer to "Guidelines for writing self-study reflections" (Appendix 2). The written responses can take the form of digital files, word-processed and printed hard-copies, or handwritten responses that are directly included in a visual journal.

1. What new lines of flight emerged for your professional practice and in what areas of professional practice?
2. What short- and long-term goals do you propose for professional practice, and why?

3. Review the list of skills and dispositions relative to envisioning professional practice discussed in this chapter. Reflect on what skills and dispositions you possess, and what skills may need further development.
4. In what ways has the self-study process advanced your understandings about your professional identities and professional practice?
5. What possibilities might be explored for disseminating outcomes of the self-study: exhibition, publication, presentation, and/or other public sharing of self-study process and outcomes?

7B Create

These prompts are designed for responding visually. See Chapter 2, Table 2.1, for ideas concerning artistic media and materials. Refer to "Guidelines for Self-Study Visual Artefacts" (Appendix 3).[2]

1. Write an illustrated dated letter to self and articulate your proposed lines of flight and your hopes and aims. Place letter in an envelope on a journal page.
2. What images, quotes, and poetry can serve as vital sources of inspiration your proposed lines of flight, pathways, and goals? Gather these into a collage.
3. Use data visualization method of a timeline, and create a visual timeline of images, text, and symbols to describe projected phases of the your proposed lines of flight. A timeline can be drawn by hand or using digital timeline makers.
4. Review your proposed lines of flight. What visual metaphor might embrace these pathways? Create an image or object in a media of your choice and place in your studio or workplace.
5. Review online and book resources for making a simple accordion-style book with pockets. Accordion-style books are used by artists and visual arts practitioners to document and reflect on professional practice (see online or print resources about accordion books). Create an accordion-style book with pockets. Books can range in height and length. Use the accordion-style book to house insights, images, and other artefacts relating to lines of flight, professional goals, and inquiry on practice.

7C Review

Review your written and visual artefacts created in Chapter 7. What impressions do you have? Record your responses in your journal.

7D Share and reflect

Share selected artefacts and insights gained from Chapter 7 with collaborators or colleagues for the purposes of further dialogue and reflection. Summarize your insights and conversations and record in your journal.

Suggested methods and media for this chapter:

Accordion-book making
Data visualization
Illustration
Letter writing
Visual journal
Visual metaphor
Writing

NOTES

1. Processes for mapping using key self-study insights to guide goal setting and map progress are credited to author Sheri R. Klein.
2. The written and visual artefact responses to prompts in Chapter 7 can be archived and revisited at a later date for reflection and mapping progress.

 Conclusion

Self-study is a systematic and highly flexible methodology for reflection on professional practice as it supports dialogic, relational, visual, interpretive, and rhizomatic methods and strategies in all phases of self-inquiry. In this text, a multitheoretical and an integrated model of self-study for visual arts practitioners was explored that focused on the intersections of identity, work culture, change, and envisioning professional practice. Strategies for engaging in arts-based self-study supported the aims to understand professional identity and practice as transdisciplinary, interconnected, dynamic, and complex.

The metaphor of a braided stream that represents the self-study model speaks to the ebb and flow of professional practice, and the intersectional and dynamic qualities of professional identity and practice. The fluctuating nature of professional practice necessitates the pursuit of discernment and clarity that can be achieved through an ongoing visually reflective practice that draws upon multiple ways of thinking and knowing.

Throughout this text, various components and considerations of the self-study model were detailed with a focus on the creation and interpretation self-study written and visual artefacts toward the aim of generating new goals and imagining new lines of flight within professional practice. A variety of end-of-chapter prompts facilitated artistic expressions using diverse materials and methods. A generous number of arts-based and mapping research methods were outlined to assist visual arts practitioners at all levels in observing professional practice, and identifying key themes, issues, questions, and metaphors emerging from the self-study. Methods for reflexivity were explored as a means to gain critical insights and clarity on the process and outcomes of self-study. Finally, methods for determining decision making, goal setting and lines of flight within professional practice were addressed.

The identification of resonating themes of self-study focused on goal setting to propel new learning and professional growth were discussed.

Strategies for creating well-being within professional practice, and caring for one's professional practice, particularly, in times of change, were also discussed as critical factors for maintaining a sustainable professional practice. Finally, the critical roles of professional communities in forming professional identities and sustaining a professional practice were also emphasized throughout the text.

Reaching professional plateaus and achieving high levels of professional engagement and enthusiasm are reasonable outcomes of self-study. The motivations that drive self-study can be diverse—some practitioners may be propelled by unexpected change, dissatisfaction with a current path; yet, others may be propelled by curiosity.

Overall, self-study can capture the highs and lows, the felt conflicts and dissonances, and the ebbs and flows within professional practice. It is a viable way to create a sustainable professional practice that can result in higher states of awareness, greater inner equilibrium, a clearer professional focus, and satisfaction that comes with an examined practice.

With the conclusion of this text, practitioners/readers can decide if the self-study cycle will conclude, or if it will continue. Some practitioners may choose to engage in self-study through individual or collaborative inquiry. Others may choose to explore opportunities to disseminate findings from self-study through exhibitions, publications, blogging, presentations, or performances. Whatever future paths are taken, as a result of the knowledge, wisdom, and insights gained from self-study guided by this text, we hope that visual arts practitioners will feel a greater confidence, clarity, hopefulness, focus, and sense of agency within their professional practice.

Appendices

Appendix 1:
Glossary

academic identity: self-perception and identification associated with academic roles, responsibilities, and activities.

art educator: a term that refers to those who teach art within a public school, private school, art museum, community setting, or postsecondary institution, such as a community college, an art school, or a four-year university.

artefact: a written, visual, or intertextual response generated in the context of self-study.

artistic identity: self-perception and identification associated with having a sustained engagement in an artistic practice and the creation of artistic works; those who identify with an artistic professional practice and connections to artistic communities of practice.

artistic media: art, digital, mixed media, and/or other materials used in the creation of an artistic work.

artistic methods: a combination of artistic media and techniques used in the creation of an artistic work.

artistic techniques: processes used to create an artistic work.

arts-based research: a form of research where artistic methods and the creation of artistic works are central to the inquiry.

authenticity: a quality of research achieved through attention to truthfulness.

bicultural identity: self-identification with at least two cultures.

border theory: a theory that illuminates the identities of professionals who cross geographical, social, and cultural borders and/or who may live and work in cultures that vary differently from their life experience.

collage mapping: a research method that utilizes the juxtaposition of drawing, photographs, and text for the purposes of creating new meaning.

collective identity: a group identity that is formed and associated through shared goals, resources, and aspirations.

communal identity: an identity that is shaped by a group.

concept mapping: a visual research method to elicit nonlinear and relational aspects of self-study insights and findings; can be used in all phases of self-study.

cultural identity: a self-identification with a particular cultural group or groups.

digital media: includes the use of text, graphics, audio, and/or visual that is shared through websites, blogs, and/or other social media.

ethics: personal and professional codes and principles that guide researcher conduct.

group cohesion: fostered through the creation of work spaces and cultures that embrace a pluralistic attitude, resulting in positive interrelationships, a sense of belonging, and a work culture of trust and respect.

hermeneutical mapping: a visual research method that focuses on the interpretation of text(s) through visualization, writing, and dialogue about the text(s).

hermeneutical research: a form of research that explores a phenomenon of the lived experience using relational and dialogic methods.

hybrid identity: an identity consisting of two or more distinct professional identities with a value or importance placed through the sequencing.

identity dissonance: occurs when professional roles and identities are not congruent with personal values.

image ethics: concerned with how images are presented and acknowledged in public forums, such as publications, presentations, and in social media.

informed consent: the receipt of permission from others to share their self-image, names or personal information with researcher and others.

integrated self-study model: a theoretically grounded and integrated framework for the purposes of self-study and reflection on the intersecting areas of professional practice through multiple ways of knowing and thinking.

integrated thinking process: a range of thinking processes that allow for divergent, qualitative, interpretive, and reflexive thinking.

interpretation: a process within self-study that involves closely looking at self-study artefacts using various methods and processes with the aim to reveal meanings.

intersectionality theory: relative to identity, it is a broadly applied theory that considers the intersections of multiple personal, social, and cultural factors shaping identity and professional practice.

mapping: a visual research methods process to interpret meanings of self-study artefacts that allows for seeing patterns and relationships within and across artefacts.

mentoring: guided interactions by an experienced professional intended to advise and support a novice, or peer professional in professional growth.

mind maps: a nonhierarchical diagram of connecting lines to depict associations between various topics.

narrative mapping: an interpretive research method that combines figurative and landscape elements, metaphorical imagery, color, and visual texture to explore the emotional tones of research phenomenon and the research process.

new media: refers to a genre that relies on technology for creation and distribution.

organizational climate: shared perceptions of how an organization feels to participants based upon its formal and informal organizational practices.

overlapping identity: two or more personal or professional identities that are simultaneously experienced.

personal identity: identity that is shaped by an individual's personality, character traits, goals, and values.

poetic method: the process of using the language from research texts in a poetic form such as, haiku, free verse, or other experimental poetic forms.

professional identity: central to the core of professional practice; is shaped by numerous intersectional personal, social, and cultural factors such as, gender, race, social class, age, exceptionality, religion, and other factors; created in the context of professional roles and sites of practice.

professional practice: refers to the conduct and work of an individual identifying with a particular profession that requires a prolonged period of education and training; can be composed of multiple and intersecting areas of practice.

qualitative thinking: poetic, metaphorical, and/or visual thinking with the aim to enhance connections and understandings about patterns and relationships.

reflective practice: a disciplined and systematic inquiry engaging intuitive and analytical processes for inquiring about professional practice.

reflexivity: a process within self-study or professional practice for examining biases, values, assumptions, and relationships.

research methodology: an approach to research that is connected to a specific theoretical framework, such as, self-study.

rhizomes: plant growths characterized by lateral shoots and with offshoots that can grow in any direction.

rigor: a quality of research achieved through immersion in the research processes.

self-study: a research methodology that enables a systematic and integrated inquiry into questions related to professional practice.

social identity: created between individuals, environments, and social institutions and the attachment of individuals to social groups.

sustainable professional practice: a professional practice that adjusts to change and is flexible and resilient.

threatened identity: the interruption of a coherent and continuous personal, social, or professional identity.

transferability: a term used to describe how research conclusions could be generalized or applicable to other research contexts or studies.

triangulation: a process used in the interpretation phase of research that can assist in identifying areas that may have been overlooked; it can bring clarity to puzzling, contradictory, or surprising issues or findings.

transnational identity: self-identification with geographical locations that are different from a place of origin.

trustworthiness: a quality of research achieved through the care of sensitive content and a careful detailing of the research process.

visual arts practitioners: professionals who have education, training, and/or work experiences in the visual arts; assume a role or position affiliated with the visual arts, such as studio artist, educator, researcher, writer, entrepreneur, therapist, community activist, curator, and/or administrator; practitioner who may be juggling multiple and overlapping professional identities associated with the visual arts.

visual essay: an exploration of a topic where the visual is an integral component; uses a sequencing or group of photographs and/or other images with a short essay.

visual journal: a sketchbook or folio used in self-study to explore questions about professional practice and to create visual artefacts using arts-based media and images and writing.

visual reflection: describes a process of exploring questions related to professional practice using visual methods and artistic media to facilitate reflection.

visually reflective practice: an approach for reflection on professional practice that utilizes artistic materials and arts-based methods in the creation of a variety of images, objects, visual journals, or other works.

workplace: an organizational structure that functions as a space for individuals and groups to achieve individual and collective goals, and to enact roles and responsibilities in a dynamic interplay between individual and group identities.

workplace climate: the tone or feel of a workplace relative to its capacity to feel welcoming, safe, and inclusive.

workplace culture: composed of an organization's values, mission and goals, policies, leadership, and the perceptions of workplace participants.

Appendix 2:
Guidelines for Writing Self-Study Reflections

These guidelines and criteria serve to guide the writing and assessment of written reflections to end-of-chapter prompts created for the purposes of self-study.

EVIDENCE(s)	High 3	Some 2	Low 1
Evidence that demonstrates an understanding of chapter concepts and theories			
Evidence of reflexivity, critical self-awareness, and examination			
Evidence of inclusivity and multiple thinking processes			
Evidence of experimentation with writing formats			
Evidence of ethics: citation of sources and references	YES NO		

Understanding: Does the written response reveal an understanding of chapter concepts, themes, and theories?

Reflexivity: Does the written response reveal a critical self-awareness about self, professional issues, and practice? How do the written responses examine values, biases, assumptions, relationships, and the perspectives of others?

Inclusivity: Does the written response provide evidence of the processes of brainstorming, observation, analysis, and intuition?

Experimentation: Does the written response embrace experimentation with writing formats (as appropriate to the prompts), such as essay, found poetry, visual poetry narrative, or other writing formats?

Ethics: Some responses may include the use of others' ideas (words, quotes, or paraphrasing) and would require a citation of the source or reference. If applicable, are appropriate sources included?

Appendix 3:
Guidelines for Self-Study Visual Artefacts

These guidelines and criteria serve as a guide and assessment tool for the purposes of determining the quality of visual artefacts created in the context of self-study.

EVIDENCE(s)	High 3	Some 2	Low 1
Evidence of exploration with artistic materials, media, and techniques			
Evidence of investment and care in creating images			
Clear connections to chapter issues			
Evidence of evocative and compelling artistic works			
Evidence of a unique and personal response			

Exploration: Have artistic media, materials, and techniques been explored?
Care: Is the work created with care, and does it show some investment of time?
Connections: How does the artefact connect to the chapter prompt?
Evocative: Are the works compelling, engaging, and revealing?
Uniqueness: How is the visual artefact unique and personal?

Appendix 4:
Creating and Using a Visual Journal for Self-Study

Purposes of the visual journal for self-study[1]

To provide a space for the creation and preservation of visual artefacts created in the context of self-study that includes:

- written responses to end-of-chapter prompts
- two-dimensional visual responses to end-of-chapter prompts
- impressions and notes from the interpretation and goal-setting phases.

Considerations for creating a visual journal

The following are some considerations for using a visual journal in the context of a self-study:

Selecting a journal format

Sources: There are numerous commercial sketchbooks available on the market produced by a number of well-known producers of art materials. You can purchase online or through local art suppliers.

Size/Kind: Typically, sketchbooks come in standard sizes: 5 x 7 inches, 8.5 x 11 inches, 8 x 12 inches, 11 x 14 inches and larger.

Sketchbooks have wire binding or a sewn binding. Depending on the size and kind, sketchbooks can range from 22 to 64 pages. Some sketchbook formats are 'portrait' style (vertical), and some 'landscape' style (horizontal).

For the purposes of visual journaling, and relevant to responding to prompts in this text, a *mixed media sketchbook* is recommended (either wire or sewn binding) that is no smaller than 8 x 10 inches, and that has a heavy weight paper, such as 140 lb. watercolor paper. Several journals may be needed.

The watercolor paper is often textured to absorb various water-based media, such as watercolors, gouache, acrylics as well as pencils, ink, markers, pastels, and collage.

Note: Sketchbooks with drawing paper are best for using dry media, such as pencils, colored pencils, charcoals, and fine markers.

Gathering art materials

The following is a suggested, but not exhaustive, list of the kind of art materials for visual journaling:

- paints: water based (acrylic, watercolor; a variety of colors)
- brushes: a variety pack of brushes (natural and synthetic; round, flat, small detail brushes; glue brush)
- pencils (hard and soft)
- colored pencils
- chalk pastels (note: this will require a fixative so surfaces are sealed)
- oil pastels
- black ink
- marker pens in various widths
- calligraphy pens
- scissors
- tape
- glue sticks or other nontoxic adhesives
- ruler
- erasers
- a variety of stencils (letters, numbers, and shapes).

Gathering collage materials

The following is a suggested list of sources for imagery and text for the purposes of collage in a visual journal. Many collage materials can be recycled from paper materials and books found in used bookstores, flea markets, second-hand, or antique stores:

- magazines
- auction catalogs (for images of paintings, objects, antiques, etc.).

- newspapers
- calendars
- postcards
- greeting cards
- decorative papers
- postage stamps
- maps
- out-of-date phone books
- out-of-date encyclopedias (from rummage sales, library sales, or second-hand stores)
- old letters
- clothing tags
- old receipts
- junk mail catalogs.

Beginning the journal

Creating the first page: This is the title page. Title your page and note the year.
Numbering the pages: Using pencil, go through the sketchbook and at the top right corner of each page, write the page number in pencil.

Unifying the pages/creating visual texture

Beginning with title page: Select a painting medium of your choice, and create a background wash for each page of your sketchbook. You will be adding various elements to these pages later. The purpose of creating a wash on each page is to create a *unifying look* through *visual texture*.

- *To create a wash:*
 Dilute paint with water and using a wide brush, create thin washes of color onto a page for a gradation of color effect. You can place washes of light color over a dark wash, or a dark wash over a light wash of color.
- *To add visual texture to pages:*
 Add patterns using stencils and/or mark making (dots, lines, or other shapes using drawing or painting tools)
 Add collage elements by layering or overlapping papers onto the sketchbook page using a glue or water-based gel medium adhesive.
 Create decorative papers by making your own patterns and designs that can be used in collage.

Consider varying compositional formats

How many pages to use per prompt? Some responses to prompts can utilize single pages or multiple pages. Some responses may require more pages than others.
Looking across the visual journal: Consider the principles of variety, balance, and unity as the journal evolves over time. Review the journal periodically to see how it can be enhanced visually using artistic media.

NOTE

1. For interpreting the visual journal as a data source, see outlined methods in Chapter 6.

Appendix 5:
Considerations: Basic Media Supplies and Materials for Self-Study

Adhesives: For use in collage; nontoxic glue sticks or adhesives that may be applied with a brush.

Brushes: Brushes come in many shapes, sizes and materials—from natural bristles (squirrel, sable, etc.) to synthetic. An assorted group of *synthetic* brushes are recommended for two-dimensional works that include the following: *flat brushes* for spreading paint efficiently; *round brushes* for details or creating linear elements; *angle brushes* for painting geometric shapes; *filberts* (flat brushes with round ends) for painting circular shapes. Larger flat brushes can be used for covering larger surfaces, such as canvases, or boards. Brushes range in sizes from 20/0 (very small brushes for minute details) to size 20 and up (large). In using watercolor, you might want to consider purchasing a few sable hairbrushes.

Canvas: Canvas is a surface for painting and can be used raw or covered with a layer of primer or gesso. Canvas comes in rolls for making customized size canvases. Canvases are also prestretched in multiple shapes (rectangles and squares) and sizes (from mini sizes to several feet) for convenience.

Collage papers: There are many kinds of art papers on the market. Smooth surface papers such as Bristol board are good surfaces for collage. Watercolor paper is excellent for any water-based media such as, watercolors, gouache, acrylics as well as ink and mixed media. Drawing paper is typically lightweight and is best for using dry media such as, pencils, colored pencils, charcoals, and fine markers. Printmaking papers are often used for drawing and collage surfaces.

Decorative papers such as marbled papers and paste papers used in book arts make interesting collage accents. Handmade decorative papers can be made using tempera paints and ink, making patterns with brushes or using stencils. These papers can be ripped or cut to use in borders or as collage elements.

Computer: Laptop for researching; editing video; scanning images.

Digital camera: For documenting artefacts and video recording performances.

Fixatives: to secure sketchbook paper surfaces when using chalk pastels or charcoal; to be used with adequate ventilation.

Markers: There are numerous kinds of markers: black (from micro-thin to thick) to calligraphy markers (in varying widths) for lettering, and colored markers in numerous widths and values. A set of colored markers (24+) is recommended with a small set of micro black markers for writing and detailing.

Misc. supplies: Erasers, masking tape, sponges, paper towels, and scissors.

Pastels: Chalk pastels are widely used in two-dimensional artworks. There are several grades of pastels; the more expensive pastels are softer with more pigment and yield a richer tone. The purchase of a mid-range pastel (not a student grade/brand) set is recommended; even with the basic colors of red, yellow, blue, white, and black, you can blend colors on the page. If you are interested in a wider range of colors, a larger set is recommended. Oil pastels can be blended and used with watercolor paint as a resist technique.

Pencils: Pencils also have a wide range: from hard to soft, and from graphite to colored pencils. It is recommended that you have a few hard pencils, soft graphite pencils, a charcoal pencil (great for smudging) and a set of medium price range (not a student grade/brand) colored pencils. There are also watercolor pencils that will blend with water.

Printer/Scanner: For printing out hardcopies of written artefacts during interpretation.

Sculpture materials: Air drying clay, paper pulp, and other nontoxic materials for creating artefacts.

Water-based media: Drawing inks (variety of colors), watercolor, gouache, tempera, and acrylic are all water-based media that can be used. These come in many colors, sizes, and brands. Try experimenting with colored inks as well as with black to create lovely effects. Watercolor paint can be purchased in individual tubes or sets. Acrylic paint can be purchased in small bottles for easy storage.

References

Adams, Jeff and Arya-Manesh, Emma (2019), "Transformative intervention: Creative practice in an education doctorate programme," in A. Sinner, R. L. Irwin, and J. Adams (eds.), *Provoking the Field: International Perspectives on Visual Arts PhDs in Education*, Bristol: Intellect, pp. 37–44.

Akhtar, Salman (1999), *Immigration and Identity: Turmoil, Treatment and Transformation*, London: Jason Aronson Publisher.

Akkerman, Sanne and Meijer, Poulien (2011), "A dialogical approach to conceptualizing teacher identity," *Teaching and Teacher Education*, 27:2, pp. 308–19.

Allen, Alexandra (2019), "Intersecting arts based research and disability studies," *Journal of Curriculum Theorizing*, 34:1, pp. 72–82.

Allen, Alexendra (2020), "Using arts-based research to understand the sociocultural facets of having invisible disabilities in a normative society," *International Journal of Education through Art*, 16:1, pp. 101–14.

Alsup, Janet (2006), *Teacher Identity Discourses*, Abingdon: Routledge.

Altman, Irwin and Low, Setha (eds.) (1992), "Temporal aspects of place attachment," *Place Attachment*, New York: Plenum, pp. 7–8.

American Disabilities Act (ADA) (1990), https://adata.org/faq/what-definition-disability-under-ada. Accessed August 8, 2019.

Anderson, Constance (1981), "The identity crisis of the art educator: Artist? teacher? both?" *Art Education*, 34:4, pp. 45–46.

Anzaldúa, Gloria (2012), *Borderlands/La Frontera: The New Mestiza*, 4th ed., San Francisco: Aunt Lute.

Artz, Benjamin (2012), "Does the impact of union experience on job satisfaction differ by gender?" *ILR Review*, 65:2, pp. 225–43.

Ashforth, Blake and Mael, Fred (1989), "Social identity: Theory and the organization," *Academy of Management Review*, 14:1, pp. 20–39.

Atchley, Robert (1976), *The Sociology of Retirement*, New York: John Wiley.

Atewologun, Doyin (2018), "Intersectionality theory and practice," *Oxford Encyclopedia, Business and Management*, https://oxfordre.com/business/view/10.1093/acrefore/9780190224851.001.0001/acrefore-9780190224851-e-48?rskey=yb7VEW&result=1. Accessed August 6, 2019.

Au, Wagner James (2008), *The Making of Second Life: Notes from the New World*, New York: HarperCollins.

Bachelard, Gaston (1994), *Poetics of Space*, Boston: Beacon Press.

Badenhorst, Cecile, McLeod, Heather, and Toll, Haley (2019), "Beyond words: Academic writing identities and imaginative (artistic selves)," *Visual Inquiry*, 7:3, pp. 197–212.

Bagnoli, Anna (2009), "Beyond the standard interview: The use of graphic elicitation and arts-based methods," *Qualitative Research*, 9:5, pp. 547–70.

Baltes, Boris and Finkelstein, Lisa (2011), "Contemporary empirical advancements in the study of aging in the workplace," *Journal of Organizational Behavior*, 32, pp. 151–54.

Banks, Marcus (2015), *Visual Methods in Social Research*, 2nd ed., London: Sage.

Barbaezat, Daniel and Bush, Mirabai (eds.) (2014), *Contemplative Practices in Higher Education*, San Francisco: Jossey-Bass.

Barner, Robert (2011), "Applying visual metaphors to career transitions," *Journal of Career Development*, 38:1, pp. 89–106.

Barney Dews, Carlos and Law, Carolyn (1995) (eds.), *This Fine Place So Far from Home: Voices of Academics from the Working Class*, Philadelphia: Temple University Press.

Barney, Daniel, Hoiland, Christensen, and Mae, Ashley (2012), "Billboard poetry project," *International Journal of Education through Art*, 8:3, pp. 337–48.

Barone, Tom (2003), "Challenging the educational imagery: Issues of form, substance, and quality in film-based research," *Qualitative Inquiry*, 9:2, pp. 202–17.

Barone, Tom and Eisner, Elliot (2012), *Arts Based Research*, Thousand Oaks: Sage.

Barron, Gill (2014), *Compendium of Acrylic Painting Techniques*, Kent: Search Press.

Bateson, Mary Catherine (2001), *Composing a Life*, New York: Grove/Atlantic.

Bayles, David and Orland, Ted (1993), *Art and Fear: Observations on the Perils (and Rewards) of Artmaking*, St. Paul: The Image Continuum Press.

Becher, Ayelet and Orland-Barak, Lily (2018), "Context matters: Contextual factors informing mentoring in art initial teacher education," *Journal of Teacher Education*, 69:4, pp. 477–92.

Becker, Howard (1964), "Change in adult life," *Sociometry*, 27:1, pp. 40–53.

Beijaard, Douve, Meijer, Pauline, and Verloop, Nico (2004), "Reconsidering research on teachers' professional identity," *Teaching and Teacher Education*, 20, pp. 107–28.

Bell, Beverley and Miraglia, Kathy Marzilli (2003), "Mayday! Mayday! Heeding the urgent call from novice teachers," *ASCD Educational Leadership*, 6:9, http://www.ascd.org/publications/classroom-leadership/jun2003/Mayday!-Mayday!.aspx. Accessed July 3, 2019.

Beltman, Susan, Glass, Christine, Dinham, Judith, Chalk, Beryl, and Nguyen Bich (2015), "Drawing identity: Beginning pre-service teacher's professional identities," *Issues in Educational Research*, 25:3, pp. 225–45.

Bennett, Dawn (2013), "The use of learner-generated drawings in the development of music students' teacher identities," *International Journal of Music Education*, 31:1, pp. 53–67. http://dx.doi.org/10.1177/0255761411434498.

Ben-Yehoshua, Naama Sabar (2009), "Teachers' self study: Identity and the qualitative paradigm," in H. Ezer (ed.), *Self-Study Approaches and the Teacher-Inquirer*, Rotterdam: Sense Publishers, pp. ix–xii.

Berger, Peter (1963), *Invitation to Sociology*, New York: Doubleday.

Berk, Sara Beth (2015), "The ABC's of art teacher professional identity: An a/r/tographic investigation into the interstitial spaces," Ph.D. thesis, Denver: University of Denver.

Berman, Adam (2018), "Social security feels pinch as baby boomers clock out for good," https://www.forbes.com/sites/greatspeculations/2018/06/21/social-security-feels-pinch-as-baby-boomers-clock-out-for-good/#480580d74995. Accessed August 5, 2019.

Bernstein, Susan Naomi, Green, Ann, and Ready, Cecilia (2001), "Off the radar screen: Gender, adjuncting, and teaching institutions," *College Composition and Communication*, 53:1, pp. 149–52.

Berry, Jill (2011), *Personal Geographies: Explorations in Mixed-Media Mapmaking*, Cincinnati: North Light Books.

Biggs, Michael and Karlson, Henrik (2011), "Evaluating quality in artistic research," in M. Biggs and H. Karlsson (eds.), *The Routledge Companion to Research in the Arts*, Abington: Routledge, pp. 405–24.

Bonasio, Alice (2018), "Exploring digital identity through avatars," https://thenextweb.com/contributors/2018/06/11/exploring-digital-identity-through-avatars/. Accessed June 11, 2020.

Booysen, Lize (2018), "Workplace identity construction: An intersectional-identity cultural lens," *Oxford Encyclopedia, Business and Management*, https://oxfordre.com/business/view/10.1093/acrefore/9780190224851.001.0001/acrefore978019. Accessed June 4, 2019.

Bosch, Ernst (1996), "Rhizomatic Painting," https://www.cokunst.nl/files/media/book_ernst_bosch_rhizomatic_painting.pdf. Accessed January 5, 2021.

Boud, David (2001), "Using journal writing to enhance reflective practice," *New Directions in Adult and Continuing Education*, 90, pp. 9–18.

Brady, Ivan (2009), "Foreword," in M. Prendergast, C. Leggo, and P. Sameshima (eds.), *Poetic Inquiry: Vibrant Voices in the Social Sciences*, Netherlands: Sense, pp. xi–xvi.

Brandenburg, Robyn and McDonough, Sharon (2019), "Ethics, self-study research methodology and teacher education," in R. Brandenburg and S. McDonough (eds.), *Ethics, Self-Study Research Methodology and Teacher Education: Self-Study of Teaching and Teacher Education Practices,* 20, Singapore: Springer, pp. 1–14.

Bransford, John and Stein, Barry (1984), *The IDEAL Problem Solver*, New York: W. H. Freeman.

Breakwell, Glynis (1986), *Coping with Threatened Identities*, London: Methuen.

Bresler, Liora (2006), "Toward connecting aesthetic based research," *Studies in Art Education*, 48:1, pp. 52–69.

Bresler, Liora (ed.) (2007), *International Handbook of Research in Arts Education*, Netherlands: Springer.

Brokaw, Tom (2001), *The Greatest Generation*, New York: Random House.

Brueggemann, Brenda Jo, Hetrick, Nicholas Yergeau, Melanie, and Brewer, Elizabeth (2012), "Current issues, controversies, and solutions," in B. J. Brueggemann (ed.), *Arts and Humanities*, Thousand Oaks: Sage, pp. 63–98.

Brygola, Elwira (2011), "The threatened identity: An empirical study," *Psychology of Language and Communication*, 15:1, pp. 63–88.

Burke, Peter and Stets, Jan (2009), *Identity Theory*, New York: Oxford University Press.

Burns, Crosby, Barton, Kimberly, and Kerby, Sophia (2012), *Brief: The State of Diversity in Today's Workforce: As Our Nation Becomes More Diverse So Too Does Our Workforce*, Washington, DC: Center for American Progress, https://www.americanprogress.org/issues/economy/reports/2012/07/12/11938/the-state-of-diversity-in-todays-workforce/. Accessed July 7, 2019.

Burton, Judith, Horowitz, Robert, and Abeles, Hal (2000), "Learning in and through the arts: The question of transfer," *Studies in Art Education*, 41:3, pp. 228–57.

Butler-Kisber, Lynn (2007), "Collage in qualitative inquiry," in G. Knowles and A. Cole (eds.), *Handbook of the Arts in Social Science Research*, Thousand Oaks: Sage, pp. 265–78.

Butler-Kisber, Lynn (2008), "Collage as inquiry," in G. Knowles and A. Cole (eds.), *Handbook of the Arts in Qualitative Research*, Thousand Oaks: Sage, pp. 265–76.

Butler-Kisber, Lynn (2010), *Qualitative Inquiry: Thematic, Narrative and Arts-Informed Perspectives*, Los Angeles: Sage.

Butler-Kisber, Lynn and Poldma, Tiiu (2010), "The power of visual approaches in qualitative inquiry: The use of collage making and concept mapping in experiential research," *Journal of Research Practice*, 6:2, Article M18, http://jrp.icaap.org/index.php/jrp/article/view/197/196. Accessed April 28, 2020.

Buzan, Tony (2018), *Mind Map Mastery: The Complete Guide to Learning and Using the Most Powerful Thinking Tool in the Universe*, London: Watkins.

Byers, Julia and Forinash, Michele (eds.) (2004), *Educators, Therapists, and Artists on Reflective Practice*, Lesley College Series in Arts and Education, New York: Peter Lang.

Cahnmann-Taylor, Melissa (2009), "The craft, practice and possibility of poetry in educational research," in M. Prendergast, C. Leggo, and P. Sameshima (eds.), *Poetic Inquiry: Vibrant Voices in the Social Sciences*, Netherlands: Sense, pp. 13–31.

Cahnmann-Taylor, Melissa and Siegesmund, Richard (eds.) (2017), *Arts-Based Research in Education: Foundation for Practice*, 2nd ed., New York: Routledge.

Cancierre, Mary Beth and Snowber, Celeste (2009), "Writing rhythm: Movement as method," in P. Leavy (ed.), *Method Meets Art: Arts Based Research Practice*, New York: Guilford, pp. 198–214.

Canrinus, Esther, Helms-Lorenz, Michelle, Beijaard, Douwe, Buitink, Jaap, and Hofman, Adriaan (2012), "Self-efficacy, job satisfaction, motivation, and commitment: Exploring relationships between indicators of teachers' professional identity," *European Journal of Psychology of Education*, 27, pp. 115–32.

Capous-Desyllas, Moshoula and Morgaine, Karen (eds.) (2017), *Creating Social Change through Creativity: Anti-Oppressive Arts-Based Research Methodologies*, Switzerland: Springer International.

Carroll, Brigid, Ford, Jackie, and Taylor, Scott (2015), *Leadership: Contemporary Critical Perspective*, Thousand Oaks: Sage.

Carter, Mindy (2014), *Teacher Monologues: Exploring the Identities and Experiences of Artists Teachers*, Rotterdam: Sense Publishers.

Caza, Brianna and Creary, Stephanie (2016), "The construction of professional identity," http://scholarship.sha.cornell.edu/articles/878. Accessed March 4, 2020.

Charney, Renee (2017), "Rhizomatic learning and adapting: A case study exploring an interprofessional team's lived experiences," Ph.D. thesis, Ohio: Antioch University.

Chávez, Alicia Fedelina and Guido-DiBrito, Florence (1999), "Racial and ethnic identity and development," *New Directions in Adult and Continuing Education*, 84, San Francisco: Jossey-Bass, pp. 39–47.

Chen, Jo Chiung Hua (2019), "To reach the unreached: Rhythms of issues, reflections, writings and art practices," in A. Sinner, R. L. Irwin, and J. Adams (eds.), *Provoking the Field: International Perspectives on Visual Arts PhDs in Education*, Bristol: Intellect, pp. 123–42.

Chilton, Gioia and Leavy, Patricia (2014), "Arts based research practice: Merging social research and the creative arts," in P. Leavy (ed.), *The Oxford Handbook of Qualitative Research*, Oxford: Oxford University Press, pp. 403–22.

Chödrön, Pema (2002), *Comfortable with Uncertainty*, Boston: Shambala.

Clark, Shawn, Gioia, Dennis, Ketchen, David, and Thomas, James (2010), "Transitional identity as a facilitator of organizational change during a merger," *Administrative Science Quarterly*, 55:3, pp. 395–438.

Clarke, Marie, Hyde, Abbey, and Drennan, Jonathan (2013), "Professional identity in higher education," in B. M. Kehm and U. Teichler (eds.), *The Academic Profession in Europe: New Tasks and New Challenges*, London: Springer, pp. 7–20.

Cohen-Evron, Nurit (2001), "Beginning art teacher negotiation of their beliefs and identity within the reality of public schools," Ph.D. thesis, Columbus: The Ohio State University.

Cohen-Evron, Nurit (2002), "Why do good art teachers find it hard to stay in the public school system?" *Studies in Art Education*, 44:1, pp. 79–94.

Collins, Patricia Hill (2015), "Mapping the margins: Intersectionality, identity politics, and violence against women of color," *Stanford Law Review*, 43:6, pp. 1241–99.

Compton, Martin and Tran, Danielle (2017), "Liminal space or in limbo?: Post graduate researchers and their personal pie charts of identity," *Compass: Journal of Learning and Teaching*, 10:4, pp. 1–14.

Connell, Raewyn W. and Messerschmidt, James (2005), "Hegemonic masculinity: Rethinking the concept," *Gender and Society*, 19:6, pp. 829–59.

Connelly, Michael and Clandinin, Jean (1999), "Shaping a professional identity: Stories of education practice," *McGill Journal of Education*, 24:2, pp. 189–91.

Cooperrider, David and Whitney, Diana (2005), *Appreciative Inquiry: A Positive Revolution in Change*, San Francisco: Berrett-Koehler Publishers.

Copeland, Andrea and Agosto, Denise (2012), "Diagrams and relational maps: The use of graphic elicitation techniques with interviewing for data collection, analysis, and display," *International Journal of Qualitative Methods*, 11:5, pp. 513–33.

Cornelissen, Judith and van Wyk, A. S. (2007), "Professional socialisation: An influence on professional development and role definition," *South African Journal of Higher Education*, 21:7, pp. 826–41.

Cornell, Stephen and Hartmann, Douglas (2007), *Ethnicity and Race: Making Identities in a Changing World*, Thousand Oaks: Pine Forge Press.

Costantino, Tracie (2010), "The critical relevance of aesthetic experience for 21st century art education: The role of wonder," in T. Costantino and B. White (eds.), *Essays on Aesthetic Education for the 21st Century*, Rotterdam: Sense, pp. 63–77.

Costantino, Traci (2015), "A qualitative study of aesthetic reflection as embodied interpretation," in A. Scarinzi (ed.), *Aesthetics and the Embodied Mind: Beyond Art Theory and the Cartesian Mind-Body Dichotomy*, London: Springer, pp. 191–210.

Costello, Carrie Yang (2004), "Changing clothes: Gender inequality and professional socialization," *NWSA Journal*, 16:2, pp. 138–55.

Costello, Carrie Yang (2006), "Who are you?" *Professional Identity Crisis: Race, Class, Gender and Success in Professional Schools*, pp. 17–34.

Cousin, Glynis (2010), "Positioning positionality: The reflexive turn," in M. Savin-Baden and C. Howell-Major (eds.), *New Approaches to Qualitative Research: Wisdom and Uncertainty*, London: Taylor & Francis, pp. 9–17.

Creativity Connects: Trends and Conditions Affecting US Artists (2016), Los Angeles: Center for Cultural Innovation.

Crenshaw, Kimberlé (1989), "Demarginalizing the intersections of race and sex: A black feminist critique of antidiscrimination doctrine, feminist theory, and antiracist politics," *University of Chicago Legal Forum*, 139.

Crenshaw, Kimberlé (1991), "Mapping the margins: Intersectionality, identity politics, and violence against women of color," *Stanford Law Review*, 43:6, pp. 1241–99.

Crenshaw, Kimberlé (2010), "Close encounters of three kinds: On teaching dominance feminism and intersectionality," *Tulsa Law Review*, 46:151, pp. 151–89.

Creswell, John, Hanson, William, Clark, Vicki, Plano, Clark, and Morales, Alexjandro (2007), "Qualitative research designs: Selection and implementation," *The Counseling Psychologist*, 35, https://dx.doi.org/10.1177/0011000006287390.

Cuddy, Amy and Fiske, Susan (2002), "Duddering but dear: Process, content, and function in stereotyping of older persons," in T. Nelson (ed.), *Ageism: Stereotyping and Prejudice Against Older Persons*, Massachusetts: MIT Press, pp. 3–26.

Cunningham, Shelly (1999), "The nature of workplace mentoring relationships among faculty members in Christian higher education," *Journal of Higher Education*, 70:4, pp. 441–63.

Daichendt, G. James (2010), *Artist Teacher: A Philosophy for Creating and Teaching*, Chicago: Intellect Books.

Daichendt, G. James (2014), *Artist-scholar: Reflections on Writing and Research*, Bristol: Intellect.

Daley, Barbara (2004), "Using concept maps in qualitative research," in A. J. Cañas, J. D. Novak, and F. M. González (eds.), *Proceedings of the First International Conference on Concept Mapping*, Universidad Publica de Navarra, September 14–17, Pamplona: Dirección de Publicaciones de la Universidad Pública de Navarra, pp.191–98.

Dalton, Jane (2019), "Lectio Divina and meditation: Exploring identity through contemplative practices," *Visual Inquiry*, 7:3, pp. 251–56.

Damasio, Antonio (1994), *Descartes Error: Emotion, Reason and the Human Brain*, New York: Penguin.

Dancy, Elton (2010), "Faith in the unseen: The intersection(s) of spirituality and identity among African American males in college," *Journal of Negro Education*, 79:3, pp. 416–32.

Daniels, L. G. (2002), "The relationship between counselor licensure and aspects of empowerment," *Journal of Mental Health Counseling*, 24:3, pp. 213–23.

Davis, Jessica Hoffman (2005), *Framing Education as Art*, New York: Teachers College Press.

Day, Christopher and Kington, Alison (2008), "Identity, well-being and effectiveness: The emotional contexts of teaching," *Pedagogy, Culture & Society*, 16:1, pp. 7–23.

D'Cruz, Heather, Gillingham, Philip, and Melendez, Sebastian (2007), "Reflexivity, its meanings and relevance for social work: A critical review of the literature," *British Journal of Social Work*, 37:1, pp. 73–90.

de Freitas, Elizabeth (2012), "The classroom as rhizome: New strategies for diagramming knotted interactions," *Qualitative Inquiry*, 18:7, pp. 588–601.

de Landa, Manuel (1997), *A Thousand Years of Non-Linear History*, New York: Zone.

Deaver, Sarah and McAuliffe, Garrett (2009), "Reflective visual journaling during art therapy and counseling internships: A qualitative study," *Reflective Practice*, 10:5, pp. 615–32.

Deem, Rosemary (2006), "Changing research perspectives on the management of higher education: Can research permeate the activities of manager-academics?" *Higher Education Quarterly*, 60:3, pp. 203–28.

Deleuze, Gilles and Guattari, Felix (1987), *A Thousand Plateaus: Capitalism and Schizophrenia* (trans. Brian Mussami), Minneapolis: University of Minnesota Press.

Denzin, Norman and Lincoln, Yvonna (eds.) (2017), *Handbook on Qualitative Research*, 5th ed., Thousand Oaks: Sage.

Depasquale, John (2016), "Blackout poetry," https://www.scholastic.com/teachers/blog-posts/john-depasquale/blackout-poetry/. Accessed April 16, 2020.

Derby, John (2012), "Art education and disability studies," *Disability Studies Quarterly*, 32:1, https://dsq-sds.org/article/view/3027/3054. Accessed April 16, 2020.

Derby, John (2013), "Nothing about us without us: Art education's disservice to disabled people," *Studies in Art Education*, 54:4, pp. 376–80.

Desai, Dipti (2003), "Multicultural art education and the heterosexual imagination: A question of culture," *Studies in Art Education*, 44:2, pp. 147–61.

DeWeerdt, Sven Bouwen, Rene, Corthous, Felix, and Martens, Hilda (2007), "Identity transformations as an intercontextual process," *Industry and Higher Education*, 20:5, pp. 317–96.

Dewey, John (1933), *How We Think: A Restatement of the Relation of Reflective Thinking to the Educative Process*, Boston: Heath.

di Leonardo, Micaela (1985), "Women's work, work culture, and consciousness," *Feminist Studies*, 11:3, pp. 490–96.

Dicker, Rory and Piepmeier, Alison (2003), *Catching a Wave: Reclaiming Feminism for the 21st Century*, Lebanon: Northeastern University Press.

Dill, Bonnie Thorton (2009), "Intersections," *Ms.*, 19:2, pp. 65–66.

Dillabough, Jo-Anne (1999), "Gender politics and conceptions of the modern teacher: Women, identity and professionalism," *British Journal of Sociology of Education*, 20:3, pp. 373–94.

Dirkx, John (2012), "Nurturing soulwork: A Jungian approach to transformative learning," in E. Taylor and P. Cranton (eds.), *Handbook of Transformative Learning: Theory and Research*, San Francisco: Jossey-Bass, pp. 116–30.

Disik, Alina (2017), "The downside of limitless career options," June 26, http://www.bbc.com/capital/story/20170626-the-downside-of-limitless-career-options. Accessed August 14, 2019.

Dissanayake, Ellen (1995), "The core of art: Making special," in E. Dissanayake (ed.), *Homo Aesetheticus: Where Art Came from and Why*, Seattle: University of Washington Press.

Duffy, Peter (ed.) (2015), *A Reflective Practitioner's Guide to (Mis)adventures in Drama Education—or—What Was I Thinking?*, Bristol: Intellect.

Dundon, Elaine (2002), *Seeds of Innovation: Cultivating the Synergy that Fosters New Ideas*, New York: American Management Association.

Dykins-Callahan, Sara (2008), "Academic outings," *Symbolic Interaction*, 31:4, pp. 351–73.

Eisenhauer, Jennifer (2010), "Writing Dora: Creating community through autobiographical zines about mental illness," *Journal of Cultural Research in Art Education*, 28, pp. 25–38.

Eisner, Elliott (2002), "From episteme to phronesis to artistry in the study and improvement of teaching," *Teaching and Teacher Education*, 18:4, pp. 375–85.

Escobar, Arturo (2008), *Territories of Difference: Place, Movement, Life, Redes*, Durham: Duke University Press.

Ezer, Hanna (2009), "Research in education, self study, and teacher identity," in H. Ezer (ed.), *Self-Study Approaches and the Teacher-Inquirer*, Rotterdam: Sense Publishers, pp. 6–24.

Family Care Giver Alliance (2003), "Who are the caregivers?" https://www.caregiver.org/women-and-caregiving-facts-and-figures. Accessed August 1, 2019.

Fetterolf, Janell (2017), "In many countries, at least four-in-ten in the labor force are women," Fact Tank: News in Numbers, March 7, https://www.pewresearch.org/fact-tank/2017/03/07/in-many-countries-at-least-four-in-ten-in-the-labor-force-are-women/. Accessed August 1, 2019.

Forest, Heather (2009), "Artful leadership for creating positive change: Reflections on arts-based autoethnography," *Storytelling, Self & Society*, 5:2, pp. 72–79.

Forks in the Road: The Many Paths of Arts Alumni (2011), *Strategic National Arts Alumni Project (SNAAP) Report*, Bloomington, IN: Indiana University.

Fritz, Robert (1989), *The Path of Least Resistance: Learning to Become the Creative Force in Your Own Life*, New York: Random House Publishing.

Fuller, Abigail (2004), "What difference does difference make? Women, race-ethnicity, social class, and social change," *Race, Gender & Class*, 11:4, pp. 1–8.

Futch, Valerie and Fine, Michelle (2014), "Mapping as a method: History and theoretical commitments," *Qualitative Research in Psychology*, 11:1, pp. 42–59.

Gallagher, Tiffany, Griffin, Shelley, Ciuffetelli-Parker, Darlene, Kitchen, Julia, and Figg, Candance (2011), "Establishing and sustaining teacher educator professional development in a self-study community of practice: Pre-tenure teacher educators developing professionally," *Teaching and Teacher Education*, 27:5, pp. 880–90.

Galotti, Kathleen (2002), *Making Decisions That Matter: How People Face Important Life Choices*, Mahwah, NJ: Lawrence Erlbaum.

Garrison, Ednie Kaeh (2004), "Contests for the meaning of third wave feminism," in S. Gillis, G. Howie, and R. Munford (eds.), *Third Wave Feminism: A Critical Exploration*, Basingstoke: Palgrave Macmillan, pp. 24–36.

Gauntlett, David and Holzwarth, Peter (2006), "Creative and visual methods for exploring identities," *Visual Studies*, 21:1, pp. 82–91.

Gee, James (2001), "Identity as an analytic lens for research in education," in W. G. Secada (ed.), *Review of Research in Education*, 25, Washington: American Educational Research Association, pp. 99–125.

Gender spectrum (Anon, n.d.), "Understanding gender," https://www.genderspectrum.org/quicklinks/understanding-gender/. Accessed April 23, 2019.

Gerber, Beverly and Guay, Doris (eds.) (2006), *Reaching and Teaching Students with Special Needs Through Art*, Reston: National Art Education Association.

Gerstenblatt, Paula (2013), "Collage portraits as a method of analysis in qualitative research," *International Journal of Qualitative Methods*, 12, pp. 294–309.

Gianneschi, Patricia RAIN (2019), email to author, August 14.

Gilbert, Dennis (1998), *The American Class Structure in an Age of Growing Inequality*, Belmont: Wadsworth Publishing Company.

Gilbert, Elizabeth (2015), *Big Magic: Creative Living Beyond Fear*, New York: Riverhead Books.

Gill, Carol (1997), "Four types of integration in disability identity development," *Journal of Vocational Rehabilitation*, 9, pp. 39–46.

Gladwell, Malcolm (2007), *Blink: The Power of Thinking without Thinking*, New York: Back Bay Books.

Goffman, Erving ([1963] 2009), *Stigma: Notes on the Management of Spoiled Identity*, New York: Simon and Schuster.

Gonder, Peggy Odell (1994), *Improving School Climate and Culture*, Report No. 27, Arlington: American Association of School Administrators.

Gonzales-Smith, Isabel, Swanson, Juleah, and Tanaka, Asuza (2011), "Unpacking identity: Racial ethnic and professional identity and academic librarians of color," in N. Pagowsky and M. Rigby (eds.), *The Librarian Stereotype: Deconstructing Perceptions and Presentations of Information Work*, Chicago: Association of College and Research Librarians, pp. 149–73.

Goopy, Suzanne and Kassan, Anusha (2019), "Arts-based engagement ethnography: An approach for making research engaging and knowledge transferable when working with harder-to-reach communities," *International Journal of Qualitative Methods*, 18. https://doi.org/10.1177/1609406918820424.

Gourlay, Lesley (2010), "Multimodality, visual methodologies, and higher education," in M. Savin-Baden and C. Howell-Major (eds.), *New Approaches to Qualitative Research: Wisdom and Uncertainty*, New York: Routledge, pp. 80–88.

Graham, Mark and Zwirn, Susan (2010), "How being a teaching artist can influence K12 art education," *Studies in Art Education*, 51:3, pp. 219–32.

Grauer, Kit and Sandell, Renee (2000), "The visual journal and teacher development," Paper presented at the annual meeting of the National Art Education Association Annual Meeting, Los Angeles, CA, March 31–April 4.

Gray, Carole and Malins, Julian (2004), *Visualizing Research: A Guide to the Research Process in Art and Design*, Farnham: Ashgate.

Green, Bill (2007), "Unfinished business: Subjectivity and supervision," *Higher Education Research and Development*, 24:2, pp. 151–63.

Greene, Maxine (2001), "Making the petrified world speak, sing, and perhaps dance," in *Variations on a Blue Guitar: The Lincoln Center Lectures on Aesthetic Education*, New York: Teachers College Press, pp. 49–56.

Greitens, Eric (2015), *Resilience: Hard Won Wisdom for Better Living*, New York: Houghton Mifflin.

Griffiths, Morwenna (2011), "Research and the self," in M. Biggs and H. Karlsson (eds.), *The Routledge Companion to Research in the Arts*, Abington: Routledge, pp. 166–85.

Hall, Douglas (1986), "Breaking career routines: Midcareer choice and identity development," in D. T. Hall (ed.), *Career development in Organizations*, San Francisco: Jossey-Bass, pp. 20–59.

Hall, James (2010), "Making art, teaching art, learning art: Concept of the artist teacher," *Journal of Art and Design Education*, 29:2, pp. 103–10.

Hamilton, Mary Lynn and Pinnegar, Stefinee (2010), "Creating representations: Collage in self-study," in D. Tidwell, M. Heston, and L. Fitzgerald (eds.), *Research Methods for the Self-Study of Practice, Self Study Teaching and Teacher Education Practice*, 9, Netherlands: Springer, pp. 155–72.

Hammer, Barbara (1984), "The artist as teacher: Problems and experiments," *Journal of Education*, 166:2, pp. 181–87.

Harper, Douglas (2002), "Talking about pictures: A case for photo elicitation," *Visual Studies*, 17:1, pp. 13–26, https://dx.doi.org/10.1080/14725860220137345.

Hatfield, Cynthia, Montana, Valerie, and Deffenbaugh, Cara (2006), "Artist/art educator: Making sense of identity issues," *Art Education*, 59:3 (May), pp. 42–47.

Heddon, Deidre and Tuner, Cathy (2010), "Walking women: Interviews with artists on the move," *Performance Research*, 15:4, pp. 14–22.

Hegewisch, Ariane and Hartman, Heidi (2019), "The gender wage gap: 2018 earnings differences by race and ethnicity," *Institute for Women's Policy Research*, September 13, https:// iwpr.org/publications/gender-wage-gap-2016-earnings-differences-gender-race-ethnicity/. Accessed June 30, 2019.

Hellsten, Laurie-Ann, Prytula, Michelle, Ebanks, Althea, and Lai, Hollis (2009), "Teacher induction: Exploring beginning teacher mentorship," *Canadian Journal of Education*, 32:4, pp. 703–33.

Heyenga, Laura (2012), *Art Made from Books*, San Francisco: Chronicle Books.

Heywood, Leslie (2006), "Introduction: A fifteen-year History of third-wave feminism," in *The Women's Movement Today: An Encyclopedia of Third-Wave Feminism*, 1, Westport: Greenwood Press, pp. xv–xvii.

Hill-Collins, Patricia (1990), *Black Feminist Thought: Knowledge, Consciousness and the Politics of Empowerment*, Boston: Unwin Hyman.

Hill-Collins, Patricia (2000), "It's all in the family: Intersections of gender, race and nation," in U. Narayan and S. Harding (eds.), *Decentering the Center: Philosophy for a Multicultural, Post-Colonial and Feminist World*, Bloomington: Indiana University Press, pp. 156–76.

Hiltunnen, Mirja and Rantala, Pälui (2015), "Creating arts-based approaches in working life development: A shift from success to significance," *International Journal of Education through Art*, 11:2, pp. 245–60.

Hoel, Helge and Salin, Denise (2003), "Organisational antecedents of workplace bullying," in S. Einarsen, H. Hoel, D. Zapf, and C. L. Cooper (eds.), *Bullying and Emotional Abuse in the Workplace: International Perspectives in Research and Practice*, London: Taylor & Francis, pp. 203–19.

Hoeptner-Poling, Linda (2019), email to author, August 16.

Hofsess, Brooke and Hanawalt, Christina (2018), "Art(full) gifts: Material disruptions and conceptual proddings as creative acts of mentoring for early career art teachers," *Visual Inquiry*, 7:3, pp. 183–96.

hooks, bell (1994), *Teaching to Transgress: Education as the Practice of Freedom*, New York: Routledge.

hooks, bell (1999), "Embracing freedom: Spirit and liberation," in S. Glazer (ed.), *The Heart of Learning: Spirituality in Education*, New York: Penguin, pp. 113–30.

Howell-White, John (2019), email to author, August 16.

Hsueh-Hua Chen, Vivian (2014), "Cultural identity," Key Concepts in Intercultural Dialogue, https://centerforinterculturaldialogue.files.wordpress.com/2014/07/key-concept-cultural-identity.pdf. Accessed March 12, 2019.

Huitt, William (1992), "Problem solving and decision making: Consideration of individual differences using the Myers-Briggs Type Indicator," *Journal of Psychological Type*, 24, pp. 33–44.

Huynh Que Lam, Nguyen, MinhTu, Angela, and Benet-Martínez, Veronica (2011), "Bicultural identity integration," in S. Schwartz, K. Luyckx, and V. Vignoles (eds.), *Handbook of Identity Theory and Research*, New York: Springer, pp. 827–42.

Ibarra, Herminia (1999), "Provisional selves: Experimenting with image and identity in professional adaptation," *Administrative Science Quarterly*, 44:4, pp. 764–91.

Ibarra, Herminia, Kilduff, Martin, and Tsai, Wenpin (2005), "Zooming in and out: Connecting individuals and collectivities at the frontiers of organizational network research," *Organization Science*, 16:4, pp. 359–71.

Ingersoll, Richard and Strong, Michael (2011), "The impact of induction and mentoring programs for beginning teachers: A critical review of the research," *Review of Educational Research*, 81:2, pp. 201–33.

Ingold, Tim (2011), *Being Alive: Essays on Movement, Knowledge and Description*, New York: Routledge.

Irwin, Rita (2004), "A/r/tography: A metonymic méstissage," in R. Irwin and A. de Cosson (eds.), *A/r/tography: Rendering Self through Arts-Based Living Inquiry*, Vancouver: Pacific Educational Press, pp. 27–28.

Janesick, Valerie (2015), "Poetry zen and qualitative research," in *Contemporary Qualitative inquiry Practicing the Zen of Research*, Walnut Creek: Left Coast, pp. 109–25.

Jarmon, Leslie, Lim, Kenneth Y. T., and Carpenter, B. Stephen (2009), "Pedagogy, education and innovation in virtual worlds," *Journal of Virtual Worlds Research*, 2:1, pp. 1–9.

Jasvec-Martek, Marian (2009), "Oscillating role identities: The academic experiences of education doctoral students," *Innovations in Education and Teaching International*, 46:3, pp. 253–64.

Jeffers, Carol (1996), "Experiencing art through metaphor," *Art Education*, 49:3, pp. 6–11.

Jeffers, Carol (2017), *The Question of Empathy: Searching for the Essence of Humanity*, Virginia Beach: Koehler Books.

Jhangiani, Rajiv and Tarry, Hammond (2014), *Principles of Social Psychology,* 1st international ed., Victoria: BC Campus, https://opentextbc.ca/socialpsychology/. Accessed July 6, 2019.

Johnson, Nicole (2019), email to author, August 16.

Johnson, William, Snyder, Karolyn, Anderson, Robert, and Johnson, Annabel (1996), "School work culture and productivity," *Journal of Experimental Education*, 64:2, pp. 139–56.

Jokela, Timo, Humarniemi, Maria, and Hiltunen, Mirja (2019), "Arts-based action research: Participatory art education research," in A. Sinner, R. L. Irwin, and J. Adams (eds.), *Provoking*

the Field: International Perspectives on Visual Arts Ph.D.s in Education, Bristol: Intellect, pp. 45–56.

Jongeward, Carolyn (2009), "Visual portraits: Integrating artistic process into qualitative research," in P. Leavy (ed.), *Method Meets Art: Arts Based Research Practice*, New York: Guilford, pp. 239–51.

Kabat-Zinn, Jon (2005), *Coming to Our Senses: Healing Ourselves and the World through Mindfulness*, New York: Hyperion.

Kahneman Daniel, Diener, Ed, and Schwarz, Norbert (eds.) (1999), *Well-Being: The Foundations of Hedonic Psychology*, New York: Russell Sage Foundation.

Kalin, Nadine, Barney, Daniel, and Irwin, Rita (2009), "Mentoring relations within A/r/tographic inquiry," *Visual Arts Research*, 35:2, pp. 11–23.

Kallio-Tavin, Mira (2015), "Representation of art as an ethical and political act," *Nordic Journal of Art and Research*, 4:2, https://doi.org/10.7577/if.v4i2.1540.

Kallio, Tavin Mira (ed.) (2020), "Disability studies as a site of knowledge in art education," *International Journal of Education through Art*, 16:1, pp. 3–11.

Kane, Mary and Trochim, William (2006), *Concept Mapping for Planning and Evaluation (Applied Social Research Methods)*, Thousand Oaks: Sage.

Kay, Lisa (2013), "Bead collage: An arts based research method," *International Journal of Education and the Arts*, 14:3, http://www.ijea.org/v14n3/. Accessed April 22, 2020.

Kay, Lisa (2019), email to author, August 18.

Kearns, Laura-Lee, Mitton-Kukner, Jennifer, and Tompkins, Joanne (2014), "LGBTQ awareness and allies: Building capacity in a bachelor of education program," *Canadian Journal of Education*, 37:4, pp. 1–26.

Keats, Patricia (2009), "Multiple text analysis in narrative research: Visual, written and spoken stories of experience," *Qualitative Research*, 9:2, pp. 181–95.

Kehrer, Lauron (2016), "Goldenrod distribution and the queer failure of women's music," *American Music*, 34:2, pp. 218–42.

Keifer-Boyd, Karen, Flavia Bastos, Richardson, Jennifer, and Wexler, Alice (2018), "Disability justice: Rethinking 'inclusion' in arts education research," *Studies in Art Education*, 59:3, pp. 267–71, https://dx.doi.org/10.1080/00393541.2018.1476954.

Kelchtermans, Geert and Vandenberghe, Roland (1994), "Teachers' professional development: A biographical perspective," *Journal of Curriculum Studies*, 26:1, pp. 45–62.

Kind, Sylvia, de Cosson, Alex, Irwin, Rita, and Grauer, Kit (2007), "Artist-teacher partnerships in learning: The in/between spaces of artist-teacher professional development," *Canadian Journal of Education*, 30:3, pp. 839–64.

King, Stephen (2007), "Religion, spirituality, and the workplace: Challenges for public administration," *Public Administration Review*, 67:1, pp. 103–14.

Kitchen, Julian, Berry, Amanda, Bullock, Shawn, Crowe, Alicia, Taylor, Monica, Guðjónsdóttir, Hafdís, and Thomas, Lynn (eds.) (2020), *International Handbook of Self-Study of Teaching and Teacher Education*, 2nd ed., Singapore: Springer.

Kjørup, Soren (2011), "Pleading for plurality: Artistic and other kinds of research," in M. Biggs and H. Karlsson (eds.), *The Routledge Companion to Research in the Arts*, Abington: Routledge, pp. 24–43.

Klein, Sheri (2008), "Holistic reflection in teacher education: Issues and strategies," *Reflective Practice*, 9:2 (May), pp. 111–21.

Klein, Sheri (2010), "Exploring hope and the inner life through journaling," *Encounter*, 23:2, pp. 48–52.

Klein, Sheri (ed.) (2012), *Action Research: Plan and Simple*, New York: Palgrave Macmillan.

Klein, Sheri (2014), "Making sense of data in the changing landscape of visual art education," *Visual Art Research*, 40:2 (Winter), pp. 25–33.

Klein, Sheri (2018), "Wabi sabi: A glimpse," *Texas Art Education Association Journal*, November, pp. 56–59.

Klein, Sheri (2019), "Moving toward third-space: Reflections on the tensions with/in qualitative research," *Canadian Art Education Review*, 46:1, pp. 72–83.

Klein, Sheri (2020), "Using artistic methods to respond and interpret research data," in M. T. Cheng and Y. Cooper (eds.), *New Visions in Art Education Research and Practices*, Shanghai: Shanghai Education Press.

Klein, Sheri and Diket, Read (1999), "Creating artful leadership," *International Journal of Leadership in Education*, 2:1, pp. 23–30.

Klein, Sheri and Diket, Read (2018), "Intersectionality and leadership: International considerations," in E. Samier and P. Milley (eds.), *Maladministration in Education: Theories, Research and Critiques*, London: Routledge, pp. 119–36.

Klein, Sheri and Miraglia, Kathy (2017), "Developing visually reflective practices: An integrated model for self-study," *Art Education Journal*, 70:2, pp. 25–30.

Klein, Sheri and Miraglia, Kathy (eds.) (2018), *Visual Inquiry*, Special Issue: "Professional Identities," 7:3, pp. 159–65.

Kleinhans, Kelly, Chakradhar, Kala, Muller, Susan, and Waddill, Paula (2015), "Multigenerational perceptions of the academic work environment in higher education in the United States," *Higher Education*, 70:1, pp. 89–103.

Knight, Linda and Lasczik-Cutcher, Alexandra (eds.) (2018), *Arts-Research-Education: Connections and Directions*, Switzerland: Springer International.

Knight, Wanda (2007), "Entangled social realities: Race, class, gender a triple threat to the academic achievement of Black females," *Visual Culture Gender*, 2, pp. 24–38.

Knight, Wanda (2010), "Sink or swim: Navigating the perilous waters of promotion and tenure: What's diversity got to do with it?" *Studies in Art Education*, 52:1, pp. 84–87.

Knowles, Gary and Cole, Ardra (2008), *Handbook of the Arts in Qualitative Research: Perspectives, Methodologies, Examples and Issues*, Thousand Oaks: Sage.

Knowles, John (2015), "Art teachers' professional identities and attitudes to promotion: A narrative," Master's thesis, West Yorkshire: University of Huddersfield.

Knowles, Malcolm, Swanson, Richard, and Holton III, Edward (2015), *The Adult Learner: The Definitive Classic in Adult Education and Human Resource Development*, 8th ed., New York: Routledge.

Koren, Leonard (2008), *Wabi Sabi for Artists, Designers, Poets and Philosophers*, Point Reyes: Imperfect Publishers.

Korthagen, Fred and Kessels, Joseph (1999), "Linking theory and practice: Changing the pedagogy of teacher education," *Educational Researcher*, 28:4, pp. 4–17.

Kortjass, Makie (2019), "Reflective self-study for an integrated learning approach to early childhood mathematics teacher education," *South African Journal of Childhood Education*, 9:1, pp. 1–11, https: doi.org/10.4102/sajce.v9i1.576.

Kosciw, Joseph, Diaz, Elizabeth, and Greytak, Emily (2007), *The 2007 National School Climate Survey: The Experiences of Lesbian, Gay, Bisexual and Transgender Youth in Our Nation's Schools*, https://www.glsen.org/sites/default/files/2007%20National%20School%20Climate%20Survey%20Full%20Report.pdf. Accessed July 2, 2019.

Kuster, Deborah, Bain, Christina, Newton, Connie, and Milbrandt, Melody (2002), "Novice art teachers: Navigating through the first year," *Visual Arts Research*, 36:1, pp. 44–54.

La Jevic, Lisa, and Springgay, Stephanie (2008), "A/r/tography as an ethics of embodiment: Visual journals in preservice education," *Qualitative Inquiry*, 14:1, pp. 67–89.

Lapum, Jennifer, Liu, Linda, Hume, Sarah, Wang, Siyuan, Nguyen, Megan, Harding, Bailey, Church, Kathryn, Cohen, Gideon, and Yau, Terrence (2015), "Pictorial narrative mapping as a qualitative analytic technique," *International Journal of Qualitative Methods*, 14:5, https://journals.sagepub.com/doi/10.1177/1609406915621408.

Lassonde, Cynthia A., Galman, Sally, and Kosnik, Clare (eds.) (2009), *Self-Study Research Methodologies for Teacher Educators, Professional Learning*, vol. 7, Rotterdam, Netherlands: Sense Publishers.

Lave, Jean and Wenger, Etienne (1991), *Situated Learning: Legitimate Peripheral Participation*, Cambridge: Cambridge University Press.

Lawler, Edward, Thye, Shayne, and Yoon, Jeongkoo (2000), "Emotion and group cohesion in productive exchange," *Journal of Sociology*, 106:3, pp. 616–57.

Le Doux, Joseph (1996), *The Emotional Brain: The Mysterious Underpinnings of Emotional Life*, New York: Touchstone.

Leavy, Patricia (2009), *Method Meets Art: Arts Based Research Practice*, New York: Guilford.

Leavy, Patricia (ed.) (2017), *Handbook of Arts-Based Research*, New York: Guilford.

Lenette, Caroline (2019), *Arts-Based Methods in Refugee Research*, Singapore: Springer.

Lewis, Duncan (2004), "Bullying at work: The impact of shame among university and college lecturers," *British Journal of Guidance & Counseling*, 32:3, pp. 281–99.

Lim, Eun-Hee (Maria) (2006), "Influences of studio practice on art teachers' professional identities," *Marilyn Zurmeulen Papers in Art Education*, 1:8, pp. 1–14.

Liu, William Ming, Pickett, Theodore, Jr., and Ivey, Allen (2007), "White middle-class privilege: Social class bias and implications for training and practice," *Journal of Multicultural Counseling and Development*, 35:4, pp. 194–206.

Locke, Edwin and Lathham, Gary (2006), "New directions in goal-setting theory," *Current Directions in Psychological Science*, 15:5, pp. 265–68.

Lord, John and Hutchinson, Peggy (1993), "The process of empowerment: Implications for theory and practice," *Canadian Journal of Community Mental Health*, 12:1 (Spring), pp. 5–22.

Loughran, John and Northfield, Jeff (1998), "A framework for the development of self-study practice," in M. L. Hamilton (ed.), *Reconceptualizing Teaching Practice: Self-study in Teacher Education*, London: Falmer Press, pp. 7–18.

Loughran, J. John, Hamilton, Mary Lynn, LaBoskey, Vicki Kubler, and Russell, Tom (eds.) (2004), *International Handbook on Self-Study of Teaching and Teacher Education Practices*, Netherlands: Springer.

Mac an Ghaill, Mairtin (1994), *The Making of Men: Masculinities, Sexualities and Schooling*, Buckingham: Open University Press.

MacDonald, Abbey (2014), "Intertwined: An investigation into becoming an artist and teacher," Ph.D. thesis, Launceston: University of Tasmania.

MacDonald, Abbey (2017), "A diptych of dilemma: Becoming an artist teacher," *International Journal of Education through Art*, 13:1, pp. 163–77.

Mannay, Dawn (2015), *Visual, Narrative and Creative Research Methods: Application, Reflection, and Ethics*, New York: Routledge.

Margolin, Indrani (2014), "Collage as method of inquiry for university women practicing Mahavakyam meditation: Ameliorating the effects of stress, anxiety and sadness," *Journal of Religion and Spirituality in Social Work: Social Thought*, 33:3, pp. 254–73.

Marlborough, Max (2016), *Hand Drawn Lettering: Draw, Print Paint*, New York: Barrons.

Marwick, Alice (2013), "Online identity," in J. Hartley, J. Burgess, and A. Bruns (eds.), *A Companion to New Media Dynamics*, 1st ed., Oxford: Blackwell Publishing, pp. 355–63.

May, Rollo (1975), *The Courage to Create*, New York: W.W. Norton.

McCabe, Scott and Stokoe, Elizabeth (2004), "Place and identity in tourists' accounts," *Annals of Tourism Research*, 31:3, pp. 601–22.

McCaffrey, Graham, Raffin-Bouchal, Shelley, and Moules, Nancy (2012), "Hermeneutics as research approach: A reappraisal," *International Journal of Qualitative Methods*, 11:3, pp. 214–29, https://doi.org/10.1177/160940691201100303.

McCandless, David (2014), *Knowledge Is Beautiful*, UK: William Collins.

McCann, Robert and Giles, Howard (2002), "Ageism in the workplace: A communication perspective," in T. D. Nelson (ed.), *Stereotyping and Prejudice Against Older People*, Cambridge: MIT Press, pp. 163–200.

McDermott, Morna (2002), "Collaging pre-service teacher identity," *Teacher Education Quarterly*, 29:4, pp. 53–68.

McKernan, James (1996), *Curriculum Action Research: A Handbook of Methods and Resources for the Reflective Practitioner*, New York: Routledge.

McLaughlin, Colleen (2003), "The feeling of finding out: The role of emotions in research," *Educational Action Research*, 11:1, pp. 65–78.

McLaughlin, Milbrey Wallin (1992), *What Matters Most in Teachers' Workplace Context?* Center for Research on the Context of Secondary School Teaching, Report No. P92-139, Washington: Office of Educational Research and Improvement.

McLeod, Heather (2019), email to author, August 9.

McLeod, Poppy, Liu, Yi-Ching, and Axline, Jill (2014), "When your second life comes knocking: Effects on personality on changes to real life from virtual world experiences," *Computers in Human Behavior*, 39, pp. 59–70.

McNiff, Shaun (2013), *Art as Research: Opportunities and Challenges*, Bristol: Intellect.

Measor, Lyneq (1985), "Critical incidents in the classroom: Identities, choices and careers," in S. Ball and I. Goodson (eds.), *Teacher's Lives and Careers*, London: Falmer, pp. 61–77.

Mendoza, Pilar (2007), "Academic capitalism and doctoral student socialization: A case study," *Journal of Higher Education*, 78:1, pp. 71–96.

Mennino, Sue Falter, Rubin, Beth, and Brayfield, April (2005), "Home-to-job and job-to-home spillover: The impact of company policies and workplace culture," *Sociological Quarterly*, 46:1, pp. 107–35.

Merriam, Sharan and Kim, Seon Joo (2012), "Studying transformative learning: What methodology?" in E. Taylor and P. Cranton (eds.), *Handbook of Transformative Learning: Theory and Research*, San Francisco: Jossey-Bass, pp. 56–73.

Mezirow, Jack (1991), *Transformative Dimensions of Adult Learning*, San Francisco: Jossey-Bass.

Mezirow, Jack (2012), "Learning to think like an adult: Core concepts of transformative learning," in E. Taylor and P. Cranton (eds.), *Handbook of Transformative Learning: Theory and Research*, San Francisco: Jossey-Bass, pp. 73–98.

Milbrandt, Melody and Klein, Sheri (2008), "Survey of art teacher educators: Qualifications, identity, and practice," *Studies in Art Education a Journal of Issues and Research*, 49:4, pp. 343–57.

Miles, B. Matthew and Huberman, A. Michael (1994), *Qualitative Data: An Expanded Sourcebook*, 2nd ed., Thousand Oaks: Sage.

Miller, Anna Cohen and Demers, Denise (2019), "Conflicting roles of mother and academic: Exploring use of arts-based self-care activities to encourage well-being," *Art/Research International: A Transdisciplinary Journal*, 4:2, pp. 611–43.

Miller, Stephen (1965), "The social dilemma of the aging leisure participant," in A. Rose and W. Petersen (eds.), *Older People and Their Social Worlds*, Philadelphia: Davis, pp. 77–92.

Mims, Rachel (2015), "Military veteran use of visual journaling during recovery," *Journal of Poetry Therapy*, 28:2, pp. 99–11.

Miraglia, Kathy Marzilli (2017), "Learning in situ: Situated cognition and culture learning in a study abroad program," in R. Shin (ed.), *Convergence of Contemporary Art, Visual Culture, and Global Civic Engagement*, Hershey: IGI Global, pp. 118–37.

Miraglia, Kathy Marzilli (2019), email to author, May 8.

Miraglia, Kathy Marzilli (forthcoming, 2021), "Women's leadership in the arts," in K. Keifer-Boyd, L. Hoeptner-Poling, S. Klein, W. Knight, and A. Pérez de Miles (eds.), *National Art Education Association Women's Caucus LOBBY ACTIVISM Feminism(s) + Art Education*, Abington: NAEA and Taylor and Francis Publishers.

Miscenko, Darja and Day, David (2015), "Identity and identification at work," *Organizational Psychology Review*, 6:3, pp. 215–47.

Miscovich, Peter (2018), "Three keys to digital workplace ecosystem success," https://workdesign.com/2018/04/three-keys-to-digital-workplace-ecosystem-success/. Accessed August 2, 2019.

Misra, Joya, Kennelly, Ivy, and Karides, Marina (1999), "Employment chances in the academic job market in sociology: Do race and gender matter?" *Sociological Perspectives*, 42:2, pp. 215–47.

Missigman, Rae (2018), *Paint, Play, Explore: Expressive Mark-Making Techniques in Mixed Media*, Blue Ash: North Light Books.

Mitchell, Claudia (ed.) (2011), *Doing Visual Research*, Thousand Oaks: Sage.

Mon, Lorri (2012), "Professional avatars: Librarians and educators in virtual worlds," *Journal of Documentation*, 68:3, pp. 318–29.

Monroe, Kristen Renwkk and Chiu, William (2010), "Gender equality in the academy: The pipeline problem," *Political Science and Politics*, 43:2, pp. 303–08.

Morley, David (2001), "Belongings: Place, space and identity in a mediated world," *European Journal of Cultural Studies*, 4:4, pp. 425–48.

Moules, Nancy (2002), "Hermeneutic inquiry: Paying heed to history and Hermes—An ancestral, substantive, and methodological tale," *International Journal of Qualitative Methods*, 1:3, Article 1, http://www.ualberta.ca/~ijqm/. Accessed May 9, 2020.

Mulvihill, Thalia M. and Swaminathan, Raji (2019), *Arts-Based Educational Research: Walking the Path*, New York: Routledge.

National Park Service (n.d.), "Fluvial features—braided stream," https://www.nps.gov/articles/braided-stream.htm. Accessed March 24, 2020.

Ndandala, Saturnin (2016), "A portrait of faculty diversity at selected elite universities," *International Journal of Higher Education Management*, 3:1, pp. 75–82.

Nelson, Jason (2010), "Teacher dispositions and religious identity in the public school: Two case studies," *Journal of Negro Education*, 79:3, pp. 335–53.

Nelson, Robin (ed.) (2013), *Practice as Research in the Arts: Principles, Protocols, Pedagogies, and Resistances*, Basingstoke: Palgrave Macmillan.

Nelson, Todd D. (ed.) (2002), *Stereotyping and Prejudice Against Older People*, Cambridge: MIT Press.

Ng, Roxanna (1994), "Sexism and racism in the university: Analyzing personal experience," *Canadian Woman Studies*, 14, pp. 41–46.

Ng, Thomas and Feldman, Daniel (2009), "Age, work experience, and the psychological contract," *Journal of Organizational Behavior*, 30:8, pp. 1053–75.

Noddings, Nel (2004), *Happiness and Education*, New York: Cambridge University Press.

Noddings, Nel (2012), *Philosophy of Education*, Philadelphia: Westview Press.

Norris, Joe (2000), "Drama as research: Realizing the potential of drama in education as a research methodology," *Youth Theatre Journal*, 14, pp. 40–51.

Northrup, Tony (2012), *How to Create Stunning Digital Photographs*, Waterford: Mason Press.

Novak, Joseph and Gowin, D. Bob (1984), *Learning How to Learn*, Cambridge: Cambridge University Press.

Novotney, Amy (2019), "Social isolation: It can kill you," American Psychological Association, https://www.apa.org/monitor/2019/05/ce-corner-isolation. Accessed August 3, 2019.

Oliver, Kristi (2019), email to author, August 14.

Oliver, Mary (1994), *A Poetry Handbook: A Prose Guide to Understanding and Writing Poetry*, Orlando: Harcourt Brace & Company.

O'Rourke, Karen (2013), *Walking and Mapping: Artists as Cartographers*, Cambridge: MIT.

Osborn, Alex (1963), *Applied Imagination: Principles and Procedures of Creative Problem-Solving*, New York: Charles Scribner's Sons.

Owens, Timothy, Robinson, Dawn, and Smith-Lovin, Lynn (2010), "Three faces of identity," *Annual Review of Sociology*, 36, pp. 477–99.

Padget, Ron (ed.) (2000), *The Teacher and Writer's Handbook of Poetic Forms*, 2nd ed., New York: T & W Books.

Palmer, Parker (2017), *The Courage to Teach: Guide for Reflection and Renewal*, San Francisco: Jossey-Bass.

Papacharissi, Zizi (2002), "The presentation of self in virtual life: Characteristics of personal home pages," *Journalism and Mass Communication Quarterly*, 79:3, pp. 643–60.

Paterson, Margo and Higgs, Joy (2005), "Using hermeneutics as a qualitative research approach in professional practice," *The Qualitative Report*, 10:2, pp. 339–57, http://www.nova.edu/ssss/QR/QR10-2/paterson.pdf. Accessed December 7, 2020.

Paterson, Myles, Higgs, Joy, Wilcox, Susan, and Villeneuve, Michelle (2002), "Clinical reasoning and self-directed learning: Key dimensions in professional education and professional socialization," *Focus on Health Professional Education*, 4:2, pp. 5–21.

Patton, Michael Quinn (2002), *Qualitative Research and Evaluation Methods*, Thousand Oaks: Sage.

Pauliny, Tara (2006), "When 'Ms Mentor' misses the mark: Literacy and lesbian identity in the academy," in B. Williams (ed.), *Identity Papers: Literacy and Power in Higher Education*, Logan: Utah State University Press, pp. 57–74.

Pearce, Steven (2018), *101 Textures in Graphite and Charcoal*, Lake Forest: Walter Foster Publishing.

Peel, Deborah (2005), "Peer observation as a transformatory tool?" *Teaching in Higher Education*, 10:4, pp. 489–504.

Perkins, David (2009), "Decision making and its development," in E. Callan, T. Grotzer, J. Kagan, R. E. Nisbett, D. N. Perkins, and L. S. Shulman (eds.), *Education and a Civil Society: Teaching Evidence Based Decision Making*, Cambridge: American Academy of Arts and Sciences, p. 1029.

Pewewardy, Cornel (2003), "To be or not to be indigenous: Identity, race, and representation in education," *Indigenous Nations Studies Journal*, 4:2, pp. 69–90.

Pfeiler-Wunder, Amy (2017), "Dressing up: Exploring the fictions and frictions of professional identity in art educational settings," *Journal of Social Theory in Art Education*, 37, pp. 28–37.

Picard, Carol (2000), "Patterns of expanding consciousness in midlife women," *Nursing Science Quarterly*, 13:2, pp. 150–58.

Pierce, Joseph and Lawhon, Mary (2015), "Walking as method: Toward methodological forthrightness and compatibility in urban geological research," *Professional Geographer*, 67:4, pp. 655–62.

Pink, Sara (2007), *Doing Visual Ethnography*, 2nd ed., London: Sage.

Pink, Sara, Hubbard, Phil, O'Neill, Maggie, and Radley, Alan (2010), "Walking across disciplines: From ethnography to arts practice," *Visual Studies*, 25:1, pp. 1–7, https://dx.doi.org/10.1080/14725861003606670.

Pinnegar, Stefinee and Hamilton, Mary (2009), *Self-study of Practice as a Genre of Qualitative Research: Theory, Methodology and Practice*, New York: Springer.

Pointdexter, Cynthia Carmon (2009), "Research as poetry," in P. Leavy (ed.), *Method Meets Art: Arts Based Research Practice*, New York: Guilford, pp. 92–99.

Polkinghorne, Donald E. (1989), "Phenomenological research methods," in R. S. Valle and S. Halling (eds.), *Existential-Phenomenological Perspectives in Psychology*, New York: Plenum, pp. 41–60.

Powell, Kimberly (2010), "Making sense of place: Mapping as a sensory research method," *Qualitative Inquiry*, 16:7, pp. 539–55.

Preparing for an Aging World: The Case for Cross-National Research (2001), Washington, DC: National Academy Press. http://www.rand.org/pubs/research_briefs/RB5058/index1.html. Accessed July 3, 2019.

Prosser, Jon (2000), "The moral maze of image ethics," in H. Simons and R. Usher (eds.), *Situated Ethics in Educational Research*, London: Routledge, pp. 116–32.

Pussetti, Chiara (2018), "Ethnography-based art. Undisciplined dialogues and creative research practices: An Introduction," *Visual Ethnography*, 7:1, pp. 1–12.

Quintana, Stephen (2007), "Racial and ethnic identity: Developmental perspectives and research," *Journal of Counseling Psychology*, 54:3, pp. 259–70.

Rabkin, Nick, Reynolds, Michael, Hedberg, Eric, and Shelby, Justin (2011), *A Report on the Artist Teaching Project: Teaching Artists and the Future of Education*, Chicago: University of Chicago Press.

Raths, Louis (1954), "Social class and education," *Journal of Educational Sociology*, 28:3, pp. 124–25.

Ravitch, Diane (2010), *The Death and Life of the Great American School System: How Testing and Choice are Undermining Education*, New York: Basic Books.

Reichers, Arnon and Schneider, Benjamin (1990), "Climate and culture: An evolution of constructs," in B. Schneider (ed.), *Organizational Climate and Culture*, San Francisco: Jossey-Bass, pp. 5–39.

Reitzes, Donald, Mutran, Elizabeth, and Fernandez, Maria (1996), "Does retirement hurt well being? Factors influencing self-esteem and depression among retirees and workers," *Gerontologist*, 36:5, pp. 649–56.

Ressler, Paula and Chase, Becca (2009), "Sexual identity and gender variance: Meeting the educational challenges," *English Journal*, 98:4, pp. 15–22.

Riddell, Sheila and Watson, Nick (2014), *Disability, Culture and Identity*, New York: Routledge.

Ritter, Jason K., Lunenberg, Mieke, Pithouse-Morgan, Kathleen, Samaras, Anastasia P., and Vanassche, Eline (eds.) (2018), *Teaching, Learning and Enacting Self-Study Methodology*, Singapore: Springer.

Robert, Pamela and Harlan, Sharon (2006), "Mechanisms of disability discrimination in large bureaucratic organizations: Ascriptive inequalities in the workplace," *Sociological Quarterly*, 47:4, pp. 599–630.

Roccas, Sonia and Brewer, Marilynn (2002), "Social identity complexity," *Personality and Social Psychology Review*, 6:2, pp. 88–106.

Rodgers, Carol and Scott, Katherine (2008), "The development of the personal self and professional identity in learning to teach," in M. Cochran-Smith, S. Feiman-Nemser, D. J. McIntyre, and K. E. Demers (eds.), *Handbook of Research on Teacher Education*, New York: Routledge, pp. 732–55.

Rodriguez, Sherri K. and Kerrigan, Monica R. (2016), "Using graphic elicitation to explore community college transfer student identity, development, and engagement," *The Qualitative Report*, 21:6, pp. 1052–70, https://nsuworks.nova.edu/tqr/vol21/iss6/4. Accessed December 7, 2020.

Rolling, James, Jr. (2013), *Arts Based Research*, New York: Peter Lang.

Rolling, James, Jr. (2015), "A far easier silence: Evolving traditions, cultural intersections entrenched inequalities," *Art Education*, 68:6 (November), pp. 4–5.

Romanowska, Julia, Larsson, Gerry, and Theorell, Tores (2013), "Effects on leaders of an arts-based leadership intervention," *Journal of Management Development*, 32:9, pp. 1004–22.

Ropers-Huilman, Rebecca and Winters, Kelly (2010), "Imagining intersectionality and the spaces in between: Theories and processes of socially transformative knowing," in M. Savin-Baden

and C. Howell-Major (eds.), *New Approaches to Qualitative Research: Wisdom and Uncertainty*, New York: Routledge, pp. 37–48.

Roscigno, Vincent, Mong, Sherry, Byron, Reginald, and Tester, Griff (2007), "Age discrimination, social closure and employment," *Social Forces*, 86:1, pp. 313–34.

Rose, Gillian (2016), *Visual Methodologies: An Introduction to Researching with Visual Materials*, Thousand Oaks: Sage.

Runco, Mark (2007), *Creativity, Theories and Themes: Research, Development, and Practice*, Burlington: Elsevier Academic Press.

Russell, Tom (2004), "Tracing the development of self-study in teacher education research and practice," in J. Loughran, M. Hamilton, V. K. LaBoskey, and T. Russell (eds.), *International Handbook of Self-Study of Teaching and Teacher Education Practices*, Netherlands: Springer, pp. 1191–210.

Sadler-Smith, Eugene and Shefy, Erella (2004), "The intuitive executive: Understanding and applying 'gut feel' in decision-making," *Academy of Management Executive*, 18:4, pp. 76–91.

Sagor, Richard (2000), *Guiding School Improvement with Action Research*, Alexandria: Association for Supervision and Curriculum Development.

Saldaña, Johnnie (2015), *Thinking Qualitatively: Methods of Mind*, Thousand Oaks: Sage.

Samaras, Anastasia (2011), *Self-Study Teacher Research: Improving Your Practice through Collaborative Inquiry*, Thousand Oaks: Sage.

Samuel, Edith and Wane, Njoki (2005), "'Unsettling relations': Racism and sexism experienced by faculty of color in a predominantly white Canadian University," *Journal of Negro Education*, 74:1, pp. 76–87.

Samuel, Michael and Stephens, David (2000), "Critical dialogues with self: Developing teacher identities and roles—a case study of South Africa," *International Journal of Educational Research*, 33:5, pp. 475–91.

Samuels, Gina Miranda and Ross-Sheriff, Fariyal (2008), "Identity, oppression and power," *Journal of Women and Social Work*, 23:1, pp. 5–9.

Santoro, Doris (2018), "Is it burnout?: Demoralization happens when educators face persistent challenges to their professional values," *Educational Leadership*, 75:3, pp. 10–15.

Savin-Baden, Maggi and Howell-Major, Claire (eds.) (2010), *New Approaches to Qualitative Inquiry: Wisdom and Uncertainty*, New York: Routledge.

Schenstead, Amanda Rose (2012), "The timelessness of arts-based research: Looking back upon a heuristic self-study and the arts-based reflexivity data analysis method," *Voices: A World Forum for Music Therapy*, 12:1, https://dx.doi.org/10.15845/voices.v12i1.589.

Schlageter, Keri (2020), email to author, February 19.

Schön, Donald (1983), *The Reflective Practitioner: How Professionals Think in Action*, New York: Basic Books.

Schultze, Ulrike (2014), "Performing embodied identity in virtual worlds," *European Journal of Information Systems*, 23, pp. 84–95.

Schwartz, Seth, Luyckx, Koen, and Vignoles, Vivian (eds.) (2011), *Handbook for Identity Theory and Research*, New York: Springer.

Scotti, Victoria and Chilton, Gioia (2014), "Collage as arts-based research," in P. Leavy (ed.), *Handbook of Arts-Based Research*, New York: Guilford, pp. 355–76.

Seligman, Martin (2011), *Flourish: A Visionary New Understanding of Happiness and Well-Being*, New York: Free Press.

Senagala, Mahesh (1999), "Growing rhizomes and collapsing walls: Postmodern paradigms for design education," *International Conference of the Association of Collegiate Schools of Architecture*, Rome, Italy, May 29–June 2.

Shank, Michael and Schirch, Lisa (2008), "Strategic arts-based peace building," *Peace & Change*, 33:2, pp. 217–42.

Shields, Sara (2016), "How I learned to swim: The visual journal as a companion to creative inquiry," *International Journal of Education and the Arts*, 17:8, pp. 1–25.

Shin, Ryan (2011), "Social justice and informal learning: Breaking the social comfort zone and facilitating positive ethnic interaction," *Studies in Art Education*, 53:1, pp. 71–87.

Shin, Ryan (2019), email to author, July 31.

Shokef, Efrat and Erez, Miriam (2006), "Shared meaning systems in multicultural teams," in B. Mannix, M. Neale, and Y. Chen (eds.), *National Culture and Groups: Research on Managing Groups and Teams*, 9, San Diego: Elsevier, pp. 325–52.

Sickler-Voigt, Debrah (2019), email to author, August 2.

Simmer-Brown, Judith (1999), "Commitment and openness: A contemplative approach to pluralism," in S. Glazer (ed.), *The Heart of Learning: Spirituality in Education*, New York: Penguin Group, pp. 97–112.

Sinner, Anita, Irwin, Rita L., and Adams, Jeff (eds.) (2019), *Provoking the Field: International Perspectives on Visual Arts Ph.D.s in Education*, Bristol: Intellect.

Sirin, Selcuk and Fine, Michelle (2007), "Hyphenated selves: Muslim American youth negotiating identities on the fault lines of global conflict," *Applied Developmental Science*, 11:3, pp. 1–13.

Skaalvik, Einar and Skaalvik, Sidsel (2010), "Teacher self-efficacy and teacher burnout: A study of relations," *Teaching and Teacher Education*, 86:4, pp. 981–1015.

Sluss, David and Ashforth, Blake (2007), "Relational identities and identification: Defining ourselves through work relationships," *Academy of Management Review*, 32:1, pp. 9–32.

Smith, Thomas and Ingersoll, Richard (2004), "What are the effects of induction and mentoring on beginning teacher turnover?" *American Educational Research Journal*, 41:3, pp. 681–714.

Smola, Karen Wey and Sutton, Charlotte (2002), "Generational differences: Revisiting generational work values for the new millennium," *Journal of Organizational Behavior*, 23:4, pp. 363–82.

Snell, Scott, Snow, Charles, Davison, Sue Canney, and Hambrick, Donald (1998), "Designing and supporting transnational teams: The human resource agenda," *Human Resource Management*, 37:2, pp. 147–58.

Spears, Russel (2011), "Group identities: The social identity perspective," in S. Schwartz, K. Luyckx, and V. Vignoles (eds.), *Handbook for Identity Theory and Research*, New York: Springer, pp. 203–24.

Springgay, Stephanie and Truman, Sarah (2018), *Walking Methodologies in a More-Than-Human World: Walking Lab*, New York: Routledge.

Stagoll, C. (2005), "Becoming," in A. Parr (ed.), *The Deleuze Dictionary*, New York: Columbia University Press, pp. 25–27.

Stankiewicz, MaryAnn (2019), email to author, July 15.

Steffy, Betty, Wolfe, Michael, Pasch, Suzanne, and Enz, Billie (2000), *The Life Cycle of the Career Teacher*, Thousand Oak: Corwin Press.

Stokrocki, Mary (2010), "Art and spirituality on second life: A participant observation and digital quest for meaning," *Journal of Alternative Perspectives in the Social Sciences*, 2:1, pp. 182–97.

Stokrocki, Mary (ed.) (2014), *Exploration in Virtual Worlds: New Digital Multi-media Literacy Investigations for Art Education*, Reston: National Art Education Association.

Stout, Roxanne Evans (2016), *Storytelling with Collage: Techniques for Layering, Color and Texture*, Blue Ash: North Light Books.

Strom, Kathryn, Mills, Tammy, Abrams, Linda, and Dacey, Charity (2018), "Putting posthuman theory to work in collaborative self-study," in D. Garbett and A. Ovens (eds.), *Pushing Boundaries and Crossing Borders: Self-Study as a Means for Researching Pedagogy*, Herstmonceux: S-STEP, pp. 35–41.

Subedi, Binaya (2006), "Theorizing a 'halfie' researcher's identity in transnational fieldwork," *International Journal of Qualitative Studies in Education*, 19:5, pp. 573–93.

Sulewski, Jennifer, Boeltzig, Heike, and Hasan, Rooshey (2012), "Art and disability: Intersecting identities among young artists with disabilities," *Disability Studies Quarterly*, 32:1, http://dsqsds.org/article/view/3034/3065. Accessed August 8, 2019.

Sullivan, Graeme (2004), "Studio practice as research," in E. Eisner and M. Day (eds.), *Handbook of Research and Policy in Art Education*, New Jersey: Lawrence Erlbaum, pp. 803–22.

Sullivan, Graeme (2009), *Art as Research: Inquiry in the Visual Arts*, 2nd ed., Thousand Oaks: Sage.

Sutters, Justin (2019), "Printmaking as metaphor: Foucauldian notions of inscription as representative," *Visual Inquiry*, 7:3, pp. 245–50.

Swain, John and French, Sally (2000), "Towards an affirmation model of disability," *Disability & Society*, 15:4, pp. 569–82.

Symington, Alison (2004), "Intersectionality: A tool for social and economic justice," *Women's Rights and Economic Change*, 9, pp. 1–8.

Tamrat, Emmanuel (2014), "Rumi quotes: 25 sayings that could change your life Quotezine," http://www.quotezine.com/rumi-quotes/. Accessed December 7, 2020.

Tanaka, Azusa, Gonzalez-Smith, Isabel, and Swanson, Juleah (2014), "Unpacking identity: Racial, ethnic, and professional identity and academic librarians of color," in N. Pagowsky and M. Rigby (eds.), *The Librarian Stereotype: Deconstructing Perceptions and Presentations of Information Work*, Chicago: Association of College and Research Libraries, pp. 149–73.

Tariq, Memooma and Syed, Jawad (2017), "Intersectionality at work: South Asian Muslim women's experiences of employment and leadership in the United Kingdom," *Sex Roles*, 77, pp. 510–22.

Terriquez, Veronica (2015), "Intersectional mobilization, social movement spillover, and queer youth leadership in the immigrant rights movement," *Social Problems*, 62:3, pp. 343–62.

Thomas, Peter and Thomas, Donna (2011), *Making Books by Hand*, Gloucester: Quarry Books.

Thornton, Alan (2005), "The artist teacher as reflective practitioner," *International Journal of Art and Design*, 24:2, pp. 166–74.

Thornton, Alan (2013), *Artist, Researcher, Teacher: A Study of Professional Identity in Art and Education*, Bristol: Intellect.

Tidwell, Deborah, Heston, Melissa, and Fitzgerald, Linda (eds.) (2009), *Research Methods for the Self-Study of Practice*, Netherlands: Springer.

Tidwell, Deborah, Heston, Melissa, and Fitzgerald, Linda (eds.) (2010), *Research Methods for the Self-Study of Practice, Self Study Teaching and Teacher Education Practice*, 9, Netherlands: Springer.

Tierney, William and Rhoads, Robert (1993), *Enhancing Promotion, Tenure and Beyond: Faculty Socialization as a Cultural Process*, Washington: George Washington University.

Tisdell, Elizabeth (2003), *Exploring Spirituality and Culture in Adult and Higher Education*, San Francisco: Jossey-Bass.

Tishman, Shari (2018), *Slow Looking: The Art and Practice of Learning Observation*, New York: Taylor and Francis.

Todd-Adekanye, Clarissa (2017), "Visual journaling for (self) education through art education," Master's thesis, Philadelphia: Moore College of Art and Design.

Tracey, Shelley and Allen, Joe (2013), "Collage making for interdisciplinary research skill training in Northern Ireland," in D. E. Clover and K. Sanford (eds.), *Lifelong Learning, the Arts and Community Cultural Engagement in the Contemporary University: International Perspectives*, Manchester: Manchester University Press, pp. 96–108.

Trede, Fransiska, Macklin, Rob, and Bridges, Donna (2012), "Professional identity development: A review of higher education literature," *Studies in Higher Education*, 37:3, pp. 365–84.

Tufte, Edward (1990), *Envisioning Information*, Connecticut: Graphics Press.

Tufte, Edward (1997), *Visual Explanations: Images and Quantities, Evidence and Narrative*, Connecticut: Graphics Press.

Twigger-Ross, Clare and Uzzell, David (1996), "Place and identity process," *Journal of Environmental Psychology*, 16, pp. 205–20.

Unrath, Kathleen, Anderson, Mark, and Franco, Mary (2013), "The becoming art teacher: Reconciliation of teacher identity and the dance of teaching art," *Visual Arts Research*, 39:2, pp. 82–92.

Unrath, Kathleen and Nordlund, Carrie (2009), "Postcard moments: Significant moments in teaching," *Visual Arts Research*, 35:1 (Spring), pp. 91–105.

Van Cleave, Kendra (2008), "The self-study as an information literacy program assessment tool," *College & Undergraduate Libraries*, 15:4, pp. 414–31.

Van der Vaart, Gwenda, van Hoven, Bettina, and Huigen, Paulus P. P. (May 2018), "Creative and arts based research methods in academic research: Lessons from a participatory research project in the Netherlands," Forum Qualitative Sozialforschung / Forum, *Qualitative Social Research*, 19:2, Article 19, http://dx.doi.org/10.17169/fqs-19.2.2961.

Van Houtte, Mieke (2004), "Climate or culture? A plea for conceptual clarity in school effectiveness research," *School Effectiveness and School Improvement*, 16:1, pp. 71–89.

Van Leeuwen, Theo and Jewitt, Carey (2000) *Handbook of Visual Analysis*, London: Sage.

Van Manen, Max (1990), *Researching Lived Experience: Human Science for an Action Sensitive Pedagogy*, Ontario: University of Western Ontario.

Van Manen, Max (1997), *Researching Lived Experience*, 2nd ed., London: Althouse.

Veenstra, Gerry (2011), "Race, gender, class, and sexual orientation: Intersecting axes of inequality and self-rated health in Canada," *International Journal for Equity in Health*, 10:3, pp. 1–11.

Vignoles, Vivian, Schwartz, Seth, and Luyckx, Koen (2011), "Introduction: Toward an integrative view of identity," in V. L. Vignoles, S. J Schwartz, and K. Luyckx (eds.), *Handbook of Identity Theory and Research*, New York: Springer, pp. 1–27.

Walker, Sydney (2004), "Big ideas: Understanding the artmaking process—reflective practice," *Art Education*, 57:3 (May), pp. 6–12.

Wang, Qingchun, Coemans, Sara, Siegesmund, and Hannes, Karin (2017), "Arts based methods in socially engaged research practice: A classification framework," *Art/Research International: A Transdisciplinary Journal*, 2:2, pp. 5–39.

Ward-Harrison, Sabrina (2011), *The Story Happening*, San Francisco: Chronicle Books.

Weber, Max (1968), *Economy and Society*, G. Roth and C. Wittich (eds.), New York: Bedminister Press.

Weber, Sandra and Mitchell, Claudia (2004), "Visual artistic modes of representation for self-study," in J. J. Loughran, M. L. Hamilton, V. K. LaBoskey, and T. Russell (eds.), *International Handbook on Self-study of Teaching and Teacher Education Practices*, Netherlands: Springer, pp. 979–1037.

Wenger, Etienne (1998), *Communities of Practice: Learning, Meaning and Identity*, Cambridge: Harvard University Press.

West, Anne (2004), *Mapping: The Intelligence of Artistic Work: An Exploration Guide to Making, Thinking and Writing*, Portland: Moth Press/Maine College of Art.

West, Chloe and Chur-Hansen, Anna (2004), "Ethical enculturation: The informal and hidden ethics curricula at an Australian medical school," *Focus on Health Professional Education*, 6:1, pp. 85–99.

Wexler, Alice (2009), *Art and Disability: The Social and Political Struggles Facing Education*, New York: Palgrave Macmillan.

Wheeldon, Johannes and Faubert, Jacqueline (2009), "Framing experience: Concept maps, mind maps, and data collection in qualitative research," *International Journal of Qualitative Methods*, 8:3, pp. 68–83.

White, John Howell (2019), email to author, August 18.

Williams, Judy, Ritter, Jason, and Bullock, Shawn (2012), "Understanding the complexity of becoming a teacher educator: Experience, belonging, and practice within a professional learning community," *Studying Teacher Education*, 8:3, pp. 245–60.

Wilson, Gloria (2018), "Construction of the Blackademic: An arts-based tale of identity in and through academia," *Visual Inquiry Learning and Teaching in Art*, 7:3, pp. 213–26.

Winslow, Sarah (2010), "Gender inequality and time allocations among academic faculty," *Gender and Society*, 24:6, pp. 769–93.

Wu, Jennifer (2013), "Choosing my avatar & the psychology of virtual worlds: What matters?," *Kaleidoscope*, 11, Article 89, https://uknowledge.uky.edu/kaleidoscope/vol11/iss1/89. Accessed December 10, 2020.

Yellow Bird, Michael (1999), "What we want to be called: Indigenous peoples' perspectives on racial and ethnic identity labels," *American Indian Quarterly*, 23:2, pp. 1–21.

Yoon, Injeong (2017), "Exploring transnational life through narratives: A study on transnational experiences of Korean students in an American university," in R. Shin, M. Lim, M. Bae-Dimitriadis, and O. Lee (eds.), *Pedagogical Globalization: Traditions, Contemporary Art and Popular Culture of Korea*, Viseu, Portugal: InSEA Publications, pp. 240–53.

Zembylas, Michalinos (2003), "Interrogating 'teacher identity': Emotion, resistance and self transformation," *Educational Theory*, 53:1, pp. 107–27.

Zwirn, Susan (2006), "Artist or art teacher: The role of gender identity formation and career choice," *Teaching Artist Journal*, 4:3, pp. 167–75.

Index

Page numbers in *italics* refer to figures; page numbers in **bold** refer to tables.